FROM THE PAIN COME THE DREAM

THE RECIPIENTS OF THE REEBOK HUMAN RIGHTS AWARD

UMBRAGE EDITIONS

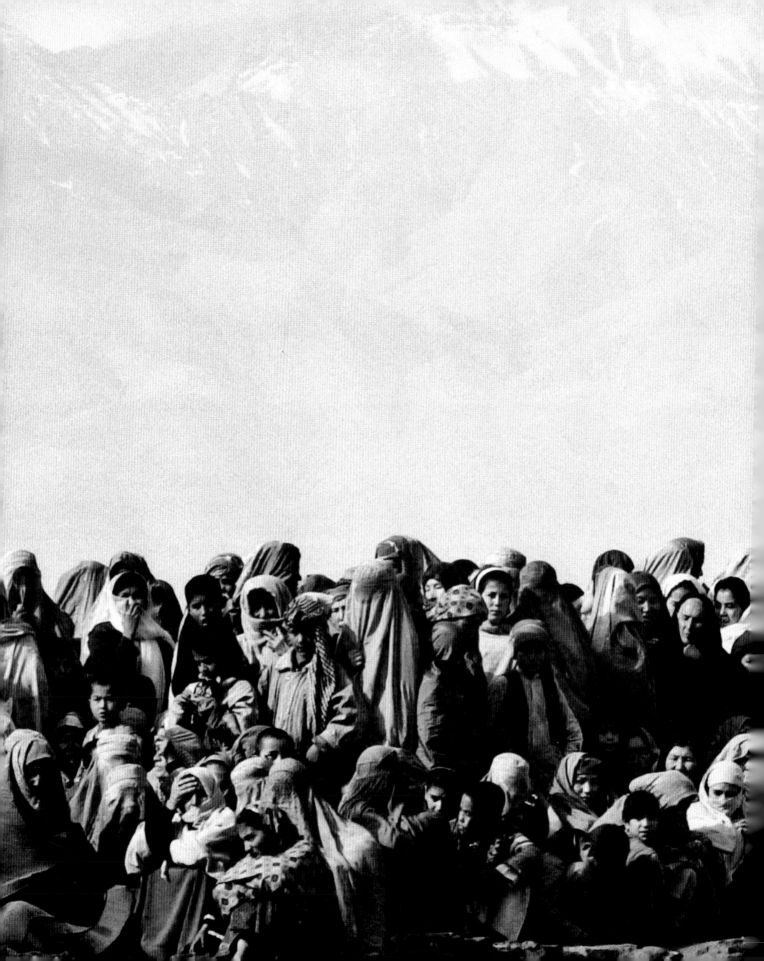

ARTICLE 1: ALL HUMAN BEINGS ARE BORN FREE AND EQUAL IN DIGNITY AND RIGHTS. THEY ARE ENDOWED WITH REASON AND CONSCIENCE AND SHOULD ACT TOWARDS ONE ANOTHER IN A SPIRIT OF BROTHERHOOD.

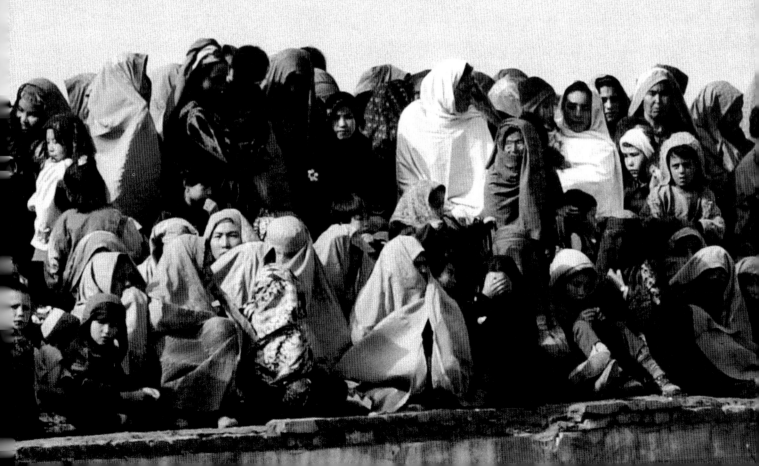

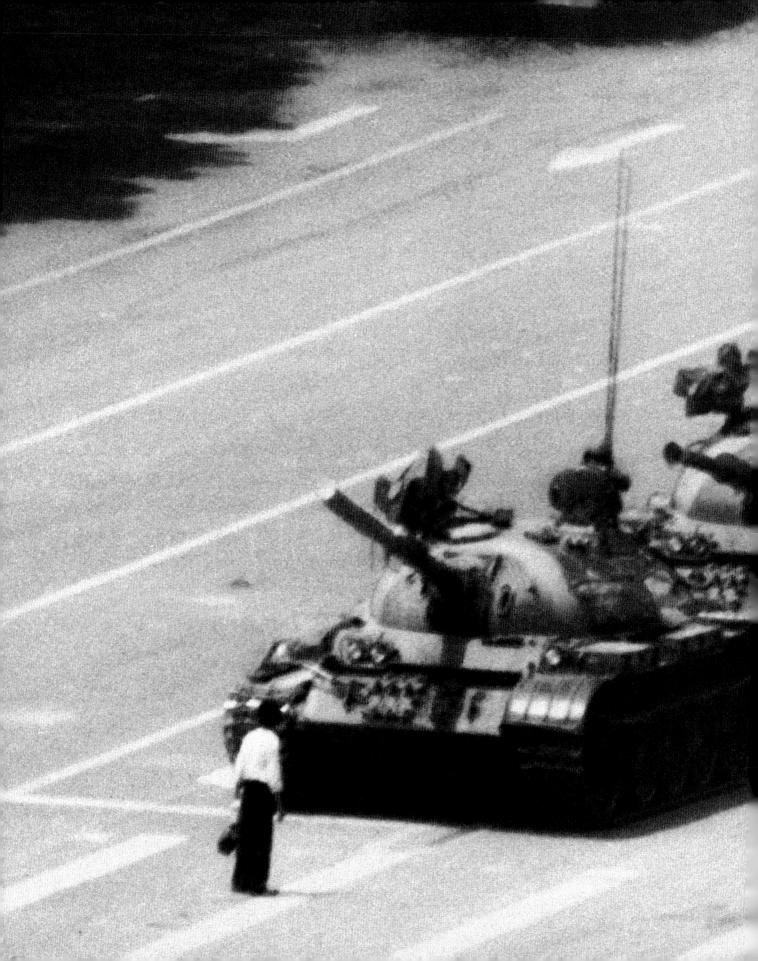

ARTICLE 3: EVERYONE HAS THE RIGHT TO LIFE, LIBERTY, AND SECURITY OF PERSON.

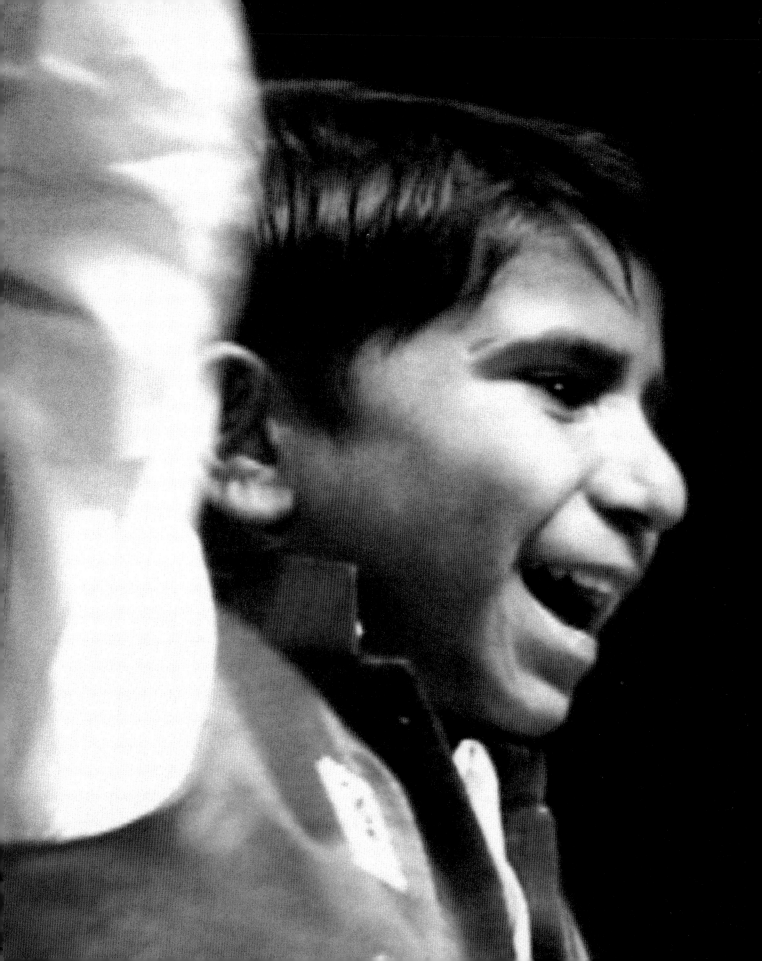

FROM THE PAIN COME THE DREAM

THE RECIPIENTS OF THE REEBOK HUMAN RIGHTS AWARD

Published by Umbrage Editions
515 Canal Street
New York, NY 10013
www.umbragebooks.com

ISBN 1-884167-35-7
Library of Congress Cataloging-in-Publication Data available

Printed in the United States of America

All Reebok International Ltd.'s profits from the sale of this book will be donated to **FOREFRONT**, a nonprofit organization founded by recipients of the Reebok Human Rights Award in 1993. To learn more, contact Forefront at 333 Seventh Avenue, 13th Floor, New York, NY 10001; phone: 212 845 5200; email: forefront@forefrontleaders.org; website: www.forefrontleaders.org.

CONTENTS

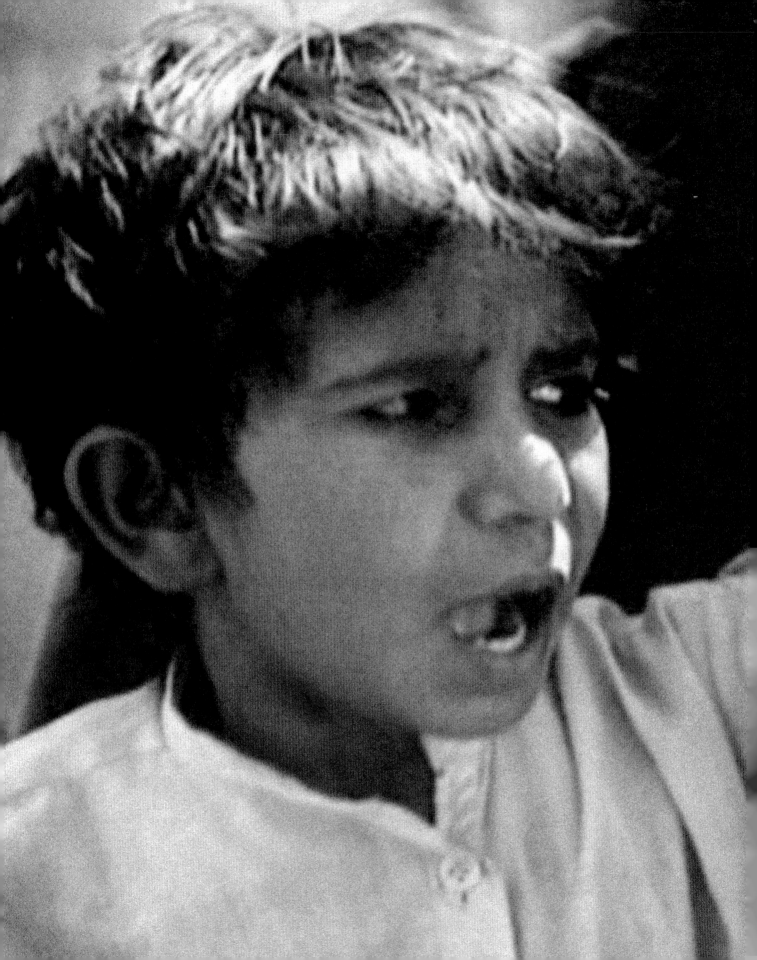

FROM THE PAIN COME THE DREAM
THE STORY OF IQBAL MASIH

HE SQUATS ON THE LONG EDGE OF A WOODEN PLATFORM, HIS EYES INCHES AWAY FROM THE INTRICATE FLORAL PATTERN HE'S WEAVING. HIS BREATHING IS RASPY FROM INHALED WOOL FIBERS, AND HIS FINGERS THROB WITH AN EARLY ARTHRITIS. JUST AS HE RAISES HIS KNIFE TO TRIM A ROW OF KNOTTED THREADS, HIS LEG TWITCHES IN ITS SHACKLE, AND THE BLADE SLICES HIS SKIN. HE TWITCHES NOW WITH FEAR—OF HIS BLOOD SPLASHING THE FLOWERS, OF HIS DEBT GROWING, OF ANOTHER BEATING. HE IS FIVE YEARS OLD.

When **IQBAL MASIH** was four, his father sold him into slavery for 600 rupees, the equivalent of twelve dollars, to pay for the wedding of an older son. For the next six years, Iqbal was shackled to a loom in a small carpet factory for up to fifteen hours a day. When fatigue slowed his fingers, he received lashes on his back and head. Once, when he tried to defy his owner's orders to work through the night, he was thrown into a dark closet, where he was tied at the knees and hung upside down.

The years spent hunched over a loom, inhaling lint and eating barely enough to survive, had bowed Iqbal's spine, weakened his lungs, and stunted his growth. By the time he turned ten, he was still the size of a child half his age.

And while Iqbal's bones stopped growing, his debt did not. He was charged for his training, his tools, and his scant meals. He was fined for making mistakes, for asking questions, even for being sick. By the time he had been weaving carpets for six years, his pay had risen to twenty rupees a day, yet his debt had spiraled to an insurmountable 13,000 rupees. And Iqbal's plight was not unusual. He was one of millions of Pakistani children in bonded labor. Across the country—and across the region—boys and girls were spending their childhoods tying knots in carpets, stitching soccer balls, crushing stones, rolling cheap cigarettes called *beedis,* soldering delicate silver flowers to jewelry, or shaping wet clay into bricks.

One day, Iqbal heard whispers about a freedom rally staged by the Bonded Labor Liberation Front (BLLF). It was 1993, a year after the Pakistani parliament had passed the Bonded Labor Act, which not only abolished the debt labor system, but also cancelled all previous debts that slave laborers had owed their masters. Risking yet another beating, Iqbal snuck away from the factory and crept into the gathering. There he was shocked to learn that his family's debt to his owner had been cancelled a year—and several million agonizing knots—earlier.

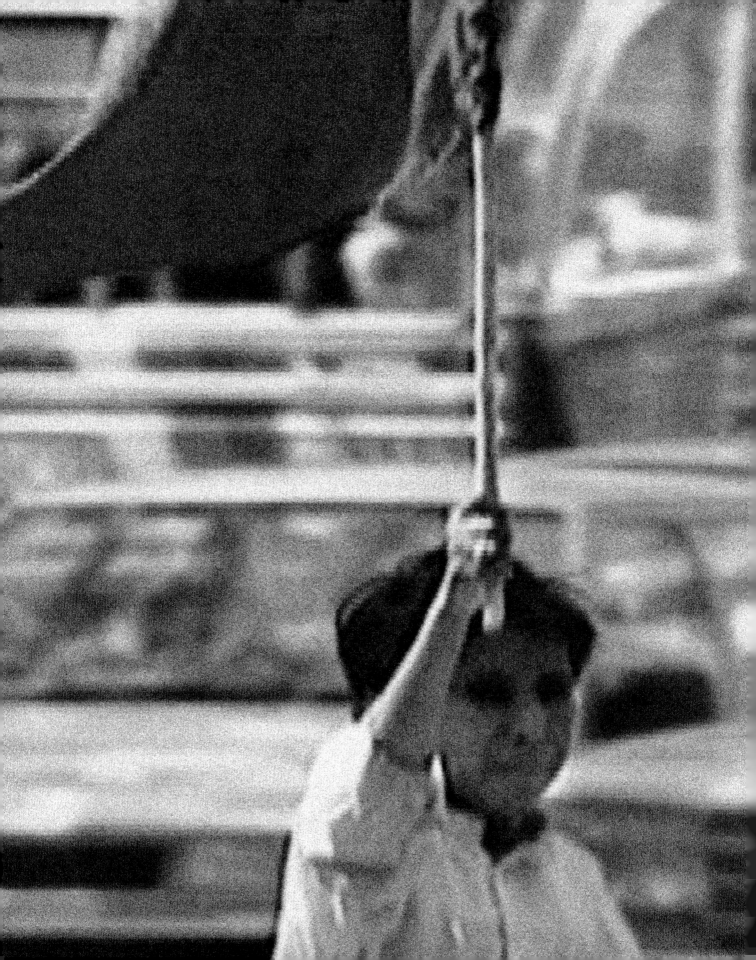

During the rally, Eshan Ullah Khan, the founder of BLLF, noticed the shy, diminutive boy. "He sat cowering in a corner, emaciated and wheezing like an old man," Khan says. "It was like he was trying to hide himself, to disappear, he was so frightened. But I felt there was something in this boy, that he had a strong will."

Iqbal's will was indeed stronger than his fear. After the meeting, he refused to resume his worn spot on the long wooden platform. A BLLF lawyer helped him obtain a freedom letter and, with the support of BLLF staff workers, he triumphantly returned to the carpet factory to declare his freedom. There he called to the other boys to join him. At the age of ten, he was finally free—free to reclaim his lost childhood, to learn to read and write, to play cricket with his friends, to watch kung fu movies.

Yet Iqbal declared that he could not be free until all children were free. From his pain came a dream. He became a spokesperson for BLLF, traveling to Europe and the United States to call for an end to child labor and a boycott of Pakistan's carpet industry, where most of the laborers were children. His activism helped free thousands of children from bonded labor, and Pakistani carpets sales began to fall. His outspokenness led to death threats, yet he remained undaunted.

In 1994, Reebok celebrated Iqbal's heroism with its Youth in Action Award. During his trip to accept the award, he was offered a chance to attend college in the United States, a generosity he gladly accepted for the future. While in Massachusetts, he also visited the Broad Meadows Middle School, where his life story shocked and outraged the students. They began an intensive campaign that resulted in hundreds of letters being sent to the leaders of countries where child bonded labor persists.

Then one balmy spring evening, less than six months later, Iqbal perched on the crossbar of a bicycle. It was Easter, and he was riding with a cousin and a friend, along a remote and dusty road, on his way to take dinner to his uncle. Suddenly, dozens of pellets of buckshot ripped into his flesh, killing him on the spot. Many blamed the carpet industry mafia for his death. Years later, the motive for his murder is still in contention, but the result is not: a young boy was shot down on Easter, early in his ministry of fighting for justice for children.

Iqbal's good work did not end with his death. From his pain came other dreams. When they learned of Iqbal's murder, the students of Broad Meadows Middle School launched a campaign to raise money for a school to educate poor Pakistani children in Iqbal's hometown. They requested donations of twelve dollars, because Iqbal had been sold for twelve dollars, he was twelve when they met him, and he was twelve when he was killed. The Broad Meadows Middle School raised more than $140,000 for the school, which opened two years after Iqbal's death. There children are allowed to learn rather than just labor; there children are allowed to hope.

The story of Iqbal's short life has influenced other youthful human rights leaders. After reading an article about Iqbal, twelve-year-old Craig Kielburger joined with friends to form Free the Children, a nonprofit youth organization that campaigns against child labor. Yet Craig felt he needed to witness the working conditions of South Asian children firsthand.

Although he was not even allowed to take the subway alone, Craig convinced his parents to allow him to fly halfway around the world. For seven weeks, he accompanied a human rights worker on a horrifying journey through the slums, sweatshops, and back alleys where so many children live in virtual enslavement. The tour completed Craig's transformation from a middle-class Canadian student into an international activist.

Under Craig's leadership, Free the Children has grown into an influential movement of young people around the world speaking out on behalf of exploited children. Like the small boy who had inspired them, Craig and the Broad Meadows Middle School students received Reebok's Youth in Action Award for their advocacy of children.

Many centuries ago, and a continent away from the tragedy of Iqbal Masih's murder, the poet Dante wrote that from a tiny spark may burst a mighty flame. Iqbal's life may have been snuffed out early, but his memory has ignited people around the world, and his mighty flame continues to burn.

EVERY MOTHER'S SON

When Reebok sponsored Amnesty International's Human Rights Now! Tour back in 1988, I considered human rights to be a worthy yet abstract cause. But on the last stop of the tour, in Buenos Aires, I came to see human rights not as merely worthy, but as real—and as gut wrenching.

Far from the crowded concert stadium, I met a group of women known as Las Madres de Plaza de Mayo, the Mothers of Plaza de Mayo. These were the brave mothers of mostly young men who had been kidnapped by the thugs of the Argentine junta.

We have since learned, from the mass graves and the testimony of people who helped throw them out of helicopters into the waters of the Atlantic Ocean, that these young men—los desaparecidos, or "the disappeared"—were, in fact, murdered. But back then, when their fate was still unknown, every Thursday afternoon at half past three, their mothers would come to the plaza, across from the presidential palace. There, wearing black dresses with photographs of their sons pinned to their chests, these women would bear witness against the regime.

As I gazed at those photographs and looked into the worn and haunted eyes of those mothers, I began to understand what the struggle for human rights means, not as an abstract concept, but to the lives of real people, whether in Argentina or Bosnia, Rwanda or Tibet, or my home country of the United States. I saw in the faces of those mothers the heartbreak that human rights cruelties cause untold millions around the world.

When we think of human rights violations, the pictures we conjure are decidedly unpleasant, and we tend to let our minds drift onward. But those mothers in that plaza in Buenos Aires—and the nuns in Tibetan prisons, and the rape victims in Bosnia, and the children who witnessed their parents being murdered in Rwanda—are looking at us and to us. They are counting on us, and it is unthinkable that we could ever turn our backs on them.

ANGEL MARTINEZ, *a former chief marketing officer of Reebok International Ltd., is a member of the Board of Advisors of the Reebok Human Rights Award Program.*

FROM THE DREAM COME THE VISION

THE HISTORY OF THE REEBOK HUMAN RIGHTS AWARD

We had been riding the crest of the fitness craze of the early 1980s, and sales had skyrocketed to a billion dollars. By 1986, the business press was calling us the fastest-growing company in the country. By coincidence, that was the same year we became one of the first international corporations to pull out of a profitable business in South Africa, when we realized that by withdrawing, we could support the struggle to end apartheid.

Our success felt wonderful, but we had a great sense of unfulfilled purpose. We were young and idealistic, and we wanted to share our success as a catalyst for change in the world. We realized that we could do more than make shoes; our consumers were young, too, and perhaps we could influence them to the good. And so we were intrigued when our advertising agency approached us with the idea of sponsoring Amnesty International's Human Rights Now! world concert tour to raise awareness of human rights abuses throughout the world. A global rock concert aimed at teaching young people about human rights and featuring such performers as Bruce Springsteen, Peter Gabriel, Sting, and Tracy Chapman seemed to fit our brand.

But the tour sponsorship carried with it some unusual restrictions. Our new friends at Amnesty warned us: no Reebok signage, no Reebok presence at press conferences, no Reebok shoes or clothing forced on the performers. Maybe a tiny "Made possible by Reebok" printed discreetly on concert programs. Moreover, the $10 million required for sponsorship was half of our entire advertising budget. Our sales force was crying for more television commercials, not a concert in Bangladesh.

Despite conventional business wisdom, our convictions carried us. We signed on, and the Human Rights Now! Tour began its journey, through more than twenty cities on five continents, raising awareness of man's inhumanity to man. Six months later, it wasn't just the consciousness of the hundreds of thousands of young people who attended the concerts that had been raised, but ours at Reebok as well. The celebration of people willing to risk everything to defend the freedom of others had humbled us—and inspired us.

From Amnesty International's dream came our vision: we decided to create the annual Reebok Human Rights Award. Now in its fifteenth year, this Award shines a bright light on the injustices that people suffer throughout the world. And it honors young men and women, thirty years or younger, who fight against darkness every day of their lives—often at great personal risk and always against great odds.

Since the program's inception in 1988, the Award has recognized seventy-two recipients from thirty-four countries who have selflessly pursued what they knew to be right and just, whether it was to free young slaves in Ghana, testify against perpetrators of Guatemalan massacres, or rescue young mothers from forced prostitution in Nepal. They all acted, knowing that the easy way to let evil win is to do nothing—to avert a glance, to turn a deaf ear, to stifle a voice.

Every year recipients of the Reebok Human Rights Award come forward to tell their stories to the world—and every year we are struck by their spirit, determination, and fortitude. They tell us stories of horror and despair, then counter those stories with an undaunted affirmation of humanity and a courageous pursuit of positive change.

Li Lu, a leader of the Tiananmen Square demonstrations and one of the earliest Award recipients, expressed the resolve of all the Award winners when he said, "Sometimes it is hard to believe that the sweet can defeat the bitter, the kind beat back the cruel. But I am here to tell you that evil is not our destiny, tyranny is not our fate."

The inspiration of these human rights heroes has led Reebok to examine the human rights implications of our business practices and the direction of our corporate philanthropy. Now, I don't know if Reebok has sold a single pair of shoes because we support human rights. No dealer has ever told us that, faced with a choice of two brands, the customer finally said, "I'll take the human rights shoe." But I do know that our commitment to justice—our stand for values—has defined the culture at Reebok. And I know that our commitment makes employees proud to be part of the company.

Over the past fifteen years, we have been privileged to learn much from the Reebok Human Rights Award recipients. We have learned firsthand about tyranny, and we have learned firsthand about courage. They have taught us what can be accomplished by just one person. And they continue to teach us what can be achieved when one becomes many.

PAUL FIREMAN *is the chairman and chief executive officer of Reebok International Ltd.*

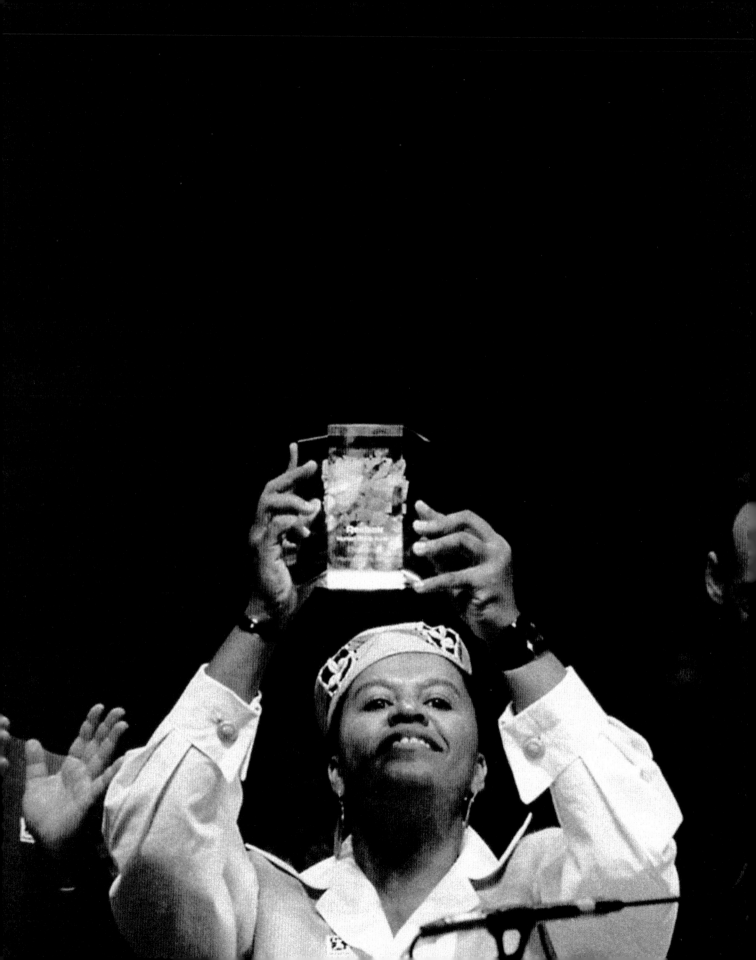

FROM THE VISION COME THE PEOPLE

THE RECIPIENTS OF THE REEBOK HUMAN RIGHTS AWARD

Imagine feeling your three-year-old brother ripped from your arms and seeing him crushed to death before your unbelieving eyes. Then imagine having to work for his killer, every day for two years.

Imagine playing in a field with your friends when suddenly, in a single blast, you have lost your eyesight and one of your forearms.

Imagine having your two-year-old daughter snatched from you and held hostage, somewhere in the filthy bowels of Bombay's red light district, as you're forced to service a stream of men.

Imagine being beaten, tortured, and imprisoned without cause. Imagine being sold into slavery. Imagine having your entire family massacred.

Many Reebok Human Rights Award recipients have not needed to imagine such horrors; they have lived them, survived, and even triumphed.

Other recipients began as witnesses—witnesses to the suffering of children orphaned by violence, women tortured for advocating peace, men persecuted for defending the rights of others. Still others looked beyond their own comfortable lives to imagine—and then help ameliorate—the pain of strangers.

Each year, the Reebok Human Rights Award celebrates young human rights heroes, providing them with a grant for the nongovernmental organization of their choice and shining a positive, international light on their work. Awardees must be thirty years of age or younger, they cannot advocate violence or belong to an organization that advocates violence, and they must be working on an issue that directly relates to the Universal Declaration of Human Rights.

It is easy, in this often brutal world, to lose faith in the human spirit. But once you read the stories of these remarkable young men and women, you will find your faith restored. Their stories do not leave us paralyzed with despair, but show us how even the most treacherous evil cannot withstand the force of true courage and commitment. And each of their stories reveals a simple truth: a single dedicated person can bring transforming light into darkness.

REEBOK HUMAN RIGHTS AWARD RECIPIENTS

"THERE IS VIOLENCE, THERE IS DISCRIMINATION, THERE ARE SOCIAL INJUSTICES. SOMEBODY MUST DO SOMETHING, AND I THINK I AM THAT PERSON."

HEALTH AND HUMAN RIGHTS

The International Gay and Lesbian Human Rights Commission (IGLHRC) works to secure the full enjoyment of human rights for all people and communities subject to discrimination or abuse on the basis of sexual orientation or expression, gender identity or expression, or HIV status. IGLHRC pursues this mission through advocacy, documentation, coalition building, public education, and technical assistance. www.iglhrc.org

The Joint United Nations Programme on AIDS (UNAIDS) is the main advocate for global action on HIV/AIDS. UNAIDS leads, strengthens, and supports an expanded response aimed at preventing the transmission of HIV, providing care and support, reducing the vulnerability of individuals and communities to HIV/AIDS, and alleviating the impact of the epidemic. www.unaids.org

ADAUTO BELARMINO ALVES

BRAZIL 1994 AGE 29

BUILDING BRIDGES TO COMBAT SOCIAL INJUSTICE

A YOUNG MAN WALKING DOWN A STREET IN RIO DE JANEIRO WAS SURROUNDED BY A GROUP OF BOYS AND DRAGGED INTO AN ALLEY. THEY PUNCHED AND KICKED HIM REPEATEDLY BECAUSE HE WAS A HOMOSEXUAL. A POLICEMAN, WHO HAD WATCHED THE SCENE UNFOLD, SIMPLY WALKED AWAY. BUT A YOUNG ACTIVIST NAMED ADAUTO ALVES DID NOT LOOK THE OTHER WAY. HE DEDICATED HIS LIFE TO DEMANDING BASIC HUMAN RIGHTS FOR PEOPLE THAT MANY BRAZILIANS WANTED TO IGNORE—GAYS, TRANSVESTITES, PEOPLE WITH AIDS, DRUG ADDICTS, COMMERCIAL SEX WORKERS, AND PRISONERS.

Homosexuals in Brazil have been routinely harassed, beaten, and even murdered. The vast majority of these hate crimes have gone unsolved and the perpetrators unpunished. Police have often been involved in the violence and victimization—arbitrarily arresting homosexuals and committing extortion or blackmail against them. Gay rights organizations have also documented the existence of twelve paramilitary groups dedicated to killing homosexuals and transvestites throughout Brazil.

As a prominent activist, Adauto received numerous death threats and was himself a victim of violence. In 1992, he was attacked by the police for "appearing" to be homosexual and was thrown into jail. And in 1993, he was badly beaten by a group of neo-Nazi youth because he was disseminating AIDS information. This well-publicized attack galvanized Brazil's human rights community to denounce violence against homosexuals and to put pressure on the police to provide better protection for gay and lesbian citizens.

But even physical danger did not deter Adauto from his mission. As coordinator of the AIDS and Preventive Health Project for the Institute of Religious Studies, he established community programs for people with AIDS and walked the streets at night in poor and dangerous neighborhoods distributing lifesaving information to people at risk.

One of Adauto's most important achievements was to build bridges among people who face similar oppression, but who have traditionally viewed each other with suspicion or contempt. He helped people at risk for HIV—prostitutes, drug addicts, the homeless, and gay men—learn to work together to further AIDS education and to curtail the spread of the virus. He also united the gay and lesbian communities so they could work more effectively to combat homophobia and violence.

Adauto was regarded as an articulate leader with an unsurpassed compassion and dedication to defending the rights of social minorities. He won the respect of both the powerless and the powerful. In 1993, at the request of the Brazilian government, he participated in the UN World Conference on Human Rights and helped to bring international attention to the issue of violence against homosexuals, prostitutes, and transvestites.

Adauto died of AIDS in 1999. Until his death, he remained an ardent advocate of the rights of sexual minorities in Brazil and in the fight against AIDS.

"IT TOOK ME A WHILE TO REALIZE THAT DISCRIMINATION IS NOT JUST AGAINST LATINOS, AND THAT OUR STRUGGLE IS NOT HARDER THAN ANYBODY ELSE'S. WHAT WE NEED TO DO IS WORK TOGETHER AND GET RID OF ALL OF IT."

GET INVOLVED

DISCRIMINATION AND RACISM

The National Conference for Community and Justice (NCCJ) works to transform communities to provide fuller opportunity and to be inclusive and just—through institutional change—by empowering leaders. NCCJ's programming facilitates community and interfaith dialogues and provides workplace consultations, youth leadership development, and seminarian and educator training. www.nccj.org

The National Council of La Raza (NCLR) works to reduce poverty and discrimination, and improve life opportunities for Hispanic Americans. NCLR's approaches include providing organizational assistance in management, governance, program operations, and resource development to Hispanic community-based organizations in urban and rural areas nationwide, especially those that serve low-income and disadvantaged Hispanics and offer applied research, policy analysis, and advocacy. www.nclr.org

PEDRO ANAYA

UNITED STATES 2003 AGE 24

EMPOWERING YOUTH TO FIGHT AGAINST DISCRIMINATION

AN ACTIVIST IN SAN DIEGO'S LATINO COMMUNITY, PEDRO ANAYA HAS A PASSION FOR EMPOWERING THE DISENFRANCHISED. HE IS A LEADING VOICE IN THE FIGHT FOR THE RIGHTS OF MIGRANT FARM WORKERS AND UNDOCUMENTED IMMIGRANTS, AND AN INSPIRING YOUTH LEADER DEDICATED TO COMBATING DISCRIMINATION.

Latinos of Mexican origin are the fastest growing minority group in the United States. Many are undocumented and come to the United States seeking work, often taking on undesirable low paying jobs. In California's agricultural business alone, thousands of undocumented Latino farm workers work extremely long hours for very low wages. Many work amid dangerous pesticides and often suffer chronic back injuries, but have little or no access to health care. In recent years, intensified border restrictions have severely limited the flow of undocumented migrants and forced many desperate Mexicans to take more dangerous routes across snowy mountains, rivers, and the desert. Hundreds of deaths have been reported from drowning, hypothermia, heat stroke, and highway accidents. Others suffer at the hands of unscrupulous smugglers.

The son of undocumented immigrants, Pedro, like other Latinos, experienced the indignity of discrimination in school and in the community. As a young teenager, he sought empowerment in gangs rather than in activism. But some influential mentors and a school assignment helped steer him in a positive direction. When asked to write about an American hero, he chose Mexican American activist César Chavez. Dismayed when his teacher rebuked him for writing about a Mexican rather than an American hero, Pedro vowed to raise aware-

ness about Chavez. Since then, he has used Chavez's life and values as a model to inspire young people.

While still in high school, Pedro organized a campaign to rescind a California proposition that would have prevented undocumented workers from receiving benefits or public services. In college, he brought students and inner-city organizations together to support the United Farm Workers. He proved to local farm workers that by organizing, they could gain a voice regardless of legal status or language. And Pedro marshaled support to force growers to address health and safety problems and to replace deplorable worker encampments with proper housing. In 1997, he organized a boycott against Driscoll Strawberries to protest poor working conditions that resulted in three major San Diego stores pulling Driscoll Strawberries off their shelves. And in 1999, he organized a fast, which included 300 people, to protest human rights abuses in the strawberry industry. Every major television station in San Diego County covered the event.

Today, Pedro is the continuing education director for the National Conference for Community and Justice, an organization dedicated to fighting bias, bigotry, and racism in the United States. His programs help young people confront their prejudice and combat discrimination and social injustice in their own lives and communities.

"I SHED TEARS OF JOY WHEN I LEARNED THAT I WAS NOMINATED AS A HUMAN RIGHTS DEFENDER." —STATEMENT ISSUED FROM JAKARTA'S CIPINANG PRISON

GET INVOLVED

HUMAN RIGHTS MONITORING

The Asian Forum for Human Rights and Development (FORUM-ASIA) works to facilitate collaboration among human rights organizations in Asia to develop a regional response for the promotion of human rights and democracy. www.forumasia.org

For more information about advocacy initiatives on East Timor, visit the **Human Rights Watch** site: www.hrw.org/campaigns/timor

FERNANDO DE ARAUJO

EAST TIMOR 1992 AGE 26

STANDING UP TO THE STRONG ARM OF OPPRESSION

ON NOVEMBER 12, 1991, MORE THAN ONE HUNDRED UNARMED CIVILIANS WERE GUNNED DOWN WHILE ATTENDING THE FUNERAL OF A PRO-SEPARATIST ACTIVIST IN DILI, EAST TIMOR. MANY MORE WERE WOUNDED. AMNESTY INTERNATIONAL, ALONG WITH A NUMBER OF JOURNALISTS, REPORTED THAT THE PERPETRATORS WERE INDONESIAN SOLDIERS, AND THAT THE ATTACK HAD BEEN UNPROVOKED. TWELVE DAYS LATER, A YOUNG ACTIVIST NAMED FERNANDO DE ARAUJO WAS ARRESTED IN JAKARTA AND CHARGED WITH "SUBVERSION" FOR LEADING A NONVIOLENT PROTEST OF THE DILI MASSACRE, EVEN THOUGH HIS INDICTMENT MADE NO REFERENCE TO VIOLENT OR SUBVERSIVE ACTS. HE WAS SENTENCED TO NINE YEARS IN PRISON UNDER THE SUHARTO REGIME'S SWEEPING ANTI-SUBVERSION LAW.

In 1974, Portugal—which had ruled this half of the island of Timor for 400 years—called for Timorese self-determination. But independence was crushed in 1975 when Indonesia invaded and annexed East Timor. The occupation was extremely harsh and repressive. Human rights violations were rampant, and the military routinely silenced calls for freedom. During the occupation, more than 100,000 East Timorese civilians were killed.

Fernando was the founder and leader of RENETIL (Resistencia Nacional dos Estudantes de Timor Leste), a student group seeking independence from Indonesia. Despite ongoing intimidation, repression, and threats of torture and death, Fernando and his group worked courageously to document and disseminate information to international groups on human rights violations in East Timor. RENETIL sought a nonviolent end to the occupation, and its position was consistent with that of the United Nations, which did not recognize Indonesia's sovereignty over the territory. In fact, the United Nations passed several resolutions condemning Indonesia's invasion of East Timor.

Prior to his arrest, Fernando communicated regularly with human rights organizations abroad and in Indonesia, and with foreign diplomats and the media. After his arrest, RENETIL had to go underground. From his prison cell, Fernando helped establish a network of activists to carry on this vital work. They continued to gather information and to distribute a regular newsletter that was widely described as very useful, credible, and informative.

Because of his incarceration, Fernando was not able to attend the award ceremony in 1992. But from his jail cell, he issued this statement: "This award is not for me, but for the East Timorese people. Therefore it must be used for their common interest, and above all, for the defense of human rights."

With the help of Forefront, Fernando was released from prison in 1998, two years before the end of his original sentence. East Timor finally achieved independence and forced the Indonesia military out in 1999. Today, Fernando de Araujo serves as a cabinet member in the East Timorese government, and is working to put in place a constitution that reflects and protects the identity of the East Timorese people and that honors human rights.

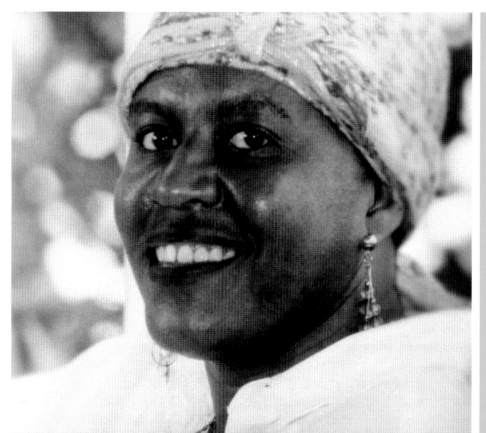

"WHEN YOU TALK ABOUT DEMOCRACY, IT MEANS THE RIGHT FOR A PERSON TO EXIST AS A HUMAN BEING. THAT MEANS THE PERSON HAS TO HAVE THE RIGHT TO ADEQUATE HEALTH CARE."

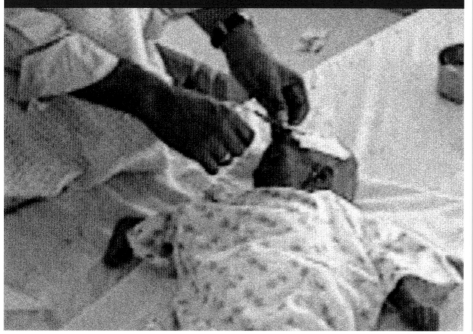

GET INVOLVED

HEALTH AND HUMAN RIGHTS

The Association for the Promotion of Comprehensive Family Health (Association pour la Promotion de la Santé Intégrale de la Famille, or APROSIFA) provides clinical and social action programs to the poorest segments of society in Haiti. www.forefrontleaders.org/aprosifa

Doctors Without Borders/ Médecins Sans Frontières delivers emergency aid to victims of armed conflict, epidemics, and natural and manmade disasters, as well as to others who lack health care because of social or geographic isolation. www.doctorswithoutborders.org

ROSE-ANNE AUGUSTE

HAITI 1994 AGE 30

SEEKING JUSTICE FOR THE POOR

FOLLOWING A MILITARY COUP IN 1991, A GROUP OF HAITIAN SOLDIERS WALKED INTO THE STATE UNIVERSITY HOSPITAL AND EXECUTED SEVERAL PATIENTS. PHYSICIANS BECAME TOO FRIGHTENED TO PROVIDE MEDICAL SERVICES, SO THE HOSPITAL CLOSED. IT WAS HAITI'S ONLY TRAUMA FACILITY. PATIENTS AND COUP VICTIMS BEGAN DYING FROM WOUNDS THAT COULD HAVE BEEN TREATED. A NURSE AND HUMAN RIGHTS ACTIVIST NAMED ROSE-ANNE AUGUSTE TOOK AN AXE, BROKE DOWN THE DOOR, AND REOPENED THE HOSPITAL. SHE CONVINCED A NUMBER OF PHYSICIANS AND NURSES TO WORK WITH HER AND ACTED AS DE FACTO HOSPITAL DIRECTOR FOR SEVERAL DAYS UNTIL SHE WAS REMOVED BY THE MILITARY. BUT THAT DIDN'T DETER HER COMMITMENT TO PROVIDING HEALTH CARE FOR POVERTY-STRICKEN HAITIANS.

Haiti has long been regarded as one of the poorest nations in Latin America. Rose-Anne has dedicated her life to fighting for social justice in a country where living conditions have been characterized by extreme human suffering. While in nursing school, she organized a nurses' student union and pressed for better care for poor patients. Both her internship at Hôpital Sainte-Therese in Hinche and her work with grassroots organizations led her to define patients' lack of access to health care as a human rights abuse. When Haiti's first democratically elected president, Jean-Bertrand Aristide, was overthrown by a military coup, the already inadequate state of health care in Haiti deteriorated even further. Despite widespread violence, repression, and dangerous repercussions for human rights activists, Rose-Anne remained committed to seeking health care for the poor.

Rose-Anne converted an abandoned house in Kafou Fey, one of the poorest and most dangerous areas of Port-au-Prince, and founded the first clinic for poor women—Klinik Pou Fanm Kontrole Ko-l Pi Bye. According to Americas Watch, the military perceived Kafou Fey as pro-Aristide and considered the residents of this area subversive. Consequently many of Rose-Anne's patients were victims of political violence. Although the clinic was originally intended to serve twenty to thirty women a day, it quickly expanded to include children and men and began serving more than 200 patients a day.

Rose-Anne has become well known for bringing human rights violations to the attention of health providers and human rights observers. She was editor of a now-banned publication on women's rights and was a founding member of the Ad Hoc Committee on Violence Against Women, which organized the only post-coup conference on the subject. She assisted women seeking refuge from military authorities and helped endangered people escape from Haiti. As a result of her work, her own life was threatened many times.

Today, Rose-Anne lives in Canada, but she is still actively involved with the clinic and visits Haiti several times a year. She continues to speak out about human rights abuses and works to make the local health care system more responsive to victims of oppression.

"PEOPLE WITH MENTAL ILLNESS WHO COMMIT MINOR OFFENSES TYPICALLY END UP IN JAIL, RATHER THAN RECEIVING THE MENTAL HEALTH CARE THEY DESPERATELY NEED. IF WE CAN GET THEM ACCESS TO TREATMENT, WE CAN PREVENT FURTHER CRIMES AND STOP THE CYCLE OF REPEAT OFFENSES."

HEATHER BARR

UNITED STATES 2001 AGE 29

A TENACIOUS CRUSADER FOR CHANGE

WE'VE ALL SEEN HOMELESS PEOPLE ON THE STREETS—THE MENTALLY ILL ONES—WEARING RAGGED, DIRTY CLOTHES, WALKING AIMLESSLY, TALKING TO IMAGINARY VOICES. MOST OF US LOOK AWAY, HOPING OUR EYES NEVER MEET. BUT HEATHER BARR, A YOUNG ATTORNEY IN NEW YORK, DIDN'T TURN AWAY. SHE LOOKED A DIFFICULT ISSUE IN THE EYE AND DECIDED TO DO SOMETHING ABOUT IT.

In New York City, people with mental illness—most of them homeless—are being thrown in jail at unprecedented rates. More than 25,000 inmates with mental illness pass through the city's jails each year. In the past, these people would have received treatment in state hospitals. But over the last twenty years, most psychiatric institutions have been closed, and the support services these people need to live in the community are no longer available. So, without treatment, they just keep cycling in and out of shelters and jails.

Heather knew that two things had to happen to change this tragic situation: people with mental illness needed treatment, not jail time; and there needed to be a discharge plan to provide basic follow-up services for people with mental illness when they are released, so they don't fall back into the same hopeless cycle.

Working with the nonprofit Urban Justice Center, Heather founded the Nathaniel Project. This first-of-its-kind alternative to incarceration program gives judges the option to recommend treatment rather than imprisonment. Now viewed as a national model, the Nathaniel Project helps defendants with mental illness receive psychiatric care and gain

access to services to help them with benefits, housing, and employment skills.

Heather was also the lead attorney in the landmark case of Brad H. v. The City of New York. This case, upheld by the New York State Supreme Court, forced New York City to end its practice of releasing prisoners without any financial support or follow-up services—a practice that essentially dumped mentally ill prisoners onto the street and perpetuated a cycle of offense, imprisonment, release, and new offense. The outcome of this case has had national impact, as other states across the country have begun providing similar services to prisoners with mental illness returning to the community—for fear that they could be sued for failing to do so.

Heather grew up an only child in a remote part of Alaska. She ran away to Seattle when she was fifteen, put herself through college, and eventually earned a law degree from Columbia University.

Today, she continues her work at the Urban Justice Center and has achieved significant victories in the fight for housing and medical services for people with mental illness in New York.

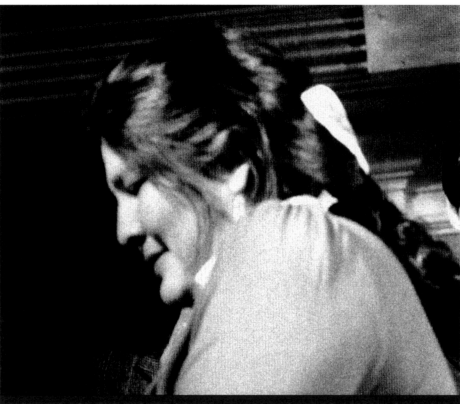

FIGHTING FOR THE RIGHTS OF THE NAVAJO PEOPLE TO REMAIN ON THEIR ANCESTRAL LANDS

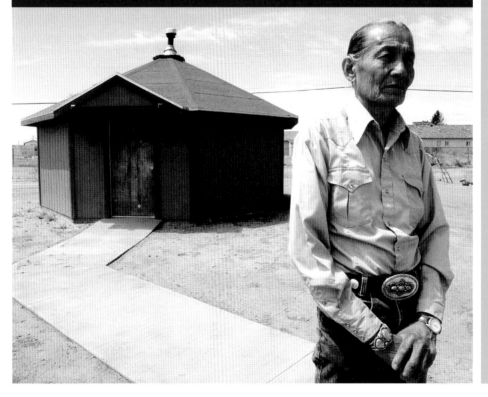

GET INVOLVED

INDIGENOUS PEOPLES' RIGHTS

The Native American Rights Fund (NARF) provides legal representation and technical assistance to Native American tribes, organizations, and individuals nationwide. NARF works to preserve tribal existence, protect tribal natural resources, promote human rights and accountability of governments, and develop Indian law and education about Indian rights, laws, and issues. www.narf.org

The Indian Law Resource Center aims to meet the needs of indigenous peoples who are struggling to overcome the devastating problems that threaten native peoples. Through its programmatic work, the center seeks to advance the rule of law, to establish national and international legal standards that preserve indigenous human rights and dignity, and to challenge governments worldwide to esteem all human beings equally. www.indianlaw.org

LOUISE BENALLY-CRITTENDEN

UNITED STATES 1989 AGE 26

DEFENDER OF NATIVE AMERICAN RIGHTS

IN 1974, ELEVEN-YEAR-OLD LOUISE BENALLY-CRITTENDEN LEARNED THAT THE GOVERNMENT WAS GOING TO FORCE HER NAVAJO TRIBE FROM THEIR NATIVE LANDS AND RELOCATE THEM TO ANOTHER AREA IN ARIZONA. THREE YEARS LATER, AT THE AGE OF FOURTEEN, SHE WAS ARRESTED FOR PROTESTING THE INSTALLATION OF A BARBED-WIRE FENCE ON HER ANCESTRAL LAND. THAT FENCE, WHICH SURROUNDED THEIR ONCE UNENCUMBERED RESERVATION, HAD BECOME SYMBOLIC OF THE PAIN, INJUSTICE, AND DISINHERITANCE THAT SHE AND HER PEOPLE FELT. LOUISE'S ARREST ONLY SERVED TO FUEL HER DETERMINATION TO DEFEND THE RIGHTS OF THE NAVAJO.

The U.S. government, after considerable lobbying efforts by coal and uranium interests, passed the Navajo-Hopi Act in 1974. This act effectively forced 15,000 Navajo off their ancestral homelands in the Big Mountain region of Arizona, an area with huge coal deposits. According to an international tribunal in 1980, this policy violated the American Convention on Human Rights and the United Nations Universal Declaration of Human Rights. Louise and her family were among the few Navajo people to resist relocation, a word that does not even exist in the Navajo language. To them, to be "relocated" meant to disappear and never be seen again. Louise committed her life to trying to reverse a series of governmental policies that had a tragic impact on the Navajo people and their traditional, self-sufficient lifestyle.

On behalf of the Big Mountain Legal Defense Fund, Louise helped to create twenty-two support organizations designed to channel national and international support to the people of Big Mountain. She served as an effective spokesperson and representative for her people by articulating their plight to the outside world. Louise also worked on a grassroots level with Support for Future Generations, a community organization dedicated to assisting the people of Big Mountain.

Louise played critical roles in two of the most effective documentations of the human rights injustices borne by Native Americans. She conducted interviews for the book *Cry, Sacred Ground: Big Mountain USA* and for the Academy Award-winning documentary *Broken Rainbow*.

Today, Louise remains active in organizing for the needs and rights of traditional people. She is currently working on establishing networks that promote the economic self-sufficiency of native people both in the United States and Mexico.

"IT WAS LIKE ONE HAD BOUGHT A CHICKEN, WHEN IN REALITY IT WAS A LITTLE GIRL, A HUMAN BEING—SOMEONE WHO HAD BEEN TORN FROM HER FAMILY. IT WAS MORE THAN CHILD PROSTITUTION; IT WAS A PROBLEM OF HUMAN RIGHTS."

GET INVOLVED

SLAVERY AND TRAFFICKING IN PERSONS

The Center for the Protection of Children's Rights is involved in combating the commercial sexual exploitation of children and assisting young people who have been sexually abused or forced into prostitution. The center works in all areas of child abuse, neglect, and exploitation. www.thaichildrights.org/english/CPCR history.html

The International Human Rights Law Group's Initiative Against Trafficking in Persons focuses on building the capacity of community groups and addressing the issue of trafficking in people through advocacy, information generation, analysis, and policy recommendations. www.hrlawgroup.org/initiatives/ trafficking_persons

MARIE-FRANCE BOTTE

BELGIUM 1993 AGE 30

UNDAUNTED RESCUER OF CHILDREN FORCED INTO PROSTITUTION

IN 1986, MARIE-FRANCE BOTTE WAS WORKING IN REFUGEE CAMPS ALONG THE THAI-CAMBODIAN BORDER WHEN SHE NOTICED THAT CHILDREN FROM THE CAMPS WERE DISAPPEARING, ONE AFTER ANOTHER. SHE THEN MADE ANOTHER HORRIFYING DISCOVERY: THE CHILDREN WERE BEING FORCED INTO SEXUAL SERVITUDE IN THAILAND'S FLOURISHING SEXUAL TOURISM INDUSTRY. IN FACT, HUNDREDS OF THOUSANDS OF CHILDREN FROM THROUGHOUT THE COUNTRY—SOME AS YOUNG AS SIX YEARS OLD—WERE WORKING IN BROTHELS. THEY HAD BEEN ABDUCTED AND TRAFFICKED THROUGH A SOPHISTICATED NETWORK OF CHILD BROKERS, OR SOLD INTO PROSTITUTION BY FAMILY FRIENDS OR EVEN FAMILY MEMBERS.

Marie-France placed herself at great risk to tape-record interviews with the children and their adult clients in secret, to learn how the trade operated. She shared this information with the international human rights community through a report issued by Doctors Without Borders, becoming the first to expose this humanitarian crisis.

Marie-France also became coordinator of the Center for the Protection of Children's Rights, working to rescue children from brothels, place them in safe shelters and, whenever possible, return them to their villages. She traveled to rural areas to halt the actual sale of children. Over a three-year period, she worked with Thailand's Central Police to rescue 1,100 children between the ages of six and sixteen. Eighty percent of these children suffered from sexually transmitted diseases and as many as half were infected with HIV.

Brothel owners and members of the local mafia repeatedly threatened Marie-France. In 1989, two men attacked her in Bangkok, beating her severely, breaking her ribs, and burning her with cigarettes. On another occasion she found her two cats nailed to her front door.

In 1990, Marie-France "bought" a battered eight-year-old girl for $800 and returned her to her village. The child, who later died of AIDS, was the inspiration for Marie-France's 1993 book, *Le Prix d'Un Enfant* (The Price of a Child), which documented the social, physical, and emotional tragedies that these children were suffering.

After returning to her native Belgium, Marie-France continued to pursue her goal of preventing the trafficking and sale of children. She expanded her reach to China, the Philippines, and Sri Lanka, and she launched an education campaign to prevent the sex trade from taking hold in Cambodia.

"THE OTHER DAY I HELD A BABY BOY IN MY ARMS AND I COULD FEEL HIS PAIN. HIS BODY WAS TWISTED, AND CRACK HAD LEFT HIM BLIND. WHAT I WANT TO DO, AND WHAT I WANT TO KEEP DOING, IS TO STAND BETWEEN CHILDREN AND THEIR PAIN."
—JEFFREY BRADLEY

GET INVOLVED

HOMELESSNESS AND RIGHT TO HOUSING

The Supportive Housing Network of New York represents the statewide supportive housing community of more than 160 nonprofit organizations in New York that have developed and operate more than 20,000 units of safe, affordable housing with onsite services. www.shnny.org

The Association to Benefit Children, based in New York City, has, in the decade since its inception, responded swiftly and aggressively to every new threat on the ever-changing landscape of poverty, including homelessness, drug addiction, and HIV. www.a-b-c.org

Habitat for Humanity International builds simple, decent, affordable houses in partnership with those in need of adequate shelter. Since 1976, Habitat has built more than 125,000 houses in more than 80 countries. www.habitat.org

JEFFREY BRADLEY AND MARTIN DUNN

UNITED STATES 1990 AGES 27 AND 23, RESPECTIVELY

PROTECTING THE RIGHTS OF VULNERABLE CHILDREN

JEFFREY BRADLEY AND MARTIN DUNN CAME FROM WIDELY DIFFERENT BACKGROUNDS, YET THEY SHARED A COMMITMENT TO PROTECTING THE RIGHTS OF THE MOST VULNERABLE CHILDREN IN THE UNITED STATES—THOSE WHO ARE HOMELESS, DISABLED, INFECTED WITH HIV, AND ADDICTED TO DRUGS. IN THE 1980S, JEFF AND MARTY BOTH WENT TO WORK FOR THE ASSOCIATION TO BENEFIT CHILDREN (ABC), A NEW YORK CITY BASED ORGANIZATION THAT SPONSORED A NUMBER OF DIRECT SERVICE PROGRAMS TO ASSIST DISADVANTAGED CHILDREN AND FAMILIES.

Throughout the United States, and especially in New York City, hundreds of thousands of children have been denied their most basic human rights. One out of four children in New York live in poverty. Families with children are the fastest growing segment of the homeless population. Many children do not have enough to eat. Many die before their first birthday. And of those who do survive, many lack the opportunities for health and education to better their lives.

Raised in a housing project in the South Bronx, one of the most troubled areas of New York City, Jeff Bradley knew firsthand what it was like to live among pain, suffering, tragedy, drugs, poverty, and crime. Because of his own upbringing, he committed himself to working at ABC with children who suffered from AIDS, drug addiction, and homelessness. While in college, he began an internship at ABC's Merricat's Castle School, a national model for mainstreaming homeless and disabled children. Following his internship, Jeff stayed on as a full-time teacher. He also served as a big brother, mentor, and organizer of advocacy campaigns on behalf of homeless families.

While serving as director of program development for ABC, Marty Dunn developed models of cost-effective, replicable programs that provided assistance, love, and hope to hundreds of children. Programs included those that focused on crack-addicted homeless infants and preschoolers and for newly re-housed homeless families. Prior to joining ABC, Marty devoted innumerable hours in high school and college volunteering with local groups working on a range of human rights issues.

Today, Jeff continues to work for ABC providing direct services and advocating for the rights of disadvantaged children in New York City. Marty works actively on affordable housing and community development in New York and is involved with environmental justice issues in his neighborhood of Brooklyn, New York.

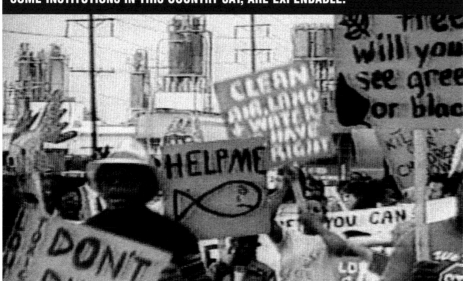

"ENVIRONMENTAL JUSTICE IS CLEARLY A HUMAN RIGHTS ISSUE. FOR WHATEVER REASON, THERE ARE CERTAIN PEOPLE—USUALLY POOR PEOPLE, PEOPLE OF COLOR, SOUTHERN PEOPLE WHO LIVE IN THE UNITED STATES—WHOSE LIVES, SOME INSTITUTIONS IN THIS COUNTRY SAY, ARE EXPENDABLE."

GET INVOLVED

ENVIRONMENTAL JUSTICE

The Southern Organizing Committee's Youth Task Force focuses its efforts in two major areas: ending environmental genocide in poor communities throughout the southern United States and stopping the mass incarceration and criminalization of youth of color within the United States. For more information on this issue, visit: www.forefrontleaders.org

Greenpeace Campaigns Against Toxics calls for an end to the manufacture, use, and disposal of hazardous, synthetic substances, particularly persistent organic pollutants, considered the worst manmade environmental toxins worldwide. www.greenpeace.org/campaigns

ANGELA ELIZABETH BROWN

UNITED STATES 1995 AGE 30

INSPIRING A NEW GENERATION TO FIGHT FOR ENVIRONMENTAL JUSTICE

THE ENVIRONMENTAL JUSTICE MOVEMENT WAS LAUNCHED IN WARREN COUNTY, NORTH CAROLINA, IN 1982, WHEN THE CREATION OF A NEW LANDFILL IGNITED PROTESTS AND MORE THAN 500 ARRESTS. ACTIVISTS FROM BOTH THE CIVIL RIGHTS AND ENVIRONMENTAL MOVEMENTS JOINED TOGETHER TO LIE DOWN IN FRONT OF TRUCKS CARRYING PCB-CONTAMINATED SOIL INTO THE PREDOMINANTLY AFRICAN AMERICAN COMMUNITY. ALTHOUGH THE PROTESTERS COULD NOT STOP DEVELOPMENT OF THE LANDFILL, THEIR STRUGGLE CATAPULTED THE NOTION OF ENVIRONMENTAL RACISM INTO THE NATIONAL SPOTLIGHT.

The Warren County protests catalyzed a U.S. General Accounting Office study that found that three out of four off-site, commercial hazardous waste landfills in eight Southern states were located in predominantly African American communities, even though African Americans composed only 20 percent of the region's population. The protests also led to a national study that found that race was the strongest variable in predicting where waste facilities would be located—a better predictor than poverty, land values, or home ownership. The study also found that three of every five African Americans and Latinos live in a community bordering on unregulated toxic waste sites.

Angela Brown, a teenager at the time, was born in a county just fifteen minutes away from Warren County's notorious PCB landfill. A natural activist, at the age of fourteen she had already organized her peers around such issues as education, voter registration drives, and women's support groups. It was in college that she began to focus her energies on environmental justice.

In 1992, Angela co-founded the Youth Task Force (YTF) of the Southern Organizing Committee in response to the newly developing environmental justice movement. YTF, one of the oldest human rights organizations founded and led by youth of color within the United States, quickly grew into a network of youth organizations spanning ten states and eighty-five universities. Working with more than 5,000 student and youth leaders within local communities, on campuses, and in prison-based organizations, YTF has focused its efforts in two major areas: ending environmental injustice in poor communities throughout the southern United States and stopping the mass incarceration of young people of color.

As executive director of YTF, Angela continues to inspire youth to organize around these issues, as well as on the negative consequences of the war on drugs and police abuse. Her efforts have served as a wake-up call to young people, urging them to acknowledge their own power to shape their surroundings and ultimately change their future.

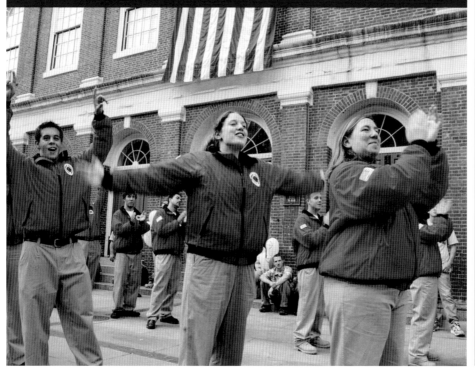

"CITY YEAR WAS BUILT ON THE BELIEF THAT ONE PERSON CAN MAKE A DIFFERENCE, AND WITH THE VISION THAT ONE DAY SERVICE WILL BE A COMMON EXPECTATION—AND A REAL OPPORTUNITY—FOR CITIZENS ALL AROUND THE WORLD."

GET INVOLVED

CHILDREN AND YOUTH

City Year provides a powerful meeting ground for young people from all walks of life. Corps members serve as teachers' aides and mentors, for example, running after-school programs, school vacation camps, and conflict resolution workshops, as well as developing HIV/AIDS curricula. www.cityyear.org

Youth Advocate Program International works with and for young people worldwide, giving voice and visibility to new ways of improving the lives of children in the twenty-first century. Program priorities include advocacy, education, and youth participation on issues such as child labor and the commercial sexual exploitation of children. www.yapi.org

MICHAEL BROWN AND ALAN KHAZEI

UNITED STATES 1989 AGES 28

INSPIRING YOUTH TO BECOME STRONG LEADERS

THE RECEDING TIDE HAD LEFT THOUSANDS OF STARFISH DYING IN THE SUN. A LITTLE GIRL WALKING ALONG THE BEACH PICKED ONE UP AND TOSSED IT BACK INTO THE OCEAN. NEARBY, A MAN CHUCKLED AND SAID, "LITTLE GIRL, THERE ARE TOO MANY STARFISH. YOU WILL NEVER MAKE A DIFFERENCE." HER SHOULDERS SLUMPED, AND SHE BEGAN TO WALK AWAY. SUDDENLY, SHE SPUN AROUND, PICKED UP ANOTHER STARFISH, AND TOSSED IT AS FAR AS SHE COULD INTO THE WATER. TURNING TO THE MAN, SHE SMILED AND SAID, "I MADE A DIFFERENCE TO THAT ONE!"

The starfish story is at the core of the teaching of City Year, an urban peace corps designed to bring change to troubled communities. In 1988, two roommates at Harvard Law School, Michael Brown and Alan Khazei, shared a vision to help the homeless, the hungry, the elderly, the disabled, and others less fortunate. They created City Year as a pilot summer program, providing the needy of Boston with more than 13,000 hours of aid in just those few months.

Initially, the corps comprised fifty people between the ages of seventeen and twenty-two from inner-city and suburban neighborhoods. In one summer, these young people sorted 125 tons of surplus food at a food bank, cleared more than ten tons of debris from vacant lots, renovated housing for the homeless, organized and ran the first Special Olympics ever held for the children of a city-run camp, and provided educational and recreational services for mentally disabled adolescents.

So successful was City Year that the summer pilot quickly grew into a year-round program, enlisting hundreds of young adults from all backgrounds for a demanding year of full-time community service and leadership development. City Year has since developed programs in cities around the country and has become a national model for the creation of an urban peace corps. Since its founding, City Year has engaged more than 2,000 young people in giving a year of service to their communities. Together, corps members have provided more than two million hours of service. Through the Serve-a-thon, City Year's annual day-long pledge event, 31,700 citizens have given more than 200,000 hours of service to people in need. Yet City Year's greatest success has been the inspiration and confidence it offers its young participants.

With Michael now president and Alan chief executive officer of City Year, both continue to actively pursue their own youthful dream, encouraging young people to become community leaders and making a difference to the lives of thousands of people.

"I WILL NOT SERVE IN THE DEFENSE OF A RACIST POLITICAL SYSTEM."

GET INVOLVED

DISCRIMINATION AND RACISM

The Centre for the Study of Violence and Reconciliation is dedicated to making a meaningful contribution to peaceful and fundamental transformation in South Africa and in the Southern African region. www.csvr.org.za

The Desmond Tutu Peace Foundation was established to advance the philosophy and practices of Archbishop Desmond Tutu through leadership academies in the United States and Africa. The academies focus on developing emerging leaders who act for peace, reconciliation, and restorative justice. www.tutufoundation-usa.org

DAVID BRUCE

SOUTH AFRICA 1988 AGE 25

TAKING A STAND AGAINST RACISM

IN 1988, DAVID BRUCE STOOD TRIAL FOR REFUSING TO DEFEND THE APARTHEID SYSTEM BY SERVING IN THE SOUTH AFRICAN ARMY. HIS TRIAL WAS A PHENOMENAL EVENT CAPTURING NEWS HEADLINES EVERY DAY FOR A WEEK, EVEN ON STATE-OWNED TELEVISION. "MY REFUSAL TO SERVE," DAVID TESTIFIED, "IS BASED ON MY OWN POLITICAL AND MORAL CONVICTIONS. THE ROLE OF THE SOUTH AFRICAN DEFENSE FORCE IS NOT THAT OF A NEUTRAL PEACEKEEPING FORCE. IT IS UPHOLDING AND DEFENDING A RACIST POLITICAL SYSTEM."

David was the second person to be charged with this offense, and his stand reflected a growing opposition to being forced to serve in an army that defended apartheid. For standing up for his beliefs, David became the first conscientious objector to receive *and serve* a full six-year sentence.

At the time of David's arrest and trial, all white male South Africans were conscripted to serve in the South African Defense Force. Conscientious objection and alternative service were legally recognized, but only for those who could convince the Board of Religious Objection tribunal that their objection was nonpolitical, was religiously based, and had universal application. The severity of David's sentence was greeted with dismay, even from the far-right Conservative Party. The nature of his offense allowed for no remission of sentence. Therefore, he served the full six years in prison until 1994.

As a student attending the University of Witwatersrand, David served as a member of the National Union of South African Students (NURAS) Projects Committee. He was engaged in many projects designed to raise consciousness about the political reality in South

Africa and to assist the anti-apartheid movement's struggle for political change. Although accepted into the Law Faculty for graduate study after obtaining his bachelor's degree, David decided not to continue his studies. Instead, he wanted to devote his efforts to the anti-apartheid movement. He could have left the country and joined approximately 10,000 other South African conscientious objectors in exile, but he chose to stay and work to change the system. The courage of his anti-racist stand brought messages of support from all areas of South African society as well as from all over the world.

Conscription has been abolished in South Africa, and today David is the senior researcher in the Criminal Justice Policy Unit at the Centre for the Study of Violence and Reconciliation (CSVR) in South Africa. The CSVR is a multidisciplinary institute concerned with policy formation, implementation, service delivery, education, training, and consulting services to organizations and the community. The CSVR also operates its own trauma clinic to provide counseling services for both victims and perpetrators of violence.

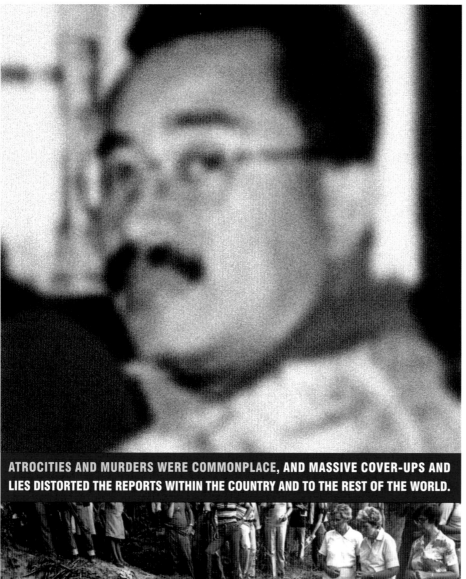

ATROCITIES AND MURDERS WERE COMMONPLACE, AND MASSIVE COVER-UPS AND LIES DISTORTED THE REPORTS WITHIN THE COUNTRY AND TO THE REST OF THE WORLD.

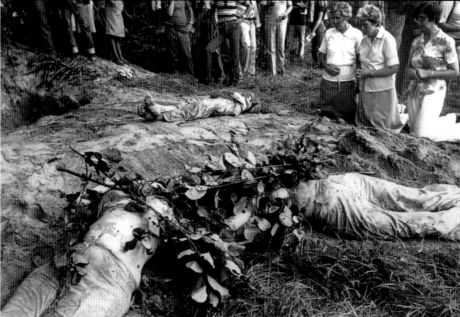

GET INVOLVED

HUMAN RIGHTS MONITORING

The Salvadoran Association of Human Rights for Homosexuals, Lesbuals, Bisexuals and Transsexuals—Entre Amigos (Between Friends)—works to protect and promote the rights of sexual minorities in El Salvador. www.entreamigos.org.sv

The Center for Justice and International Law (CEJIL) was founded in 1991 by a group of prominent human rights defenders in Latin America and the Caribbean. CEJIL's principal objective is to achieve the full implementation of international human rights norms in the member states of the Organization of American States (OAS) through the use of the Inter-American System for the Protection of Human Rights and other international protection mechanisms. www.cejil.org

JOAQUIN ANTONIO CACERES

EL SALVADOR 1988 AGE 27
CHRONICLER OF THE TRUTH

AGAINST A BACKDROP OF DISAPPEARANCES, VIOLENCE, AND DEATH SQUADS IN EL SALVADOR, ARCHBISHOP OSCAR ROMERO ASKED MEMBERS OF THE CATHOLIC CHURCH TO COME TO HIS COUNTRY AND WALK SIDE-BY-SIDE WITH HIS PEOPLE IN SUPPORT OF THE POOR AND HUMAN RIGHTS. ON MARCH 24, 1980, ARCHBISHOP ROMERO WAS ASSASSINATED. IN NOVEMBER, SIX LEADERS OF THE DEMOCRATIC LEFT OPPOSITION WERE ABDUCTED AND THEIR MUTILATED BODIES WERE FOUND ON THE SIDE OF THE ROAD. IN DECEMBER, FOUR NUNS FROM THE UNITED STATES WERE ABDUCTED, RAPED, AND MURDERED AS THEY WERE DRIVING FROM EL SALVADOR'S INTERNATIONAL AIRPORT. THESE CRIMES AND MANY OTHER EGREGIOUS HUMAN RIGHTS VIOLATIONS WERE REPORTED BY JOAQUIN ANTONIO CACERES. FOR THIS, HE WAS IMPRISONED AND TORTURED BY GOVERNMENT FORCES.

In El Salvador, a small and wealthy elite owned all the land and dominated the economy, while the overwhelming majority of the population lived in abject poverty. In the late 1970s, widespread protests broke out. In 1979, military officers removed President Carlos Humberto Romero from office, and that same year, civil war broke out between government troops and rebel leftist guerilla forces. Atrocities and murders were commonplace, and massive cover-ups and lies distorted reports both within the country and to the rest of the world.

During this turbulent period, Joaquín Antonio Caceres worked with the Commission for Human Rights in El Salvador to chronicle human rights violations. In November 1985, Joaquín and his colleagues were arrested, tortured, and forced to sign confessions of "subversive association" by government forces for their human rights reporting.

Joaquín was sent to prison for thirteen months and became an Amnesty International "prisoner of conscience."

During his detention, Joaquín and his colleagues wrote and produced the "Report on the Use of Torture," which documented the official use of systematic torture of political prisoners by the government. The report also described instances of arbitrary violence, disappearances, and extrajudicial executions of Salvadoran citizens. International pressure contributed to Joaquín's release from prison in 1986. Despite great personal risk, he decided to remain in El Salvador to continue to work for human rights.

Today, Joaquín is the coordinator of an education program for sexual minorities at the Salvadoran Association of Human Rights for Homosexuals, Lesbians, Bisexuals and Transsexuals. The organization Entre Amigos (Between Friends) was founded by Joaquín and others in 1994.

"I THINK IT IS IMPORTANT THAT PEOPLE WHO ARE DIRECTLY AFFECTED BY INJUSTICE LOOK AT THAT INJUSTICE AND FIGURE OUT HOW THEY WOULD LIKE TO RESOLVE IT. MY ROLE IS TO HELP THEM COME UP WITH A VISION FOR WHAT THEY WANT THEIR COMMUNITY TO BE."

GET INVOLVED

MIGRANT AND IMMIGRANT RIGHTS

Make the Road by Walking is a membership-led organization based in Bushwick, New York. Its members are primarily low-income Latino and African American residents of Bushwick and surrounding neighborhoods. Make the Road by Walking fights for justice and opportunity through community organizing on issues of concern to its multigenerational membership. Its members promote economic justice and participatory democracy by increasing the power of the community, particularly youth, to achieve self-determination through collective action. www.maketheroad.org

The Center for Community Change works to help grassroots leaders build strong organizations that bring large numbers of low-income people together to become a force for change in their communities. These organizations tap a community's capacity for self-help, develop strong leaders, provide critical services, build homes, develop businesses, give residents a say in their community's future and, perhaps most important, give low-income people a sense of hope. www.communitychange.org

ANUSUYA CHATTERJEE

UNITED STATES 2003 AGE 29

CATALYST FOR COMMUNITY ACTION

AT AN EARLY AGE, ANUSUYA (OONA) CHATTERJEE WAS ENCOURAGED BY HER FAMILY TO QUESTION WHY THINGS WERE THE WAY THEY WERE AND WHY THEY COULDN'T BE DIFFERENT. HER PARENTS, WHO IMMIGRATED TO THE UNITED STATES FROM INDIA IN 1968, HAD A STRONG COMMITMENT TO SOCIAL JUSTICE THAT THEY INSTILLED IN THEIR DAUGHTER. BOTH IN HIGH SCHOOL AND IN COLLEGE, OONA WROTE FOR HER SCHOOL NEWSPAPERS AND FOUND HERSELF DRAWN TO SOCIAL JUSTICE ISSUES. AS SHE INTERVIEWED ACTIVISTS, SHE BECAME INSPIRED BY THEIR PASSION AND THEIR ABILITY TO INSTIGATE CHANGE. THAT INSPIRATION EVENTUALLY LED HER TO BECOME A COMMUNITY ACTIVIST IN BROOKLYN, NEW YORK.

Bushwick is a low-income community of color in Brooklyn where half the people live below the poverty line. Many of the predominantly Latino and African American residents struggle to make a living in the garment factories that line the streets. Less than a third of Bushwick's total population has graduated from high school, and the dropout rate is almost double the citywide average.

While attending New York University School of Law, Oona and a colleague began providing free legal services to the people of Bushwick. In 1997, they founded Make the Road by Walking (MRBW), a unique community-based organization built on the belief that the center of leadership must be within the community itself. Since then, the organization has grown dramatically and now includes more than 600 members, a member-elected board composed of low-income community residents, and a staff of twelve. The organization emphasizes leadership development, democratic participation, and collective effort in solving community problems. Decisions are made by consensus, and MRBW members must pay a fee or volunteer time to participate in the organization and receive its services.

Over the past five years, MRBW has made significant improvements to the lives of Bushwick residents. Members recently forced New York City to conform to federal law and provide translation services to non-English speakers in all of its food stamp, welfare, and Medicaid offices. They also compelled dozens of neighborhood employers to pay more than $100,000 in illegally withheld wages to garment workers. They have educated residents on how to prevent, detect, and treat lead poisoning.

In addition, MRBW members launched GLOBE (Gays and Lesbians of Bushwick Empowered) to fight homophobia and to provide the community's first safe space for gay men and women. And, with Oona as the driving force, their Youth Power Project recently helped redirect $53 million of New York City's budget away from the expansion of juvenile jail facilities and toward youth development projects.

Today, Oona remains committed to helping MRBW expand its programs and improve neighborhood conditions. Her current focus is on education reform and improving opportunities for young people.

"WITHOUT EDUCATION, WE HAVE NOT COME INTO POWER. WITHOUT EDUCATION, WE HAVE NOT COME INTO KNOWLEDGE. WITHOUT EDUCATION, WE HAVE NOT COME INTO HUMAN RIGHTS."

DILLI BAHADUR CHAUDHARY

NEPAL 1994 AGE 25

PROMOTING EDUCATION TO HELP END BONDED LABOR

IN THE 1950S, MEMBERS OF THE THARU, AN ETHNIC MINORITY IN NEPAL, WERE FORCED FROM THEIR ANCESTRAL LANDS AND REDUCED TO VIRTUAL SLAVERY. EVEN THOUGH THE COUNTRY HAD OFFICIALLY ABOLISHED SLAVERY IN 1926, THE LOW WAGES THE LANDOWNERS PAID THE THARUS FORCED ENTIRE FAMILIES INTO SERVITUDE BY COMPELLING THEM TO BORROW FROM THEIR LANDLORDS TO BUY FOOD, CREATING A PERPETUAL CYCLE OF DEBT. SUCH BONDED LABOR WAS NOT NEW TO NEPAL, A CASTE-BASED SOCIETY IN WHICH MEMBERS OF THE SOCIAL ELITE—EVEN PARLIAMENT MEMBERS AND POLICE OFFICERS—HAVE OFTEN "OWNED" THEIR LOWER-CASTE SERVANTS.

To help the Tharu better understand their legal rights and overcome their status as bonded laborers, Dilli Chaudhary began teaching them to read when he was only fifteen. A year later, at great personal risk, he founded the Backward Society Education Organization (BASE), a nonprofit agency dedicated to advocating on behalf of Nepal's 200,000 bonded laborers.

In 1992, Nepali law made bonded labor illegal, but many laborers remained unaware of their rights, and vested interests in the Nepali government and local landlords continued to ignore the law. Dilli's efforts to teach the Tharu their rights led to harassment, death threats, and even imprisonment on several occasions. In 1993, during one of those arrests, 2,000 people surrounded the compound where Dilli was detained to protest his arrest and to ensure that he was unharmed. He was released shortly thereafter. A year later, thugs connected to the local landlords again attacked him, but Dilli escaped unharmed.

Despite those threats, BASE flourished under Dilli's leadership, educating thousands of bonded laborers and other members of the lower castes. In July 2000, Dilli was able to report to the international community a tremendous milestone: the Nepalese cabinet had voted to make keeping people in debt bondage, directly or indirectly, punishable by three to ten years in jail. The cabinet also eradicated all debts that the bonded workers owed landlords.

BASE staff and volunteers went door to door to inform enslaved men, women, and children about their new freedom. They also undertook the difficult tasks not only of ensuring the enforcement of the law, but also of finding food, housing, education, and economic opportunities for those freed from enslavement.

In October 2000, the humanitarian aid that had been used to help the Tharu rebuild their lives ran out. As a Reebok Human Rights Award recipient, Dilli was able to tap into the Forefront network to advocate for international assistance in the crisis.

"WE WANT TO ATTRACT THE ATTENTION OF THE INTERNATIONAL COMMUNITY IN THE HOPE OF RESTORING SECURITY AS WELL AS SOCIAL PEACE."

GET INVOLVED

HUMAN RIGHTS MONITORING

La Voix des Sans Voix, a human rights organization in Kinshasa, Democratic Republic of Congo, investigates and documents human rights abuses in Congo, conducts human rights education, and offers sociomedical and legal assistance to victims of torture and other rights violations. www.congonline.com/vsv/index.html

The International Human Rights Law Group works in the Democratic Republic of Congo on advocacy, strategic human rights legal initiatives and training, the empowerment of local advocates to expand the scope of human rights protections, and the promotion of broad participation in building human rights standards and procedures at the national, regional, and international levels. www.hrlawgroup.org

FLORIBERT BAHIZIRE CHEBEYA

DEMOCRATIC REPUBLIC OF CONGO 1992 AGE 29

A STRONG VOICE AGAINST REPRESSION

LATE AT NIGHT, BEHIND CLOSED DOORS, A YOUNG STUDENT TYPED AWAY ON AN OLD TYPEWRITER, PREPARING A BULLETIN ABOUT HUMAN RIGHTS ABUSES IN HIS COUNTRY. HE KNEW THAT IF HE GOT CAUGHT, HE WOULD LIKELY BE ARRESTED AND BEATEN. BUT HE ALSO KNEW THAT THE ONLY WAY TO BRING ABOUT CHANGE WAS TO ALERT HIS FELLOW CITIZENS AND THE WORLD TO THE INJUSTICE AND REPRESSION THAT THE PEOPLE OF ZAIRE FACED EVERY DAY.

For more than 25 years, the people of Zaire (now known as the Democratic Republic of Congo) lived under the oppressive regime of President Mobutu Sese Seko. There was only one legal political party—his—and during his rule, Mobutu burdened his country with one of the worst human rights records in Africa. His security forces routinely punished critics with harassment, arbitrary detention, and execution. But in 1983, a grassroots human rights movement began to take hold. Led by then twenty-year-old Floribert Bahizire Chebeya, a group of courageous students founded La Voix des Sans Voix (VSV), or the Voice of the Voiceless.

Mobutu's oppressive rule forced groups struggling for human rights and political change to work underground. From 1983 to 1990, with no budget and few resources, Floribert and VSV produced a reliable bulletin on the country's human rights situation, which was distributed throughout Zaire and to international human rights organizations. During that time, Floribert lived in constant danger. To avoid attracting police attention, he often posed as a jogger while distribut-

ing his bulletin door to door. His phone lines were tapped, and he was frequently harassed. After a meeting with the Lawyers Committee for Human Rights in 1989, he was threatened by security forces. But by the end of the 1980s, it was evident that the messages of the VSV and other activist groups were making an impact.

In the face of rising dissatisfaction, Mobutu announced the beginning of democratic reforms in April 1990, calling for a new constitution and multiparty elections. New political parties bloomed, and the people cheered their hopes for freedom. But a few months later, in response to a university student demonstration, Mobutu's security forces cut the electricity and massacred 150 students in their dormitories. Floribert took up the slain students' cause and once again sounded an international alarm. Mobutu, however, remained in power for another seven years.

Today, although human rights are still severely restricted in the Democratic Republic of Congo, Floribert presses on, determined to speak out for the victims of abuse and to carry their message to the outside world.

ACTIVISTS WERE DETAINED WITHOUT TRIAL, THEIR HOUSES FIREBOMBED, THEIR PHONES TAPPED.

GET INVOLVED

DISCRIMINATION AND RACISM

The Nelson Mandela Foundation works to expand and formalize the work Nelson Mandela has done throughout his life. Mr. Mandela is personally committed to developing a strong infrastructure that continues and improves on his initiatives as his legacy to Africa, and his foundation is actively expanding and developing its three primary sectors: democracy, education, and health care. www.mandelavisit.com/ found.htm#nelsonFoundation

For more information on combating racism, visit this **Human Rights Watch** website for information and action suggestions: www.hrw.org/campaigns/race

JANET CHERRY

SOUTH AFRICA 1988 AGE 27
ANTI-APARTHEID ACTIVIST

IN 1948, THE SOUTH AFRICAN GOVERNMENT IMPLEMENTED A POLICY OF RACIAL SEGREGATION KNOWN AS APARTHEID. IN 1985, A WAVE OF UPRISINGS AGAINST APARTHEID BEGAN TO SWEEP ACROSS THE BLACK TOWNSHIPS IN SOUTH AFRICA. SECURITY FORCES TRIED TO CONTROL THE UNREST WITH A CONTAINMENT POLICY THAT INCITED DANGEROUS CONFRONTATIONS. SPORADIC VIOLENCE BROKE OUT AND BLACK LEADERS WERE ROUTINELY HARASSED AND IMPRISONED. ACTIVISTS WERE DETAINED WITHOUT TRIAL, THEIR HOUSES FIREBOMBED, THEIR PHONES TAPPED. A STATE OF EMERGENCY WAS DECLARED AND MOST HUMAN RIGHTS ACTIVITIES WERE BANNED. JANET CHERRY, AN ANTI-APARTHEID ACTIVIST WHO OPPOSED MILITARY CONSCRIPTION, WAS DETAINED WITHOUT CHARGE FOR EIGHTEEN DAYS, AND THUS BEGAN ONE OF SEVERAL DETENTIONS FOR HER ANTI-APARTHEID WORK.

Janet was born and raised in Cape Town, South Africa, and became politically active while studying at the University of Cape Town. She was involved in the Wages Commission, doing support work for independent black trade unions, and in worker education and adult literacy programs. In 1982, she was recruited into the African National Congress (ANC) underground. Then in 1983, she was elected general secretary of the National Union of South African Students, an organization committed to the advancement of human rights. At that time, she was involved in the formation of the End Conscription Campaign (ECC), an organization dedicated to ending military conscription in South Africa's racist society.

Janet relocated to Port Elizabeth in 1984 to set up an adult education program. She also helped establish the Port Elizabeth branch of the ECC and became its chairperson. When a state of emergency was declared in 1985, and her adult education program was no longer permitted to operate, Janet became active in crisis clinics in Port Elizabeth. These clinics primarily helped parents find their missing children, most of whom were being held in incognito detention by security forces.

In August 1986, Janet was detained once again by security forces, this time for eleven months. While in prison, she studied for her honors degree in African economic history. After her release in 1987, she took a post with the Institute for Democratic Alternatives in South Africa. She was arrested again without charges in 1988, and released with no explanation a few months later. She was released, however, under house arrest, which meant she could not leave her house after six in the evening, she could not leave the city of Port Elizabeth, and she was banned from communicating with the press. In spite of the efforts to suppress her work, Janet remained dedicated to ending conscription and apartheid in South Africa.

Today, Janet is a lecturer in the Sociology Department at the University of Port Elizabeth, and continues to be involved in human rights issues with Amnesty International.

"IF I CANNOT GIVE UP HOPE, NOBODY ELSE SHOULD."

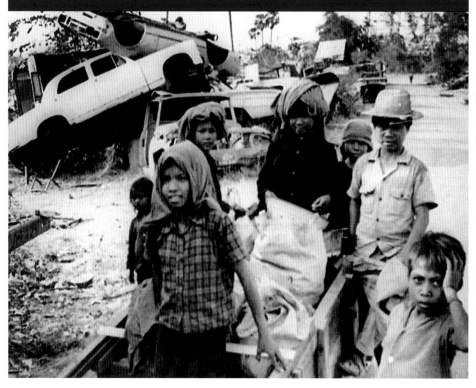

CONFLICT RESOLUTION

Cambodian Master Performers Program (CMPP) seeks to locate and support the few Cambodian master musicians and performers who survived the reign of the Khmer Rouge by recording and documenting their performances. In so doing, CMPP aims to preserve and revive ancient cultural traditions that are threatened with extinction.
www.cambodianmasters.org

Cambodia Volunteers for Community Development (CVCD) works to involve youth in the rebuilding of Cambodia through community service. CVCD educates and mobilizes tens of thousands of Cambodian youths and the general public on HIV/AIDS awareness, environmental restoration projects, and human rights. It also teaches technical and computer skills to street children, homeless youth, and sex workers. www.cvcd.org

For more information on human rights in Cambodia, visit the **Lawyers Committee for Human Rights** website: www.lchr.org

ARN CHORN-POND

UNITED STATES 1988 AGE 20
HELPING TO HEAL YOUNG VICTIMS

WHEN ARN CHORN-POND WAS ONLY NINE YEARS OLD, HIS FAMILY WAS EXECUTED IN A KHMER ROUGE DEATH CAMP. OF THE 500 CHILDREN FORCED INTO THE CAMP, ONLY SIXTY SURVIVED. IN THE KILLING FIELDS OF CAMBODIA, ARN WAS FORCED TO UNDRESS THE CHILDREN AND HOLD THEIR HANDS WHILE THE KHMER ROUGE MURDERED THEM WITH A MAKESHIFT PICKAX. LONG AFTER HE ESCAPED, THE HORRIFYING MEMORIES OF THE CEASELESS EXECUTIONS CONTINUED TO HAUNT HIM, BUT THEY DIDN'T IMMOBILIZE HIM. INSTEAD, HE DEDICATED HIS LIFE TO ENDING THE SUFFERING OF CHILDREN WHO WERE VICTIMS OF THIS HORRIBLE ATROCITY.

The Khmer Rouge was a communist movement that controlled the government of Cambodia from 1975 to 1979. Communist leader Pol Pot led the group for much of its existence. During its regime of terror, more than 1.5 million Cambodians were massacred. In the years that followed, surviving children languished in refugee camps. In 1984, under the auspices of the Religious Task Force, Arn co-founded an organization called Children of War to help end the suffering of children held hostage by war and violence and to help them rebuild their lives.

This youth program brought together young Cambodian war survivors with U.S. teenagers for the purpose of effecting change through training, education, and participation in youth empowerment activities. The group used nationwide tours, leadership training workshops, and school visitations to revitalize grassroots youth action groups. From its inception in 1984 though 1988, Children of War trained a core leadership group of 150 young people representing twenty-one countries. More than 100,000 U.S. students from 480 schools participated in the program. Arn was also one of the few surviving Cambodians to return to the border camps. While attending Brown University, Arn devoted his summers from 1986 through 1988 to teach and assist those still displaced by war. Additionally, he was the youngest Cambodian involved in diplomatic efforts for reconciliation.

Arn not only personally triumphed over the adversity of his youth and the period of holocaust in his troubled homeland, he became a leading voice testifying to Amnesty International groups in several cities. He also worked to persuade the United Nations to take action to prevent the recurrence of genocide and massive violations of human rights in Cambodia.

In 1991, Arn returned to Cambodia to involve youth in the rebuilding of Cambodia through community service. In recent years, he worked with at-risk youths and gang members on violence prevention in Lowell, Massachusetts, and is currently working on a project to preserve the work of the surviving masters of Cambodian traditional music.

"CHILDREN ARE FEEDING FROM GARBAGE BINS. UNEMPLOYMENT HAS GONE SO HIGH THAT PEOPLE ARE NO LONGER KEEPING TRACK OF IT. AND THE REGIME IN PLACE DOESN'T SEEM TO CARE."

GET INVOLVED

HUMAN RIGHTS MONITORING

The Center for Law Enforcement Education (CLEEN) promotes respect for human rights and cooperation between civil society and law enforcement agencies in the lawful discharge of their duties in Nigeria, through research and publications, human rights education, and community empowerment programs. kabissa.com/cleen

For more information on human rights issues in Nigeria, visit: www.hrw.org/africa

INNOCENT CHUKWUMA

NIGERIA 1996 AGE 30

DEFENDING HUMAN RIGHTS AGAINST A BRUTAL MILITARY REGIME

AS A UNIVERSITY STUDENT, INNOCENT CHUKWUMA LEARNED THE BRUTALITY OF HIS COUNTRY'S MILITARY REGIME FIRSTHAND. A COMMITTED HUMAN RIGHTS ACTIVIST AND STUDENT LEADER, HE ORGANIZED A SERIES OF PROTESTS IN AN EFFORT TO BRING CHANGE TO A NATION RACKED BY POLITICAL TURMOIL. AFTER BEING REPEATEDLY ARRESTED AND JAILED FOR HIS ACTIVISM, IN 1989, HE WAS ARRESTED FOR ORGANIZING A NATIONAL STUDENT DEMONSTRATION AGAINST GENERAL SANI ABACHA'S REPRESSIVE POLICIES. THROWN INTO PRISON AND ABANDONED BY HIS FAMILY, WHO FEARED MILITARY REPRISALS, INNOCENT ENDURED A MONTH OF SOLITARY CONFINEMENT.

Nigeria's Civil Liberties Organization (CLO) stepped forward to provide the young prisoner with free legal counsel and eventually won his freedom. Inspired by the group's support, Innocent joined CLO upon his graduation. As a member of CLO, he was jailed again, this time for spearheading a protest against the government's annulment of national elections. He later rose to become the organization's national director.

As leader of CLO, Innocent pioneered a program to publicize human rights abuses committed by the Nigerian police forces. His research exposed an institutionalized culture of brutality and torture in Nigeria's criminal justice system, which led to the country's first-ever human rights training workshop aimed at preventing police misconduct.

In 1996, Innocent successfully lobbied the United Nations Commission on Human Rights to pass a resolution condemning Nigeria's human rights record. The move enraged Nigerian authorities, and Innocent began to receive death threats.

Undeterred, Innocent dedicated himself to reforming Nigeria's corrupt law enforcement agencies. He founded the Center for Law Enforcement Education (CLEEN), an organization that works both to change police attitudes toward the public and to educate poor Nigerians about their civil rights and the legal system. In addition to his criminal justice work, he was one of the founders of United Action for Democracy, Nigeria's principal pro-democracy political party. In 1997, Innocent successfully lobbied the United Nations to appoint a special human rights investigator for Nigeria. Today, he continues to be an outspoken critic of political corruption and injustice at home and abroad.

"THE EVIDENCE WE FOUND CLEARLY POINTED TO RACE AS THE MOST SIGNIFICANT FACTOR IN THE APPLICATION OF THE DEATH PENALTY."

TANYA COKE

UNITED STATES 1988 AGE 24

WORKING TO ABOLISH THE DEATH PENALTY

A BLACK MAN ON DEATH ROW FACED EXECUTION, HAVING BEEN CONVICTED ON THE BASIS OF LITTLE EVIDENCE BY A RACIST JURY IN GEORGIA. ALTHOUGH HE HAD A VALID CONSTITUTIONAL CHALLENGE TO HIS DEATH SENTENCE, HE WAS NOT ABLE TO OBTAIN AN ATTORNEY. AT THE SAME TIME, A YOUNG WOMAN NAMED TANYA COKE WORKED WITH COLLEAGUES TO PRESENT STATISTICAL EVIDENCE CITING RACE AS THE MOST SIGNIFICANT FACTOR IN THE APPLICATION OF THE DEATH PENALTY IN THE STATE OF GEORGIA. ALTHOUGH THE COURT RULED FIVE TO FOUR AGAINST, AND THIS PRISONER WAS EXECUTED WITHOUT BENEFIT OF REVIEW, TANYA HAD SET THE WHEELS IN MOTION FOR GREATER LEGAL PROTECTION AGAINST THE IMPOSITION OF THE DEATH PENALTY IN A DISCRIMINATORY MANNER.

In the 1980s, there was no U.S. government agency to keep track of who had been sentenced to death and who was to be executed. So there was no way that abolitionists could be mobilized to act against executions. Tanya Coke stepped in and became a monitor of the country's death row system and a staunch advocate for the abolishment of the death penalty.

Tanya began her work at the Legal Defense Fund in 1986, and she became one of the most ardent spokespeople calling for an end to the death penalty in the United States. As director of the Capital Punishment Research Project of the NAACP Legal Defense and Educational Fund, Tanya monitored America's entire 21,000-person death row system. She maintained and disseminated the nation's only authoritative source of information on the death penalty, *Death Row USA*. Tanya's reports were used by the courts, government agencies,

schools, the media, and defense counsels in the resolution and study of various death penalty-related issues.

Tanya also had notable success in recruiting competent legal representation for death-row inmates unable to obtain help. Because of her efforts, statistical evidence was presented to the U.S. Supreme Court citing race as the most significant factor in the application of the death penalty in Georgia. Along with her colleagues, Tanya initiated legislation in Congress to curb the arbitrary use of the death penalty in the United States.

Today, Tanya Coke is director of the Gideon Project of the Open Society Institute. The Gideon Project supports programs that promote the fair administration of criminal justice, including better funding, standards, training, and oversight of the defense function.

GET INVOLVED

REFUGEES AND ASYLUM SEEKERS

Wayfarer House is a transitional housing site for people released from detention who have nowhere else to go. At Wayfarer House, those granted asylum can "find their feet" for 90 days and meet others who are experiencing the same challenges in adjusting to life in the United States. www.afsc.org

The Women's Commission for Refugee Women and Children works to ensure that refugee and displaced women, children, and adolescents are given protection, are encouraged to participate in programs of humanitarian assistance and protection, and have access to education, health services, and livelihood opportunities. www.womenscommission.org

"THIS PLACE IS A PRISON. THERE ARE NO WINDOWS, AND THE REFUGEES ASK QUESTIONS LIKE, 'WHAT DOES IT LOOK LIKE IN AMERICA, BECAUSE I HAVEN'T SEEN IT?'"

WILLIAM COLEY

UNITED STATES 2001 AGE 30

LIFELINE FOR POLITICAL ASYLUM SEEKERS

ONE MORNING, A YOUNG MAN IN THE CONGO WOKE UP TO SEE A GROUP OF SOLDIERS BEATING HIS FATHER TO DEATH BECAUSE OF HIS POLITICAL BELIEFS. THEN THEY HAULED THE SON OFF TO PRISON, WHERE HE TOO WAS BEATEN AND TORTURED. EVENTUALLY, HE ESCAPED AND STOWED AWAY ON A CARGO SHIP HEADED FOR THE UNITED STATES. WHEN HE ARRIVED, HE WAS TURNED OVER TO THE U.S. IMMIGRATION AND NATURALIZATION SERVICE AND IMPRISONED AT THE DETENTION CENTER IN ELIZABETH, NEW JERSEY, WHERE HE REMAINED FOR MORE THAN THREE YEARS. HIS ONLY CRIME HAD BEEN SEEKING A SAFE HAVEN FROM PERSECUTION.

The 1996 Illegal Immigrant Reform and Responsibility Act requires that once asylum seekers arrive in the United States and establish a "credible fear of persecution," they must be detained until they can present their asylum claim to a judge. Many of these refugees have fled political repression, torture, or slavery, and some suffer from significant trauma. Even though they have not committed a crime, they are held in windowless prisons with degrading conditions. When they are finally released and accepted into the country, they are given no post-release aid or information of any kind.

As director of the New Jersey Detention Project of Jesuit Relief Services, William Coley was a driving force in the movement to improve conditions for detained refugees seeking asylum in the United States. He developed English and religious classes and recruited hundreds of volunteers to participate in a visitor program to offer solace and support to detainees. "We're trying to help reduce the stress encountered in detention," Will said. "By visiting with detainees, we remind them that they are not forgotten by the outside world, and that someone is there to listen to their concerns."

In November 1999, however, the INS suspended Will's English classes and religious programs, claiming that they inspired a false hope among the refugees and could prove to be "subversive" if the detainees learned how to demand their rights. Despite these barriers, Will continued to manage the visitor program, and he went on to develop a post-release program to help paroled detainees find housing, jobs, and health care. His deep commitment to the cause was best reflected in his personal actions; he was known, for example, to pick up paroled detainees on the highway and provide them with assistance, often at his own expense.

Will continues to lobby and speak extensively to alert the public and policy-makers about the unjust treatment of asylum seekers and to search for a more humane system. Today, he is program coordinator of Wayfarer House, a transitional housing site for people released from detention who have nowhere else to go.

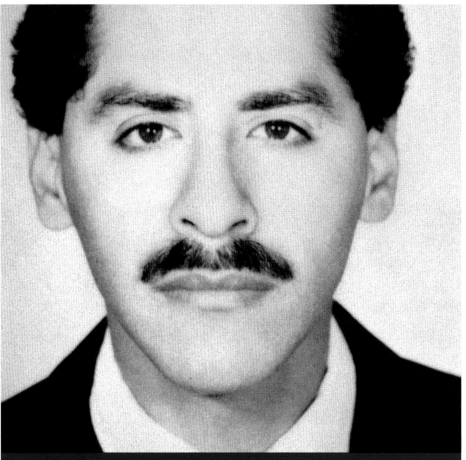

"OUR JAILS ARE FILLED WITH INDIGENOUS PEOPLE WHO HAVE NO IDEA WHY THEY'RE THERE, WHO ENDURE PROCEEDINGS IN A LANGUAGE THEY DON'T UNDERSTAND."

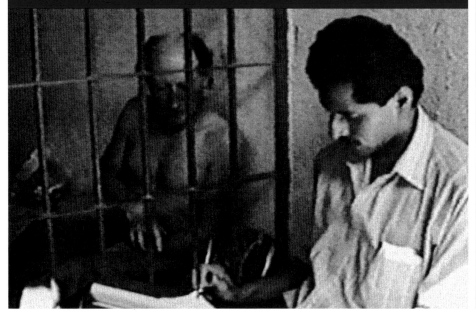

GET INVOLVED

INDIGENOUS PEOPLES' RIGHTS

Red de Defensores Comunitarios por los Derechos Humanos (Network of Public Defenders), composed of young people from four mostly indigenous regions in Chiapas, Mexico, works to highlight the human rights violations committed by the military and police through documentation and legal intervention. www.geocities.com/red_de_defensores

The Lawyers Committee for Human Rights—Mexico Policing Project addresses the fact that police abuse stems from both defects in criminal procedure and institutional weaknesses in the police system. Accordingly, the project seeks to improve the treatment of those caught up in the criminal justice system by pushing for reform of criminal procedures in Mexico. www.lchr.org/mexico_policing

MIGUEL ANGEL DE LOS SANTOS CRUZ

MEXICO 1995 AGE 30

SEEKING JUSTICE FOR THE FORGOTTEN PEOPLE

MORE THAN A CENTURY AGO, CHIAPAS WAS CALLED THE SLAVE STATE OF MEXICO. MANY WOULD ARGUE THAT THE NAME REMAINS APT TODAY, AS ITS INDIGENOUS PEOPLE CONTINUE TO STRUGGLE AGAINST POVERTY AND DISCRIMINATION. THE STATE, WHOSE POPULATION IS LARGELY INDIGENOUS, HAS ENORMOUS INDUSTRIAL AND AGRICULTURAL WEALTH. YET MOST HOMES ARE WITHOUT ELECTRICITY, A HIGH PERCENTAGE OF THE CHILDREN ARE MALNOURISHED, AND THOUSANDS OF PEOPLE DIE EACH YEAR FROM CURABLE DISEASES. IN ADDITION, THE INDIGENOUS PEOPLE OF CHIAPAS HAVE LONG BEEN SUBJECTED TO SOCIAL INEQUITIES, UNFAIR TREATMENT, AND EXPLOITATION, FACTORS THAT KINDLED AN ARMED UPRISING IN JANUARY 1994 BY A REBEL FORCE, THE ZAPATISTA ARMY OF NATIONAL LIBERATION. THE GOVERNMENT RESPONDED WITH MILITARY FORCE.

Human rights lawyer Miguel Angel de los Santos Cruz had worked on indigenous issues long before the revolt. After witnessing mistreatment of peasants by local police at an early age, he devoted himself to the study of law and economics, intending to use his training to defend indigenous people. As an attorney for the Fray Bartolomé Human Rights Center, Miguel Angel did just that—representing the victims of abuse by government authorities. His legal work contributed to the publication of a Spanish language critique of the repressive Chiapas criminal code.

In 1994, Miguel Angel became the lawyer for the organization Coordination for Peace, or CONPAZ, a human rights group founded to end the unrest in Chiapas. He defended more than a hundred indigenous Mexicans accused of membership in the guerrilla Zapatista Army, represented local women raped by the Mexican army, and led inquiries into the murders of an investigative journalist and three homosexual men.

Miguel Angel continues to work as an attorney for political prisoners. In 1999, he founded Red de Defensores Comunitarios por los Derechos Humanos, a network of trained community members who provide legal advice to indigenous people. Twenty-eight community defenders now help at least 30,000 people in twelve regions of Chiapas.

"IF THERE IS HOPE FOR CHANGE, IT LIES WITH THE NATION'S YOUTH. BUT BEFORE THERE CAN BE CHANGE, WE NEED TO TEACH THAT THERE ARE LIMITS TO WHAT IS ACCEPTABLE, THAT THERE ARE BETTER WAYS TO TREAT EACH OTHER WITHOUT VIOLENCE."

GET INVOLVED

CHILDREN AND YOUTH

La Conscience educates and organizes youth and the larger public around human rights and democracy, and mobilizes them to make political, social, and economic change in their communities. The organization also publishes a newspaper of the same name that focuses on human rights issues and is written and produced entirely by young people. For more information, visit: www.forefrontleaders.org

Youth Advocate Program International works with and for young people worldwide, giving voice and visibility to new ways of improving the lives of children in the twenty-first century. Program priorities include advocacy, education, and youth participation on such issues as child labor and the commercial sexual exploitation of children. www.yapi.org

KODJO DJISSENOU

TOGO 2001 AGE 24

A POWERFUL VOICE FOR HUMAN RIGHTS

IN 1989, A TWELVE-YEAR-OLD ORPHAN NAMED KODJO DJISSENOU MADE HIS FIRST STAND AGAINST INJUSTICE. A FELLOW CLASSMATE, A YOUNG GIRL, TOLD HIM THAT A TEACHER HAD UNFAIRLY GIVEN HER A FAILING GRADE BECAUSE SHE REFUSED HIS SEXUAL ADVANCES. KODJO WENT TO THE TEACHER AND THE PRINCIPAL—BUT THEY REFUSED TO DO ANYTHING. SO THE NEXT MORNING, KODJO ORGANIZED 200 STUDENTS TO PROTEST ON BEHALF OF THE YOUNG GIRL. EVEN WHEN THE POLICE ARRIVED AND THREATENED TO SHOOT, THE STUDENTS STOOD FAST. THEY KEPT UP THE PRESSURE UNTIL THE SECRETARY OF EDUCATION WAS SUMMONED TO THE SCHOOL AND EVENTUALLY PUBLICLY CONDEMNED THE HARASSMENT OF SCHOOLGIRLS. THAT EXPERIENCE INSPIRED KODJO TO WANT TO EDUCATE OTHER YOUNG PEOPLE IN HIS COUNTRY ABOUT THEIR HUMAN RIGHTS.

Togo, a tiny nation in West Africa, has been ruled by the same leader for more than thirty years. It is supposed to be a democratic government, but those who question or oppose the ruling party have been imprisoned, tortured, and even murdered by government soldiers. Amnesty International reports that hundreds of people were killed during the 1998 election. Their bodies were dropped from military planes into the ocean and found washed up on the beach. Togolese authorities don't investigate these crimes because they *want* to instill fear to silence voices of dissent.

When he was eighteen, Kodjo founded the organization La Conscience and launched numerous educational campaigns throughout Togo, informing people about human rights and the importance of democratic processes. He also started a newspaper with the same name, which is written and distributed entirely by young people. As the editor and publisher of *La Conscience,* Kodjo has dedicated the paper to informing and educating young people about human rights

and democratic principles, and mobilizing them to become agents of peaceful change. Despite the country's poor infrastructure, Kodjo and his youth network created an innovative system that distributes 25,000 copies to 500 schools all across Togo. The newspaper has a broader geographic reach than any other publication in the country.

Kodjo has also been an outspoken critic of the trafficking of children from Togo who are forced to work as domestic workers and prostitutes in other counties. He has alleged in print that government officials and some nongovernment organization leaders collaborate in covering up the child trade. To help combat the problem, he set up a Rapid Action Network for readers of *La Conscience* to anonymously report information about child trafficking and abuses of minors.

Today, Kodjo continues as executive director of *La Conscience* and works to promote human rights and democracy in Togo through education, mobilization, and advocacy.

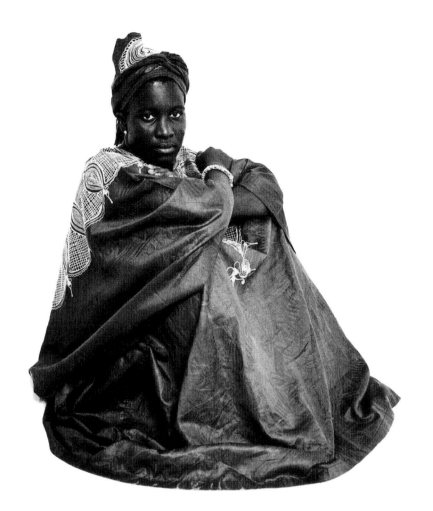

"I REALIZED THAT ONE OF US WOULD HAVE TO RISK HER LIFE TO FIGHT FOR ALL THE OTHER INNOCENT GIRLS AND WOMEN LEFT TO DIE IN THE SHRINES FOR NO SINS OF THEIR OWN."

GET INVOLVED

SLAVERY AND TRAFFICKING IN PERSONS

International Needs Ghana is a human rights organization that actively seeks the release and rehabilitation of individual Trokosi victims along the southeastern coast of Ghana. (Trokosi is a practice that requires young girls under the age of ten to be made slaves to atone for the alleged offenses of their family members.) www.intneeds.org

Survivors for Change (SFC), an autonomous affiliate of International Needs Ghana, is an organization of liberated women who in the past have suffered the enslavement of Trokosi, bondage, and other forms of discrimination. These survivors formed SFC to fight the practices that abused them and to seek economic and social empowerment. For information on SFC, visit: www.forefrontleaders.org

Anti-Slavery International, the world's oldest international human rights organization, was founded in 1839. It works exclusively against slavery and related abuses. www.antislavery.org

JULIANA DOGBADZI

GHANA 1999 AGE 24

LIBERATOR OF ENSLAVED GIRLS AND WOMEN

YEARS BEFORE JULIANA DOGBADZI WAS BORN, HER GRANDFATHER WAS ACCUSED OF STEALING THE EQUIVALENT OF TWO DOLLARS. WHEN JULIANA TURNED SEVEN, HER FAMILY CHOSE HER TO ATONE FOR HER NOW LONG-DECEASED GRANDFATHER'S CRIME. REPLACING AN OLDER SISTER WHO HAD DIED, SHE WENT TO LIVE WITH A FETISH PRIEST. SHE WORKED IN HIS FIELDS, TENDED HIS HOUSE, AND ENDURED HIS REPEATED RAPES. SHE WAS CAPTIVE TO TROKOSI, OR "SLAVE WIVES OF THE GODS," A TRADITIONAL GHANAIAN PRACTICE THAT FORCES YOUNG GIRLS TO BECOME SEX AND LABOR SLAVES IN PUNISHMENT FOR THE ALLEGED CRIMES OF ANCESTORS.

Trokosi, found primarily in the Volta region of Ghana, is based on the belief that, unless a young girl is given to a fetish shrine, family members will be cursed or even die. The girl becomes the property of the priest, who subjects her to physical, mental, and sexual abuse. When she becomes too old or dies, the family replaces her with another young girl. The atonement often continues for several generations until the fetish priest releases the family of its obligation. Although the constitution of Ghana outlaws slavery, superstition has continued to fuel the practice, and law enforcement officials have traditionally ignored what they have regarded as a spiritual affair.

After seventeen years of enslavement—and several failed attempts to escape—Juliana was finally able to flee with the help of International Needs, a nonprofit organization with a program for freed slaves. Rather than turning her back on her painful past, Juliana decided to devote her life to rescuing other girls and women from the same plight. Her testimony and public campaign contributed substantially to the passage of Ghanaian legislation that outlawed Trokosi

in 1998. Since then, more than a thousand slaves have been freed from fifteen shrines. With an estimated 4,500 girls and women still enslaved, though, Juliana continues her fight.

Risking her life and the wrath of her family, Juliana returns regularly to fetish shrines to alert the priests to her campaign and to talk to slaves about their freedom. As she moves from shrine to shrine, one of Juliana's most difficult tasks has been to convince the slaves that their freedom will not bring devastation to their families and that they will be able to learn to support themselves. Her best teaching tools have been her strength and conviction as a liberated slave.

In 2000, Juliana helped found Survivors for Change (SFC). An autonomous affiliate of International Needs Ghana, SFC is an organization of liberated women who have suffered the enslavement of Trokosi, bondage, and other forms of discrimination. Its founders are determined to fight the practices that abused them and to seek economic and social empowerment, not only for themselves, but also for the thousands of women still enslaved.

"IF JUSTICE CANNOT BE DONE, THE LEAST WE CAN DO IS HELP THE RELATIVES RETRIEVE THE REMAINS OF THE DISAPPEARED, AND HELP CONTRIBUTE IN ESTABLISHING THE TRUTH OF WHAT HAPPENED FOR THE FUTURE."—LUIS FONDEBRIDER

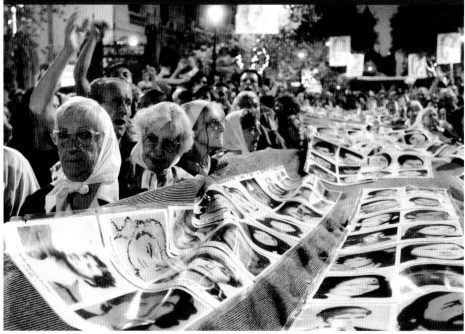

GET INVOLVED

TORTURE AND DISAPPEARANCES

The Argentine Forensic Anthropology Team/Equipo Argentino de Antropología Forense (EAAF) works to apply forensic sciences, particularly forensic anthropology, to the investigation of human rights violations. Its members act as expert witnesses and consultants for the judiciaries of countries around the world. www.eaaf.org.ar

Physicians for Human Rights (PHR) uses medical and scientific methods to investigate and expose violations of human rights worldwide. PHR supports institutions that hold perpetrators of human rights abuses, including health professionals, accountable for their actions. PHR also educates health professionals and medical, public health, and nursing students and organizes them to become active in supporting a movement for human rights and creating a culture of human rights in the medical and scientific professions. www.phrusa.org

MERCEDES DORETTI AND LUIS FONDEBRIDER

ARGENTINA 1989 AGES 30 AND 25, RESPECTIVELY

BRINGING SOLACE TO FAMILIES AND JUSTICE TO KILLERS

IN 1983, ARGENTINA RETURNED TO DEMOCRACY AFTER A REIGN OF TERROR THAT THE MILITARY REGIME HAD IMPOSED ON THE COUNTRY FOR MORE THAN SEVEN YEARS. THE NEWLY ELECTED PRESIDENT CREATED THE NATIONAL COMMISSION ON THE DISAPPEARANCE OF PERSONS (CONADEP), WHICH ESTABLISHED THAT AT LEAST 10,000 PEOPLE HAD "DISAPPEARED" UNDER THE PREVIOUS REGIME. BETWEEN 1976 AND 1978, SECURITY FORCES HAD KIDNAPPED MOST OF THESE *DESAPARECIDOS* AND TAKEN THEM TO ILLEGAL DETENTION CENTERS, WHERE THEY TORTURED AND KILLED THEM. THE BODIES WERE THEN DUMPED FROM AIRPLANES INTO THE SEA, CREMATED, OR BURIED IN UNMARKED GRAVES.

At CONADEP's instigation, judges began to exhume graves in cemeteries where *desaparecidos* were believed to be buried, but the exhumations were problematic. Bulldozers were used, and bones were broken, lost, mixed up, or left inside the graves. The evidence needed not only to identify the remains, but also to prosecute the perpetrators, was destroyed. In addition, many of the official forensic doctors had little experience in exhuming and analyzing skeletal remains; even worse, many of them had been complicit with the crimes of the previous regime. A scientific alternative to the exhumation procedures was desperately needed.

In 1984, a delegation of American forensic and genetics scientists flew to Argentina to help. Among them was Clyde Snow, one of the world's foremost experts in forensic anthropology. Snow called for a halt to nonscientific exhumations and called upon archaeologists, anthropologists, and physicians to start doing exhumations and analysis of skeletal remains in a scientific way.

Few Argentine forensic scientists were willing to become involved in the human rights investigations. Yet a group of undergraduate anthropology students, including Mercedes Doretti and Luis Fondebrider, bravely joined Snow's investigations. Later that year, inspired by their ability to help bring solace to families and justice to killers, Mercedes and Luis formed Equipo Argentino de Antropología Forense (EAAF), or the Argentine Forensic Anthropology Team, a nonprofit organization that now applies forensic anthropology to human rights investigations worldwide. Team members provide evidence for court cases involving human rights violations, inform relatives of their right to recover the remains of their loved ones, and contribute forensic evidence to the historical reconstruction of the recent past, which is often distorted or hidden by those implicated in related crimes under investigation. Such identifications have been a great source of comfort to the families of the *desaparecidos* and others unjustly killed.

Mercedes, now based in New York City, and Luis, still based in Argentina, continue their critical work. The need for their expertise takes them all over the globe, where they train other scientists, members of the local judiciary, and human rights activists in applying forensic sciences to the investigation of human rights violations.

"THIS IS A SOCIETY EMERGING FROM WAR. PEOPLE ARE POVERTY STRICKEN. AND SO MANY PEOPLE, SO MANY CHILDREN HAVE BEEN TRAUMATIZED. OUR GREATEST CHALLENGE IS TO REFORM THE JUDICIAL SYSTEM TO ADDRESS THAT."

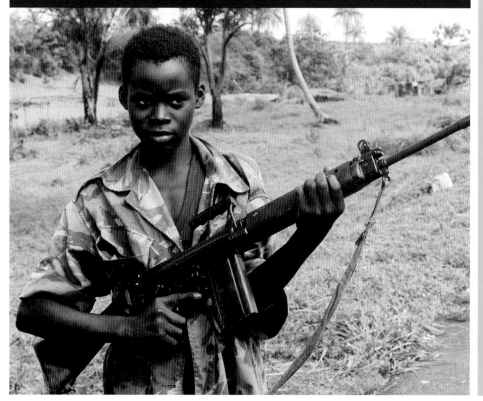

CHILDREN AND YOUTH

Defence for Children International (DCI) works to foster awareness about—and solidarity around—children's rights situations, issues, and initiatives throughout the world. In Sierra Leone, DCI works to ensure ongoing, practical, systematic, and concerted action directed toward promoting and protecting the rights of the child.
www.defence-for-children.org

The United Nations Children's Fund (UNICEF) works with national governments, nongovernmental organizations, other United Nations agencies, and private-sector partners to protect children and their rights by providing services and supplies and by helping shape policy agendas and budgets in the best interests of children. www.unicef.org

MOHAMED PA-MOMO FOFANAH

SIERRA LEONE 2003 AGE 30

DEFENDER OF CHILDREN'S RIGHTS IN A RAVAGED SOCIETY

IN 1997, A YOUNG LAW STUDENT IN SIERRA LEONE NAMED MOHAMED PA-MOMO FOFANAH RETURNED TO HIS HOME IN THE EASTERN PROVINCES TO WAIT FOR THE RESULTS OF HIS BAR EXAM. BECAUSE OF INTENSE REBEL FIGHTING, HE HAD TO WAIT FOR OVER A YEAR. DURING THAT TIME, HE SAW CHILDREN IN VILLAGES FORCED TO BECOME SOLDIERS AND COMMIT HORRENDOUS CRIMES AGAINST THEIR NEIGHBORS. ONE OF HIS UNIVERSITY COLLEAGUES WAS ABDUCTED BY REBELS, TORTURED, AND BEAT-EN TO DEATH. AND MANY TIMES, PA-MOMO AND HIS FAMILY HAD TO FLEE TO THE MOUNTAINS TO ESCAPE DANGER. BUT THROUGHOUT THIS DISTURBING TIME, HE IMMERSED HIMSELF IN THE STUDY OF CHILDREN'S RIGHTS. TODAY, HE IS ONE OF SIERRA LEONE'S LEADING ADVOCATES OF CHILDREN'S RIGHTS AND A RELENTLESS PROMOTER OF JUDICIAL AND LEGAL REFORM IN A COUNTRY THAT HAS BEEN RAVAGED BY REBELLION AND UNSPEAKABLE ATROCITIES.

During Sierra Leone's ruthless decade-long civil war, tens of thousands of civilians were killed; more than 100,000 were mutilated, tortured, and raped; and millions were driven from their homes. Many were compelled to work as slave laborers, and children were forced to become soldiers and commit violent acts against family and neighbors. This decade of destruction left 75 percent of Sierra Leone's population under the age of twenty-five and decimated the country's economy and infrastructure. Today, extreme poverty is rampant, and an adequate juvenile justice system nearly nonexistent. As a result, orphaned children have become victims of abuse as well as offenders—often resorting to crime just to survive.

When he was finally admitted to the bar in 1998, Pa-Momo helped set up the Sierra Leone office of Defence for Children International and provided free legal counsel for both juvenile offenders and victims of abuse. In addition to directly representing clients, Pa-Momo has been instrumental in instigating a number of reforms to ensure children's rights, including keeping children accused of serious offenses out of adult prisons where they can be further victimized. He established a monitoring system for juveniles in jails and worked with different departments to reduce delays in the courts. He has also educated the public about children's rights and lobbies the government to enact the Convention on the Rights of the Child.

To further strengthen his fight for the protection and welfare of children, Pa-Momo and three other lawyers created the Lawyers Centre for Legal Assistance (LAWCLA) in 2001. LAWCLA is the first and only organization in Sierra Leone to offer free legal services to indigent and vulnerable victims of human rights abuses. In its first year, LAWCLA advised more than 3,000 people and provided legal assistance to nearly 800 people.

Today, Pa-Momo continues working with LAWCLA and Defence for Children International in his relentless pursuit to see that children's rights are protected in Sierra Leone.

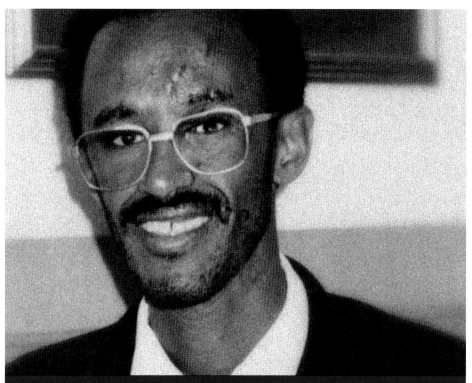

"IT IS A QUESTION OF BASIC HUMAN RIGHTS. CITIZENS SHOULD ENJOY THEIR INDEPENDENCE BY MOVING FREELY FROM PLACE TO PLACE, WITHOUT FEAR, IN THEIR OWN COUNTRIES."

GET INVOLVED

HEALTH AND HUMAN RIGHTS

Landmine Survivors Network was created by landmine survivors for landmine survivors. The network is dedicated to helping the hundreds of thousands of civilian landmine victims and preventing more from joining their ranks. They work to help mine victims and their families recover through an integrated program of peer counseling, sports, and social and economic integration into their communities. www.landminesurvivors.org

The International Campaign to Ban Landmines, launched in 1992, brings together more than 1,300 human rights, humanitarian, children's, peace, disability, veterans', medical, humanitarian, landmine action, development, arms control, religious, environmental, and women's groups in more than ninety countries who work locally, nationally, regionally, and internationally to ban antipersonnel mines. www.icbl.org

ABRAHAM GEBREYESUS

ERITREA 1998 AGE 27

ADVOCATE WORKING TO ERADICATE LANDMINES

MORE THAN 120 MILLION LANDMINES ARE SCATTERED ACROSS THE EARTH, NEAR FOOTPATHS, IN FIELDS, BESIDE ROADS, WAITING TO EXPLODE UNDER A FOOTSTEP AS LIGHT AS A CHILD'S. NOT SO LONG AGO, ABRAHAM GEBREYESUS WAS ONE OF THOSE INNOCENT CHILDREN. HE WAS ELEVEN YEARS OLD, PLAYING IN THE FIELDS OF HIS SMALL VILLAGE IN ERITREA, WHEN SOMETHING CAUGHT HIS EYE. THINKING IT WAS A BATTERY, HE WENT TO DISLODGE IT. BUT IT WAS ONE OF AN ESTIMATED TWO MILLION LANDMINES BURIED IN ERITREAN SOIL. IT EXPLODED, BLINDING HIM AND TEARING THROUGH HIS RIGHT ARM.

The accident was both the legacy of a long and bitter civil war fought between Ethiopia and Eritrean guerrillas, and a shattering example of the devastation wrought by landmines. An exploding landmine maims or kills a man, woman, or child every twenty minutes. That's seventy-two times a day, more than 25,000 times a year.

Abraham has used his experience to become an eloquent advocate for landmine survivors everywhere. After learning Braille at a school for the blind, he became one of the first visually impaired students to attend the university in the Eritrean capital of Asmara, where he earned his law degree, focusing on the rights of the disabled. He also became an effective leader in the movement to ban landmines. He shares his story at international conferences, lobbies governments throughout the world to ban anti-personnel mines, and campaigns for support services for landmine survivors.

In the summer of 1997, after friends and supporters launched a world-wide fundraising campaign, Abraham underwent eye surgery, which radically improved his vision. A few months later, 122 countries signed the first global treaty banning antipersonnel mines. Despite such good news, countless landmines remain unearthed in scores of battle-scarred nations—as many as one-third of all developing countries—where they kill and maim innocent victims years after peace treaties have been signed.

After participating in a training program for human rights advocates at Columbia University in 1999, Abraham returned to Eritrea to open an office of the Landmine Survivors Network. He is now in Germany, where his application for political asylum is being processed. And he continues to be active in the International Campaign to Ban Landmines, determined to fight for the day when all the world's children can share the basic human right of playing without fear of triggering deadly devices.

"YOU CANNOT LIBERATE PEOPLE. YOU CAN ONLY HELP PEOPLE LIBERATE THEMSELVES."

GET INVOLVED

FREEDOM OF EXPRESSION

The Kenya Human Rights Commission (KHRC) is a nonprofit organization working to protect and promote human rights in Kenya. Through various programmatic approaches and activities, KHRC monitors human rights violations, researches human rights issues, undertakes advocacy interventions, and conducts human rights education activities. KHRC works in partnership with individuals and communities in different parts of Kenya to put into place the building blocks of an active, community-based human rights movement. www.hri.ca/partners/khrc

World Organization Against Torture is the largest international coalition of nongovernmental organizations fighting against torture, summary executions, forced disappearances, and all other forms of cruel, inhuman, and degrading treatment. www.omct.org

NDUNGI GITHUKU

KENYA 2001 AGE 27

AN INDOMITABLE SPIRIT IN THE STRUGGLE FOR A JUST SOCIETY

IN 1992, A GROUP OF MOTHERS GATHERED AT THE FREEDOM CORNER OF UHURU PARK IN NAIROBI FOR AN ALL-NIGHT VIGIL, CALLING FOR THE RELEASE OF THEIR SONS, WHO WERE POLITICAL PRISONERS JAILED ON FABRICATED CHARGES. A YOUNG ART STUDENT NAMED NDUNGI GITHUKU STOOD WITH THEM. THAT EXPERIENCE INSPIRED HIM TO DEDICATE HIS TALENTS TO RAISING AWARENESS AND IMPROVING HUMAN RIGHTS IN KENYA. NDUNGI WAS THE FIRST ARTIST TO RECEIVE A REEBOK HUMAN RIGHTS AWARD. HIS SONGS, CARTOONS, POEMS, AND PERFORMANCES HAVE INFORMED AND INSPIRED, EDU-CATED AND MOBILIZED KENYANS IN THE SHADOW OF AN INCREASINGLY REPRESSIVE REGIME.

Political repression had become a way of life for people in Kenya. Police often brutalized those who challenged the policies of President Daniel arap Moi's regime. Human rights and civic education activists were labeled as "security threats" and routinely harassed. Peaceful demonstrators were charged with unlawful assembly and thrown in jail. Many were tortured; others just "disappeared." The Moi regime characterized twenty-seven-year-old artist/activist Ndungi Githuku as a "security threat" for his work as an actor, playwright, musician, and cartoonist. As a result of his activism, he was repeatedly arrested, beaten, and tortured.

Ndungi helped found several Kenyan human rights groups, including Release Political Prisoners and People Against Torture. But he is best known for his work as the founder, director, lead actor, principal playwright, and songwriter of Pamoja (Together) Theatre Group. Established in 1998, the eighteen-member troupe traveled throughout Kenya, performing plays based on Ndungi's painful experiences in police custody. His performances called attention to police brutality and government corruption and advocated for gender equity.

Pamoja members, who ranged in age from seventeen to twenty-eight, performed whenever Ndungi was not in prison. But since groups engaging in civic education were regular targets of the police, simply putting on a play was often enough to result in his incarceration. Yet prison did not silence him: when in jail, Ndungi used the opportunity of a "captive audience" to educate other prisoners as well as guards about international prison codes, police brutality, and government corruption.

A photograph of Ndungi writhing in agony after being beaten by police became an iconic representation of the Moi regime's mistreatment of prisoners. Ndungi regularly visited victims of politically instigated violence in many parts of the country, documenting their experiences and consoling and encouraging them. He has been ardently involved with human rights organizations across Africa, including the Kenyan Human Rights Commission, and his documentary videotapes, songs, cartoons, and poetry have been regarded as important tools in the Kenyan human rights movement.

In 2002, Ndungi founded the Mulika Communications Trust, and today continues to express, educate, and organize for change in Kenya using all his many creative talents, from demonstrations to songs, poetry, cartoons, and theater.

"THE DEATH PENALTY IS A VIOLATION OF THE MOST FUNDAMENTAL HUMAN RIGHT: LIFE."

The Southern Center for Human Rights works to enforce the constitutional protection against "cruel and unusual punishment" by challenging excessive and degrading forms of punishment and cruel and inhuman conditions of confinement. The center challenges discrimination against people of color, the poor, and the disadvantaged in the criminal justice and corrections systems in the southern region of the United States, raises public awareness of these issues, and works with community groups and individuals to improve the criminal justice and corrections systems and to develop constructive, humane, and nonviolent solutions to crime. www.schr.org

The International Centre for Criminal Law Reform and Criminal Justice Policy (ICCLR) is an independent, nonprofit institute formally affiliated with the United Nations. ICCLR's objectives are to contribute to international criminal justice policy development through analysis, research, and consultation, and to provide technical assistance to implement international policies and standards. www.icclr.law.ubc.ca

TANYA GREENE

UNITED STATES 1999 AGE 28

GUARDIAN OF EQUALITY AND SEEKER OF JUSTICE

THE DISCREPANCIES ARE GLARING: A BLACK PERSON WHO KILLS A WHITE PERSON IN THE UNITED STATES IS NINETEEN TIMES MORE LIKELY TO BE SENTENCED TO DEATH THAN A WHITE PERSON WHO KILLS A BLACK PERSON. AND, ONE STUDY IN PHILADELPHIA FOUND, BLACK DEFENDANTS ARE FOUR TIMES MORE LIKELY TO RECEIVE THE DEATH PENALTY THAN WHITE DEFENDANTS FOR SIMILAR MURDERS. THESE NUMBERS ARE MORE THAN STATISTICS TO TANYA GREENE. WHEN SHE WAS TEN YEARS OLD, PRISON GUARDS KILLED HER COUSIN STEVIE WHILE HE WAS SERVING ON DEATH ROW. A FEW YEARS LATER, HER COUSIN ARTHUR WAS KILLED. "NO ONE SOUGHT JUSTICE TO AVENGE THEIR DEATHS," SHE SAYS. "I GUESS THOSE BLACK MEN WERE NOT CONSIDERED WORTHY."

Tanya has made it her life mission to see that the death penalty is abolished in the United States. While that struggle continues, she focuses additional energies on the just application of the death penalty. Through painstaking research, she has exposed gross instances of racial discrimination and other injustices in how the death penalty is applied. And through compelling arguments in the courtroom, she has won precedent-setting cases that have saved lives and prompted widespread changes in how jury forepersons are selected.

After earning her degree from Harvard Law School in 1995, Tanya worked at the Southern Center for Human Rights, representing indigent capital clients throughout Alabama and Georgia who might otherwise have gone without counsel. At the same time, she served as the death penalty resource counsel for the National Association of Criminal Defense Lawyers, providing capital defense resources and expertise to any of the 10,000 association members in the United States, consulting daily with attorneys who needed help in identifying viable trial and appellate challenges, locating experts, and crafting pleadings. Also as an aid to lawyers, Tanya initiated the Life Vote Project, in which jurors and attorneys in capital cases are interviewed to find out what makes a jury decide against the death penalty.

In 2001, after relocating to New York City, Tanya resumed her work against the death penalty at the New York Capital Defender Office in Manhattan, where she represents capitally charged people at trial and on appeal in New York State.

"I HAVE LEARNED THAT DISEASE IS NOT ONLY CAUSED BY A GERM OR A VECTOR, BUT ALSO BY THE SOCIAL, ECONOMIC, POLITICAL, AND ENVIRONMENTAL CONDITIONS IN WHICH PEOPLE LIVE. AND TO TREAT THE DISEASE, DOCTORS SHOULD ALSO FIND WAYS TO CHANGE THE CONDITIONS THAT MAINTAIN AND BREED THE DISEASE."

ERNEST GUEVARRA

PHILIPPINES 2003 AGE 24

HEALER AND ADVOCATE FOR PEACE

**ERNEST GUEVARRA IS A COURAGEOUS PHYSICIAN AND HUMAN RIGHTS ACTIVIST DEDICATED TO BRING-
ING HEALTH SERVICES TO PEOPLE CAUGHT IN CONFLICT ZONES AND TO HELPING INNOCENT VICTIMS,
PARTICULARLY CHILDREN, RECOVER FROM THE TRAUMA.**

In the Philippines, armed conflict between government forces and Muslim separatist groups has escalated in the past few years, despite attempts at peace negotiations. In 2000, the Abu Sayyaf, a loosely organized Muslim rebel group, increased its kidnapping for ransom in the southern islands. The military has responded by indiscriminately bombing civilian targets, causing massive displacement. People alleged to be Muslim rebels or sympathizers have been arbitrarily arrested, tortured, and killed.

Ernest knew at an early age that he wanted to become a doctor and to work for peace and human rights. As a student activist, he founded the organization Medical Students for Social Responsibility and spearheaded a number of campaigns advocating for the health needs of the vulnerable and disadvantaged. In 1999, he became a student representative with International Physicians for the Prevention of Nuclear War, where he helped form a cohesive network of global, regional, and local student leaders engaged in an ambitious program of peace, disarmament, and human rights advocacy. He also co-organized the first Asia-Pacific Training on Medicine and Human Rights in Manila. And in 2000, Ernest was one of a group of medical students who organized a conference in Sarajevo on the medical problems of refugees, landmine victims, and the rights of children in conflict zones.

When he graduated, Ernest became a volunteer doctor in Mindanao with the Medical Action Group, providing care to victims of human rights violations. One month after September 11, 2001, Ernest joined a fact-finding mission to Basilan, an area with a number of Muslim rebel groups. Government forces were arresting hundreds of Muslim suspects, and it was alleged that many of them were being tortured. As Ernest examined the prisoners, an armed guard threatened him with an M16 rifle and locked him up with the detainees. Undaunted, Ernest continued his work and demanded that the prisoners receive proper treatment. When he was finally released, Ernest and the team continued their mission, narrowly escaping mortar fire and abduction.

Despite the personal risk, Ernest chose to remain in Mindanao, where he became the coordinator of a psychosocial intervention program for children traumatized by conflict. That program was disrupted in early 2003 when the Philippine military, in search of a rebel group, invaded the region where Ernest was working. Thousands of villagers were forced to leave the area. As the only doctor in the region, Ernest responded to the crisis, providing emergency care to more than 20,000 refugees.

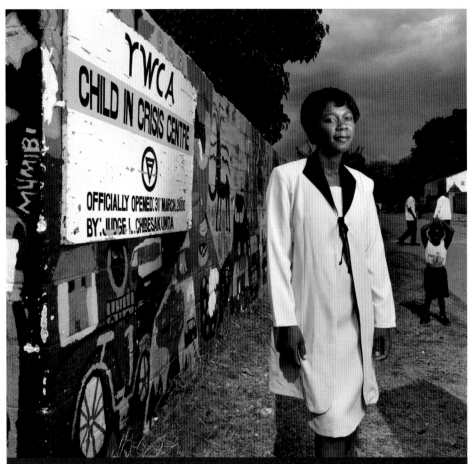

"WE HAVE TO MAKE AN ALL-OUT EFFORT TO TEACH PEOPLE ABOUT THE DEVAS-
TATING EFFECTS OF ABUSE AND HOW WE CAN PROTECT OUR CHILDREN."

GET INVOLVED

CHILDREN AND YOUTH

The New Life Center for Zambian Children provides emergency accommodation, psychosocial counseling, legal advice, and medical attention to physically and sexually abused children; advocacy through training of principal authorities; and awareness raising about child abuse and violence against children. For more information, visit: www.forefrontleaders.org

The Children's Rights Division of Human Rights Watch monitors human rights abuses against children around the world and campaigns to end abuses carried out or tolerated by governments. When appropriate, the division also deals with abuses carried out by armed opposition groups. www.hrw.org/children

KAVWUMBU HAKACHIMA

ZAMBIA 2002 AGE 27

ADVOCATE AGAINST CHILD ABUSE

A YOUNG GIRL IS RAPED BY A MAN WHO BELIEVES THAT SEX WITH A VIRGIN WILL CLEANSE HIM OF HIV. A CHILD, ORPHANED BY AIDS, IS TAKEN IN BY AN AUNT WHO DOESN'T FEED HIM BECAUSE SHE BARELY HAS ENOUGH FOOD FOR HER OWN CHILDREN. A GIRL IS ATTACKED BY A SOLDIER, WHO RECEIVES JUST A ONE-DAY JAIL SENTENCE BECAUSE NO ONE WANTS TO ACKNOWLEDGE THE CRIME. SADLY, THESE STORIES ARE ALL TOO COMMON IN A COUNTRY WHERE AIDS AND POVERTY HAVE FUELED ANOTHER EPIDEMIC—CHILD ABUSE. BUT ONE WOMAN, KAVWUMBU HAKACHIMA, IS WORKING TO CHANGE ALL THAT.

Zambia, a small country in south-central Africa, has been devastated by poverty and AIDS. More than half of all Zambians go days without eating; millions of others exist on one meal a day. Added to this tragedy, at least one million Zambians are living with AIDS and more than a half million children have been orphaned by this disease. With nowhere to go, many of them are forced to live on the streets, where they have increasingly become victims of physical and sexual abuse. Even though child abuse is widespread, it is often hidden because of cultural taboos in Zambian society.

Kavwumbu Hakachima grew up in a family of sixteen children. Although she was very poor, she had one important advantage: a loving and supportive family. In a society that places little value on the education of girls, her father, in particular, encouraged her to achieve. Kavwumbu went on to win scholarships for both high school and college—a rare accomplishment for a Zambian woman. She decided early on that she wanted to help children who didn't have those same advantages.

As head of the YWCA Children in Crisis Center in Lusaka, Kavwumbu worked directly with children, rescuing them from abusive homes, counseling those who suffered physical and sexual abuse, and demanding police action when necessary. She also created television and radio programs in seven major languages that were broadcast throughout Zambia to break the conspiracy of silence against child abuse.

But educating the public was only part of her campaign. Public institutions also had to be sensitized to the needs and rights of children. Kavwumbu developed training programs on the causes and signs of child abuse for public service providers—from social workers to police officers to doctors. She succeeded in convincing the police department to expand the mandate of its victims support unit to include protection of abused children. And she trained judges and court workers on the sensitive handling of abused children.

Today, Kavwumbu is developing an independent project, the New Life Center for Zambian Children, to provide abused children with emergency shelter, counseling, legal advice, and medical attention.

"WOMEN SUFFER FROM DISCRIMINATION, HARASSMENT, AND ABUSE. AND IN SOME PARTS OF THE WORLD THEY ARE EVEN BEING SYSTEMATICALLY MURDERED."

RANA HUSSEINI

JORDAN 1998 AGE 30

SPEAKING OUT AGAINST "HONOR KILLINGS"

IN 1994, A JORDANIAN TEENAGER KILLED HIS YOUNGER SISTER, KIFAYA, THEN CHEERFULLY SURRENDERED TO THE POLICE. HE ADMITTED TO STRAPPING KIFAYA TO A CHAIR, ORDERING HER TO RECITE A VERSE FROM THE KORAN, THEN STABBING HER TO DEATH. HE DECLARED HIMSELF PROUD TO HAVE RESTORED HIS FAMILY'S HONOR, WHICH HAD BECOME SULLIED WHEN KIFAYA WAS RAPED BY THEIR YOUNGER BROTHER. THEIR RELATIVES AGREED THAT THE MURDER HAD BEEN NECESSARY TO CLEANSE THE FAMILY'S HONOR. WHAT WAS UNUSUAL ABOUT THE HOMICIDE WAS NOT ITS COLD-BLOODED BRUTALITY, NOR THE FAMILY'S SANCTION OF THE CRIME, NOR THE KILLER'S BOASTFULNESS, BUT ITS COVERAGE IN A NATIONAL NEWSPAPER.

In defiance of local custom, Rana Husseini, then a cub reporter for the *Jordan Times,* investigated the crime and wrote about it, becoming the first journalist to expose "honor killings," a practice in which women are murdered by family members for suspected "immoral" behavior. When Rana broke the story, one-third of all reported homicides in Jordan were honor killings. Each year dozens of women were murdered in the name of honor, and yet the government had no effective sanction against the killings. Under protection of the law, offenders tended to receive light sentences, if not outright exoneration; the average term served for an honor killing was less than eight months.

After reporting on Kifaya's murder, Rana continued to defy social taboo and risk her own life in order to investigate honor killings. She spoke with victims' families, interviewed female prisoners, combed through police files, and challenged policy makers to discuss strategies to eradicate the practice. Convinced that honor killings—the most extreme and underreported human rights violations in Jordan— require the creation of a legal framework to condemn them, she was persistent in forcing this highly sensitive, mostly hidden issue into the arena of public policy.

When Rana received the Reebok Human Rights Award, the media exposure about her cause intensified, not only in Jordan, but internationally as well. The silence was broken for good, and honor killings, once tacitly ignored, suddenly became a very public issue in Jordan—and beyond.

Although awareness had been raised, the killings unfortunately didn't stop. The week Rana attended the Reebok Human Rights Award ceremony, members of a Turkish woman's family crushed her with a tractor because they suspected her of adultery. A Palestinian woman who had been raped by her brother-in-law was dragged to death behind a vehicle. And a Jordanian Christian woman sought asylum in the United States, because her relatives were determined to kill her for marrying a Muslim man and bearing his child.

Encouraged by a greater and more sympathetic audience, Rana continues to speak out about violence against women in Jordan and the Middle East, hoping to prod government officials into action and to change entrenched cultural attitudes.

"THE MOST IMPORTANT THING IS THAT EVERYBODY—WITH NO EXCLUSION— SHOULD VIEW THE ISSUE OF HUMAN RIGHTS FROM ONE ANGLE, THE ANGLE OF THE INTERNATIONALLY GUARANTEED HUMAN RIGHTS ACCORDING TO INTERNATIONAL CONVENTIONS AND THE RULE OF LAW."

GET INVOLVED

HUMAN RIGHTS MONITORING

Al-Haq is a Palestinian human rights organization founded in 1979 by Palestinian lawyers concerned with the protection and promotion of human rights principles and the rule of law. www.alhaq.org

For more information on Palestinian human rights issues, visit: www.lchr.org/defenders/ hrd_middle_east/hrd_middle_east.htm

www.amnesty.org

SHA'WAN JABARIN

WEST BANK 1990 AGE 30

HUMAN RIGHTS MONITOR IN THE WEST BANK

IN DECEMBER 1987, WIDESPREAD DEMONSTRATIONS, STRIKES, AND RIOTS BROKE OUT THROUGHOUT THE GAZA STRIP AND WEST BANK IN WHAT BECAME KNOWN AS THE *INTIFADA*—ARABIC FOR "THROWING OFF," OR UPRISING. IT BEGAN AS A SPONTANEOUS EXPRESSION OF PALESTINIAN FRUSTRATION AND RESENTMENT AT TWENTY YEARS OF ISRAELI RULE AND JEWISH SETTLEMENT IN THE GAZA STRIP AND WEST BANK. BUT AS THE MOVEMENT EXPANDED AND BECAME MORE VIOLENT, ISRAEL RESPONDED WITH INCREASINGLY HARSH REPRISALS, WHICH DREW STRONG INTERNATIONAL CRITICISM. CIVILIAN DEATHS AND INJURIES WERE SUFFERED ON BOTH SIDES. AMID THIS TURBULENCE, A YOUNG PALESTINIAN ACTIVIST NAMED SHA'WAN JABARIN WAS JUST BEGINNING HIS WORK WITH AL-HAQ, A HUMAN RIGHTS ORGANIZATION DEDICATED TO PROMOTING HUMAN RIGHTS AND RESPECT FOR THE RULE OF LAW IN THE GAZA STRIP AND WEST BANK.

Al-Haq, the West Bank affiliate of the International Commission of Jurists, provided one of the few safeguards available to protect the rights of the civilian population. Sha'wan joined the organization in August 1987 and began documenting lawyer–client files, sworn affidavits, and reports from victims of abuse. Al-Haq housed the only specialized human rights library in the West Bank. He also served as a paralegal for the organization, gathering information of human rights violations from victims, eyewitnesses, and activists.

Because of the Israeli policy of administrative detention, which allowed imprisonment without official charges or trial, Sha'wan was imprisoned on several occasions for his activism. He was beaten and held in detention for months at a time, without being charged with a crime, and was listed as one of Amnesty International's prisoners of conscience. But even while incarcerated, he continued his work. He was instrumental in reporting to the Lawyers Committee for Human Rights the circumstances surrounding the shooting of two other administrative detainees during one detention. Despite the risks, Sha'wan worked to educate other prisoners, improve conditions, and record information on behalf of human rights for Palestinians.

Today, despite struggling with serious health problems and having spent eight years of his life in prison under administrative detention, Sha'wan continues to document human rights violations and works to protect the rights of civilians and uphold the rule of law in the Gaza Strip and West Bank.

"AT THE TIME OF OUR DEMONSTRATION, I WROTE A LETTER TO THE CHINESE GOVERNMENT SAYING, 'TODAY HERE IN TIBET I AM UNABLE TO EXPRESS MY FEELINGS AND MY FIGHT FOR TRUTH. BUT THERE WILL BE A DAY WHEN I CAN TELL IT TO THE WORLD.' NOW THAT DAY HAS COME."

LOBSANG JINPA

TIBET 1988 AGE 22

RISKING HIS LIFE TO EXPOSE THE TRUTH

IN OCTOBER 1987, A SMALL GROUP OF BUDDHIST MONKS CONDUCTED A PEACEFUL DEMONSTRATION IN SUPPORT OF THE DALAI LAMA AND TO PROTEST THE ABSENCE OF HUMAN RIGHTS IN TIBET. FOR THIS, THEY WERE BEATEN AND DETAINED BY CHINESE AUTHORITIES. WHILE MANY OF THEM WERE LATER IMPRISONED AND TORTURED, A TWENTY-TWO-YEAR-OLD MONK NAMED LOBSANG JINPA MANAGED TO AVERT CAPTURE. ALTHOUGH FORCED INTO EXILE, HE REMAINED COMMITTED TO THE STRUGGLE FOR HIS COUNTRY'S INDEPENDENCE.

Lobsang Jinpa is part of a generation of Tibetans who knew nothing except Chinese occupation since the People's Republic of China invaded Tibet in 1950. The Dalai Lama, the spiritual leader of all Tibetans, asserted that as a result of Chinese occupation, thousands of monasteries were reduced to ruins and a generation of Tibetans were denied economic and educational opportunities and a sense of national character. Added to these tragedies was the Chinese policy of promoting massive population transfers of non-Tibetans to reduce Tibetans to minority status. Lobsang sought with other monks to draw world attention to the massive violations endured by his people.

At age thirteen, Lobsang began to speak out against the exclusion of Tibetan language and culture in the school curriculum. His protests calling for change met with threats from authorities. In 1982, he joined the Sera Monastery and became a monk. There, he began to chronicle human rights abuses in Tibet. Risking a long prison term or even execution, Lobsang passed his information on to foreigners he came into contact with, hoping they would smuggle it to the outside world.

From 1983 to 1986, Lobsang, along with four other monks, represented the Sera Monastery in the Regional People's Congress of the "Tibet Autonomous Region." Throughout this period, they protested the absence of human rights in general and religious freedom in particular.

Then in 1987, Lobsang led a demonstration in support of the Dalai Lama to counter the Chinese authorities' assertion that the Tibetan people no longer supported their religious leader. Lobsang and his fellow monks were beaten, briefly detained, and released. Later, however, the Chinese police raided the monastery, brutally beat the monks, and dragged six of them away to prison. Lobsang managed to avoid capture. When the Chinese authorities offered a substantial reward for his capture or his dead body, he fled and began a nine-month trek across the treacherous Himalaya Mountains. Aided by his fellow Tibetans, he managed to make it out of the country alive. When the Chinese forces couldn't find him, they killed his father and imprisoned his mother. Lobsang made it to India, where he continued to work for human rights in Tibet from a monastery in Bangalore.

Although Lobsang won the Reebok Human Rights Award in 1988, he was not able to receive it because of his exile in India. Finally in 1990, he was able to travel to the United States and was presented with his Award. At the ceremony, he told the audience, "Even now, my fellow countrymen of Tibet are depending on the world platform and on people like you to support our cause so that we can carry on. We will continue this fight until we obtain our independence."

"WE CAN'T PROMISE THOSE SUFFERING FROM INJUSTICE THAT WE CAN ALWAYS WIN THE BATTLE, BUT WE CAN PROMISE THAT THEY WON'T BE FIGHTING ALONE."

GET INVOLVED

DISCRIMINATION AND RACISM

The Ella Baker Center for Human Rights combines litigation, organizing, media, and technology to challenge discriminatory and abusive practices of the criminal justice system. www.ellabakercenter.org

Justice Without Borders promotes, through the exchange of information, ideas, and expertise, meaningful legal representation of people throughout the world who face deprivation of life or liberty. Justice Without Borders seeks a world in which all judicial systems ensure fundamental human rights. www.justicewithoutborders.com

VAN JONES

UNITED STATES 1998 AGE 29

CHALLENGING ABUSIVE PRACTICES OF THE CRIMINAL JUSTICE SYSTEM

VAN JONES'S FUTURE WAS GOLDEN. THE MOST PRESTIGIOUS LAW SCHOOLS IN THE UNITED STATES COURTED HIM, AND WHEN HE GRADUATED FROM YALE LAW SCHOOL IN 1993, HE COULD HAVE JOINED VIRTUALLY ANY LAW FIRM IN THE COUNTRY. BUT INSTEAD, AT AGE TWENTY-FIVE, HE MADE IT HIS MISSION TO HOLD POLICE ACCOUNTABLE WHEN THEY CROSSED THE THIN BLUE LINE.

While working with the Lawyers Committee for Civil Rights in San Francisco, Van grew outraged at hearing so many cases of police misconduct and intimidation in inner-city communities. In 1994, with $50,000 in seed money that he raised himself, he founded Bay Area PoliceWatch, one of the first organizations in the country dedicated to providing counseling and legal services to victims of police harassment and brutality.

A year later, the need for PoliceWatch became dramatically evident in the case of Aaron Williams, an African American man who had been beaten, kicked, stomped on, pepper-sprayed in the face, and then left in a jail cell. The police did not wash Williams's face afterward; as a resin, the pepper-spray stuck to his skin and continued to burn until he died, still in his cell. Van launched a successful campaign to oust the police officer linked to the pepper-spraying. The case attracted national attention as one of the first times that community pressure had led to an officer's firing.

Under Van's leadership, PoliceWatch has since evolved into the Ella Baker Center for Human Rights, a nonprofit agency with twin aims: to ensure that all citizens feel empowered in their dealings with the justice system and that police officers themselves operate within the law. The center began running workshops to educate young people about their legal rights in encounters with the police, organizing campaigns calling for police accountability in urban communities, and establishing a database to allow problem officers, precincts, and practices to be tracked. The center also launched a volunteer-staffed hotline that documents callers' claims of abuse, advises them on various legal options, and refers brutality cases to a team of specially trained civil rights attorneys.

In 1998, Van opened a branch of the Ella Baker Center in New York City. On both coasts, the message of the organization remains the same: true justice is fair, honest, and colorblind. Van continues his work as executive director of the Ella Baker Center, where he has established several innovative programs addressing the issue of police violence, the rights of sexual minorities, and youth empowerment and leadership development.

"WE HAVE TRUTH, WE HAVE JUSTICE, WE HAVE COURAGE—AND WE HAVE EACH OTHER."

GET INVOLVED

HUMAN RIGHTS MONITORING

EarthRights International (ERI) combines the power of law and the power of people in defense of human rights and the environment in Southeast Asia. ERI monitors and documents human rights violations, the exploitation of natural resources that threatens indigenous cultures, and the persecution of environmentalists by governments and private businesses. www.earthrights.org

Just Earth!—Amnesty International's program for action on human rights and the environment—campaigns to save lives that are at risk and to protect the rights of environmental activists around the globe. www.amnestyusa.org/justearth

KA HSAW WA

BURMA 1999 AGE 28

FEARLESS CHAMPION OF BURMA'S OPPRESSED

SEVENTEEN-YEAR-OLD KA HSAW WA WAS LEADING A STUDENT DEMONSTRATION FOR DEMOCRACY IN BURMA WHEN SOLDIERS OPENED FIRE, KILLING MANY OF HIS FRIENDS. HE FLED RANGOON FOR THE REMOTE VILLAGES DOTTING THE JUNGLE. THERE HE WITNESSED A HORRIFIC SIGHT: A WOMAN, LYING DEAD IN THE ROAD, WITH A TREE BRANCH PROTRUDING FROM HER VAGINA. HE LATER LEARNED THAT THIS NURSE HAD BEEN ABDUCTED BY THE MILITARY TO CARE FOR SICK SOLDIERS, THEN RAPED AND KILLED. KA HSAW WA HAD WANTED TO SEEK REVENGE FOR THE DEATHS OF HIS FRIENDS, BUT THE SHOCK OF SEEING THE YOUNG NURSE MADE HIM REJECT THE PATH OF VIOLENCE.

Since 1988, the year of Ka Hsaw Wa's flight, Burma has been oppressed by the ruling military elite. The State Law and Order Restoration Council (SLORC), now renamed the State Peace and Development Council, has imposed martial law throughout the country, maintaining—and at times intensifying—restrictions on basic rights of free speech, press, assembly, and association.

In 1992, Ka Hsaw Wa began to witness the forced labor practices of SLORC troops and to learn about the many instances of rape and torture of local villagers. He decided to document the experiences of the victims through words and photographs, and he co-founded the Karen Human Rights Group to disseminate his findings to international human rights groups. His reports have served as a primary and credible source for the documentation of human rights violations in areas of Burma that have been inaccessible to international agencies.

At great personal risk, Ka Hsaw Wa has depicted the military's use of systematic rape as a method of ethnic oppression, and he has brought to light human rights violations along Unocal's natural gas pipeline across Burma. He has personally trained and placed a dozen staff members into villages along the pipeline to continue collecting evidence. He has also chosen to step into a more public advocacy role, a decision not without risk: he continues to use an alias to protect his family from retaliation by Burmese authorities—Ka Hsaw Wa means "white elephant"—and he has not seen his own mother in nearly fifteen years.

Now co-director of EarthRights International, a nongovernmental organization he helped found in 1995, Ka Hsaw Wa continues to document government-sponsored human rights abuses in Burma, share the information with the world, and help strengthen international efforts to bring democracy to Burma. Wherever the military regime violates the rights of Burma's people, Ka Hsaw Wa seeks to uncover and challenge those violations.

"IF THESE BARBAROUS ACTS WERE HAPPENING TO ANY OTHER GROUP OF PEOPLE IN ANY OTHER PART OF THE WORLD THERE WOULD BE AN INTERNATIONAL OUTCRY."

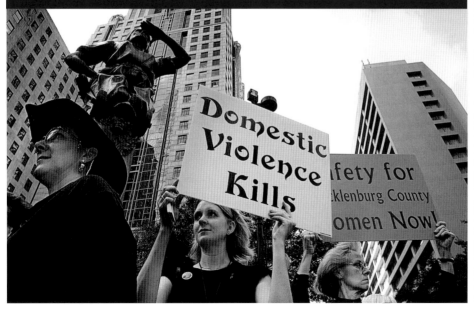

VIOLENCE AGAINST WOMEN

Peace at Home is a human rights agency dedicated to stopping domestic violence in the United States by heightening public awareness about the national emergency of domestic violence, implementing education and intervention programs, and organizing community response and involvement. www.peaceathome.org

The Women's Rights Division of Human Rights Watch fights against the dehumanization and marginalization of women and promotes women's equal rights and human dignity. www.hrw.org/women

STACEY KABAT

UNITED STATES 1992 AGE 29

ADVOCATE FOR THE RIGHTS OF BATTERED WOMEN

A SIREN SCREAMS AS AN AMBULANCE ARRIVES TO TAKE AWAY A WOMAN WHO HAS BEEN SEVERELY BEATEN BY HER HUSBAND. TWO DAYS LATER SHE RETURNS HOME. TOO AFRAID TO PRESS CHARGES, AND FEELING SHE HAS NO SUPPORT AND NOWHERE ELSE TO GO, SHE CLINGS TO THE HOPE THAT SOMEHOW HE WILL CHANGE...UNTIL THE NEXT TIME.

Every fifteen seconds a woman is battered in the United States, making domestic violence one of the leading causes of death in women. By the most conservative estimate, each year at least one million women suffer violence at the hands of someone close to them. And this abuse knows no boundaries: it affects women of all races, ages, cultures, and income levels. Many blame themselves and live in pain and silence, fearing for their own lives. And those who do speak out are often not adequately protected by the police or judicial system. Some have even been jailed for defending their own lives.

As a daughter and granddaughter of battered women, Stacey Kabat worked tirelessly to help victims of domestic violence. She was the first person in Massachusetts to document the number of victims murdered by batterers and bring attention to this issue as a human rights violation. She served as a member of the Governor's Commission on Domestic Violence, for which she focused most of her efforts on educating the public about the horrors of domestic violence and lobbying for better protection for battered women under the law.

In 1992, while working at a women's prison in Massachusetts, Stacey co-founded Battered Women Fighting Back!, which later changed its name to Peace at Home. As volunteer director, Stacey successfully recruited lawyers, law students, activists, and paralegals to target laws that did not adequately respond to domestic violence and perpetuated the unjust treatment of battered women. She also helped develop training programs on Battered Women Syndrome and worked with legislators to draft statutes expanding protection for battered women who have fought back in self-defense. In addition, Stacey worked to rehabilitate batterers who have been imprisoned by developing awareness and counseling programs. One group of prisoners was so moved by her presentation that they organized a ten-kilometer race in the prison to raise money for Peace at Home.

Stacey has appeared on numerous television and radio talk shows and has written articles to educate the community on domestic violence. She also co-produced and co-directed an Academy Award winning short subject documentary, *Defending Our Lives,* about eight women serving time for defending themselves against their batterers.

Today, Stacey continues to be a strong advocate for women's rights and remains a leader in the struggle against domestic violence. She is currently working as a registered nurse in Massachusetts.

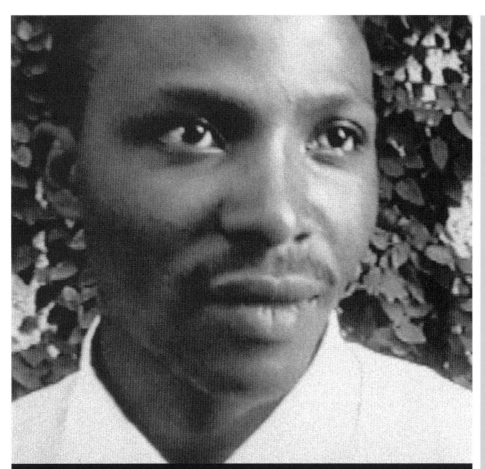

"THIS WORK IS VERY DIFFICULT, AND IT CANNOT BE DONE WITHOUT ASSISTANCE FROM ALL LEVELS OF SOCIETY TO DEFEND THE RIGHTS OF THE VICTIMS."

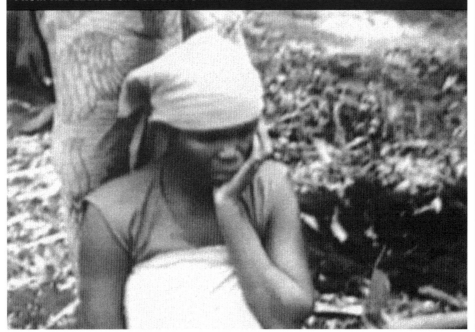

GET INVOLVED

HUMAN RIGHTS MONITORING

SOPROP, the Coalition for Social Advancement and Peace, works to promote human rights, peace, and democracy in the Great Lakes Region of Africa. It does this by monitoring human rights violations, investigating torture cases, and conducting training and educational programs on human rights. SOPROP has a particular focus on peasants and helps to strengthen their development initiatives. www.soprop.kabissa.org

The International Human Rights Law Group (IHRLG) works to strengthen the Democratic Republic of Congo's human rights movement through training and partnering with local organizations. IHRLG's training and technical assistance program works to expand the expertise of human rights leaders and legal service providers, redress gender imbalance in local groups and approaches to human rights work, encourage collaboration between organizations, and broaden the perspective and impact of local groups through international advocacy. www.hrlawgroup.org/ country_programs/drc

DIDIER KAMUNDU

DEMOCRATIC REPUBLIC OF CONGO 1998 AGE 27

CHAMPION FOR THOSE CAUGHT IN ETHNIC STRIFE

FOR DECADES NOW, THE DEMOCRATIC REPUBLIC OF CONGO, FORMERLY ZAIRE, HAS ENDURED BLOODSHED AND CIVIL STRIFE. ONE OF THE MOST VOLATILE AREAS OF THIS COUNTRY HAS BEEN THE MASISI REGION, AN ETHNIC BATTLEGROUND FOR THE BAHUNDE, HUTUS, AND TUTSIS. IN 1994, REFUGEES FLEEING THE GENOCIDE IN RWANDA FLOODED THE REGION, INTENSIFYING ETHNIC ANIMOSITIES AND STRETCHING ALREADY SCARCE RESOURCES TO THE LIMITS. THE FOLLOWING YEAR, BITTER ETHNIC CONFLICT SPARKED OFF A MASSACRE IN MASISI, FOLLOWED BY A SERIES OF ARRESTS, MURDERS, AND UNBEARABLE CRUELTIES. MOST PEOPLE WERE TOO SHOCKED, TOO NUMBED, OR TOO FRIGHTENED TO ACT. MOST PEOPLE, BUT NOT ALL.

A young refugee from Masisi, a baker by trade, could not stand by as a silent witness to injustice. Didier Kamundu traveled to Goma, a town in North Kivu, to begin advocating for displaced people. In a small shed housing a desk, two chairs, and a battered manual typewriter, he started typing out urgent petitions on behalf of illegally held prisoners and torture victims. He documented human rights abuses committed by the national army and local militias, petitioned for the release of political prisoners, secured medical care for torture victims, and collaborated on human rights reports. Undeterred by a lack of resources, he also founded Action Paysanne pour le Reconstruction et le Dévelopement Communitaire Intégral (APREDECI), a human rights organization aimed at protecting the basic rights of victims of war, most of whom are peasant farmers and small traders displaced from their homes.

When a truck carrying a group of ethnic Tutsis fleeing state-sponsored persecution broke down and was surrounded by an angry mob, it was Didier who managed to persuade the police to escort the truck to the border. When victims of torture required medical treatment, it was Didier who made it possible. And when innocent farmers were accused of being rebels, it was Didier who intervened on their behalf. Again and again, he placed himself in as much danger as the very people he was trying to protect. And in so doing, he distinguished himself as a courageous and objective leader who willingly crossed ethnic lines in one of the most embattled areas of the country.

In 1998, as the political situation in the Democratic Republic of Congo deteriorated further and the military began rounding up leaders of nongovernmental organizations in Goma, Didier was forced to flee the country and begin a life in exile. He is now pursuing a degree in international human rights law at the Université Catholique in Lyon, France, and continues to be actively involved in human rights issues in the Democratic Republic of Congo.

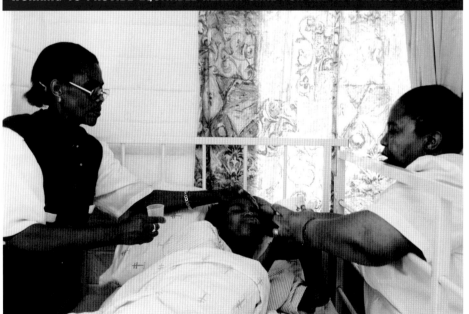

GET INVOLVED

HEALTH AND HUMAN RIGHTS

Medical Research Council, South Africa seeks to improve the nation's health status and quality of life through relevant and excellent health research aimed at promoting equity and development. www.mrc.ac.za/home.html

Physicians for Human Rights (PHR), which argues that human rights are essential preconditions for the health and well-being of all people, seeks to promote health by protecting human rights. Using medical and scientific methods, PHR investigates and exposes violations of human rights worldwide and works to stop them. www.phrusa.org

WORKING TO PROVIDE EQUITABLE HEALTH CARE FOR ALL IN A RACIST SOCIETY

SALIM ABDOOL KARIM

SOUTH AFRICA 1988 AGE 28

ANTI-APARTHEID DOCTOR FIGHTING FOR EQUAL HEALTH CARE

DURING THE LONG DECADES OF APARTHEID IN SOUTH AFRICA, THOUSANDS OF HEALTH CARE PROFESSIONALS MAINTAINED SEGREGATED OFFICES AND DELIVERED RACIALLY INEQUITABLE CARE. AS A RESULT, THE MAJORITY OF SOUTH AFRICA'S BLACK CITIZENS RECEIVED POOR OR NO HEALTH CARE. ALSO, BLACK VICTIMS OF POLICE BRUTALITY WERE OFTEN DENIED TREATMENT, AND SOME WERE EVEN ARRESTED FOR SEEKING HELP IN HOSPITALS. A SOUTH AFRICAN BORN PHYSICIAN, SALIM ABDOOL KARIM, STOOD UP TO APARTHEID AND SET OUT TO IMPROVE HEALTH CARE FOR ALL.

In 1985, the struggle for equality and social justice in South Africa reached unprecedented heights. As anti-apartheid activists staged demonstrations, strikes, and riots, violent clashes escalated significantly between demonstrators and the police. A state of emergency was declared that lasted from 1985 through 1990. As a result, the many deaths and injuries posed a significant challenge for South Africa's health care workers.

Despite its sixty-year existence, the Medical Association of South Africa (MASA) had had little impact on improving health conditions or systems for the black majority of the population. While MASA represented the professional interests of doctors well, it had never stood up against the apartheid policies of the government. In 1982, Dr. Karim became a founding member of the National Medical and Dental Association (NAMDA), a multiracial organization of health professionals that focused on the broad sociopolitical health issues of apartheid in South Africa.

Dr. Karim and NAMDA sought to achieve a nationwide primary health care network, as well as a more equitable distribution of health services in South Africa. Because of the political unrest and violence, the treatment of detainees was a particular focus of NAMDA, which established ad hoc groups in all regions of the country to monitor the health of detainees. The organization also provided both medical and psychological care upon their release, and established emergency service providers around the country. Although NAMDA was not a human rights monitoring group per se, its work greatly increased attention to human rights issues by health care professionals in South Africa. Its broad approach to health matters also effectively demonstrated the manner in which human rights work can be integrated into the medical profession.

In addition to working with NAMDA, Dr. Karim directed the Center for Epidemiological Research, which focused on the spread of HIV and the effect of political violence on health services.

Today, Dr. Karim is vice-principal and deputy vice-chancellor for research and development at the University of Natal. As one of South Africa's most distinguished scientists, he is a leader in research on HIV prevention, AIDS, and reproductive health, as well as the ethics of medical research.

"ALL OF US—BLACK, YELLOW, WHITE—WERE GIVEN A LIFE, AND THE STRUGGLE IS TO LIBERATE OURSELVES SO NO ONE HAS POWER OVER OUR LIVES. THAT'S WHAT THIS STRUGGLE IS ABOUT: LIFE AND LIBERATION."

GET INVOLVED

INDIGENOUS PEOPLES' RIGHTS

Amazon Alliance for Indigenous and Traditional Peoples of the Amazon Basin works to defend the rights, territories, and environment of indigenous and traditional peoples of the Amazon Basin. The alliance is an initiative born out of the partnership between indigenous and traditional peoples of the Amazon and groups and individuals who share their concerns for the future of the Amazon and its peoples. www.amazonalliance.org

Rainforest Action Network works to protect the earth's rainforests and support the rights of their inhabitants through education, grassroots organizing, and nonviolent direct action. The network has played a key role in strengthening the worldwide rainforest conservation movement by supporting activists in rainforest countries, as well as organizing and mobilizing consumers and community action groups throughout the United States. www.ran.org

SIA RUNIKUI KASHINAWA

BRAZIL 1993 AGE 29

CHAMPIONING THE RIGHTS OF INDIGENOUS PEOPLE

THE HISTORY OF THE AMAZON BASIN HAS LARGELY BEEN ONE OF THE EXPLOITATION OF RICH NATURAL RESOURCES. IN THE EARLY TWENTIETH CENTURY, A GROUP OF OPPORTUNISTS ARRIVED ON THE WESTERN RIM OF THE BRAZILIAN AMAZON, INTENT ON TAPPING INTO THE LUCRATIVE RUBBER TRADE. THEY DECIDED TO HARVEST THE INDIGENOUS PEOPLE AS WELL, AS SLAVES TO COLLECT THE RUBBER. LATER THE RUBBER BARONS BEGAN TO MASSACRE THE INDIGENOUS PEOPLE, WITH INCREASING INTENSITY, TO ENSURE ACCESS TO RUBBER RESOURCES. ENTIRE VILLAGES WERE SET ON FIRE. THROUGH INTIMIDATION AND DEATH, THE INDIGENOUS PEOPLE WERE DRIVEN OFF THE LAND.

Since childhood, Sia Kashinawa had labored to preserve the cultural integrity and economic viability of the Kashinawa and other indigenous people of Brazil's rainforests. At the tender age of eight, he worked in the first tribal cooperative to break the commercial monopoly of the rubber barons, who continued to exploit and slaughter the indigenous. The cooperative's success forced the rubber barons to abandon the area.

When elected as the youngest member of his tribal council, at age thirteen, Sia led his people's struggle to obtain title to their land, establishing the Jordan River reservation. Sia then traveled around the Amazon to promote the creation of similar cooperatives, a key step to establishing a tribe's economic rights and cultural survival. Sia understood that the indigenous people and the rubber tappers, historically mortal ene-mies, in fact shared a common interest in achieving economic independence. In 1987, he co-founded the Alliance of the Peoples of the Forest, the first organization aimed at achieving cooperation between the two groups. Sia received several death threats for his work; in 1988, ranchers killed his fellow leader and friend, Chico Mendes.

Indigenous people have continued to be killed in the struggle for Brazil's natural resources. The year he won the Reebok Human Rights Award, Sia spoke out to condemn the deaths of dozens of Yanomami tribe members who were massacred by illegal gold miners. Sia built the headquarters of the Kashinawa Association with the funds he received from the Award, and he became coordinator of the Indigenous People's Movement of the Jurua Valley. Since then, he has run for public office in order to better represent the rights of his people.

ON A MISSION TO PRESERVE THE DIGNITY AND CULTURE OF NATIVE AMERICANS

INDIGENOUS PEOPLES' RIGHTS

The White Earth Land Recovery Project works to facilitate recovery of the original land base of the White Earth Indian Reservation; to preserve and restore traditional practices of sound land stewardship, language fluency, and community development; and to strengthen the White Earth Indian's spiritual and cultural heritage. www.welrp.org

The Indian Law Resource Center aims to meet the needs of indigenous peoples who are struggling to overcome the devastating problems that threaten native peoples. Through their program work, the center seeks to advance the rule of law by establishing national and international legal standards that preserve indigenous human rights and dignity. The center also challenges the governments of the world to hold all human beings in equal esteem. www.indianlaw.org

WINONA LADUKE

UNITED STATES 1988 AGE 29

RECLAIMING THE LAND FOR NATIVE AMERICANS

WINONA LADUKE IS A CHIPPEWA INDIAN WHO WAS BORN IN EAST LOS ANGELES, GREW UP IN SOUTH-ERN OREGON, ATTENDED COLLEGE IN MASSACHUSETTS, AND AT AN EARLY AGE BECAME ACTIVE IN A NUMBER OF ENVIRONMENTAL CAUSES IN THE AMERICAN WEST AND SOUTHERN CANADA. BUT IN 1982, SHE MOVED TO THE HOME OF HER ANCESTORS—THE WHITE EARTH RESERVATION IN MINNESOTA. THERE, SHE EMBARKED ON A MISSION TO PRESERVE THE DIGNITY AND CULTURE OF NATIVE AMERICANS AND TO RECLAIM THE LAND THAT HAD BELONGED TO HER PEOPLE FOR HUNDREDS OF YEARS.

One of the most tragic and deplorable human rights abuses in the United States has been the shameful treatment of Native Americans. Over the past three centuries, they have suffered forced removal from their tribal lands, genocide, broken treaties, and enforced poverty. The White Earth Reservation, located in northwestern Minnesota, is the largest reservation in the state. But in the 1980s less than 10 percent of the land was actually owned by Indians. Many of them were forced to leave the reservation because there was no economically viable way to survive.

When Congress passed a bill that thwarted Indian efforts to recover land on the reservation that had been illegally taken away, Winona organized a grassroots campaign to get the voices of Native Americans heard in the U.S. Congress. A graduate of Harvard University, she helped found Anishinabe Akeeng (The People's Land), an organization of Chippewa Indians who are heirs to the land of the White Earth Reservation. In addition to filing a lawsuit and challenging the constitutionality of the bill, Winona sought other means to recover reservation lands, including attaining private funding to buy back land and lobbying the federal government to transfer land under its jurisdiction to the ownership and control of indigenous peoples. Her efforts with Anishinabe Akeeng led to the regaining of one thousand acres, and she successfully achieved an electoral redistricting that garnered political strength for residents of the reservation.

Winona and Anishinabe also helped found IKWE, a Native American women's community economic development project. Winona helped create the Indigenous Women's Network, which worked with local groups on advocacy and the promotion of positive values and self-image for Native American women. She also established an organic raspberry farm to help provide economic self-sufficiency and developed programs in language immersion to help ensure the preservation of the Native American culture. Winona's work has garnered her the status traditionally reserved for Native American tribal elders.

In 2000, Winona ran for vice president of the United States on the Green Party ticket. She has published several books, essays, and editorials, and is currently the program director for the Honor the Earth Fund.

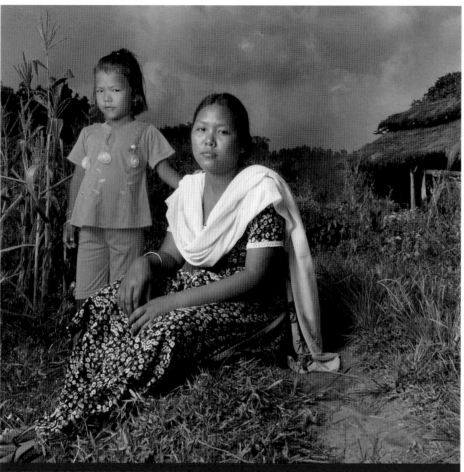

"I WANT TO BELIEVE THAT SOME DAY OUR VOICES WILL BE HEARD AND PEOPLE WILL TAKE NOTICE OF OUR PLIGHT."

GET INVOLVED

SLAVERY AND TRAFFICKING IN PERSONS

The Rescue Foundation, Mumbai seeks to identify and work with victims of trafficking from the brothels of Mumbai, India, and help them to secure their freedom. The Rescue Foundation works to reunite these young women and girls with their families when possible, and to provide assistance to enable them to lead lives of dignity. For more information on trafficking of women and girls from Nepal, visit: www.forefrontleaders.org

The Global Alliance Against Traffic in Women (GAATW), a movement of members consisting of both organizations and individuals worldwide, coordinates, organizes, and facilitates work on issues related to trafficking in persons and the women's labor migration worldwide. GAATW's aim is to ensure that the human rights of trafficked people are respected and protected by authorities and agencies. www.inet.co.th/org/gaatw

MAILI LAMA

NEPAL 2002 AGE 25

RESCUER OF SEX TRAFFICKING VICTIMS

IN 1996, MAILI LAMA LIVED IN A TINY VILLAGE IN NEPAL. ONE DAY HER INFANT DAUGHTER BECAME VERY ILL. HER HUSBAND WAS AWAY AT WORK, AND A FRIEND OFFERED TO TAKE HER TO A DOCTOR IN KATHMANDU. ON THE WAY, HE DRUGGED HER AND SOLD HER TO A SEX TRAFFICKER, WHO THEN SOLD HER TO A BROTHEL IN MUMBAI (BOMBAY), INDIA. AFTER ARRIVING AT THE BROTHEL HER DAUGHTER WAS TAKEN AWAY FROM HER. SHE WAS BEATEN, GANG-RAPED, AND GIVEN A CHOICE: FORCED PROSTITUTION OR DEATH TO HER DAUGHTER. SHE SPENT MORE THAN TWO YEARS LIVING IN WRETCHED CONDITIONS, SERVICING UP TO TWENTY MEN A DAY WHILE HER DAUGHTER WAS HELD HOSTAGE.

Sadly, Maili's story is not unique. Each year, thousands of girls—some as young as seven years old—are tricked or abducted in similar ways by sex traffickers and end up in Kamatipura, the world's largest red light district. There they are tortured into submission and quickly learn that any attempt to escape results in beatings and even death. Human Rights Watch estimates that more than 100,000 victims of forced prostitution live in Mumbai.

In August 1998, Maili and her daughter were rescued by the Nepali nongovernmental organization Maiti Nepal (Mother's House). Most young women who manage to get out are so traumatized they can barely function, but Maili made a remarkable transformation from victim to survivor to activist. When Maiti Nepal set up a rescue operation in Mumbai, she volunteered to go back to help free other girls. Most rescued girls are shunned by their families and villages, but Maili's husband and family not only welcomed her home, they supported her in her efforts to rescue other girls. With her daughter safely at home

with her mother, Maili splits her time between rescuing girls in Mumbai and caring for her child.

Maili's husband works with her to gather information and to document brothels housing Nepali girls. Maili has even entered the brothels under the guise of passing out condoms to try and reach out to these young girls, whose experiences have taught them to trust no one. She is able to gain their trust because she was once one of them. So far she has helped more than a hundred girls escape. Because of these activities, Maili and Maiti Nepal have received numerous death threats.

Once the girls have been rescued, Maili counsels them and helps them regain their self-esteem and dignity. She also helps them press charges against the perpetrators. Even though the number of victims is staggering and the personal danger ever present, Maili has dedicated her life to saving one girl at a time and bringing an end to this human rights atrocity.

Today, Maili works with the Rescue Foundation in Mumbai and continues to rescue and help victims of sex trafficking.

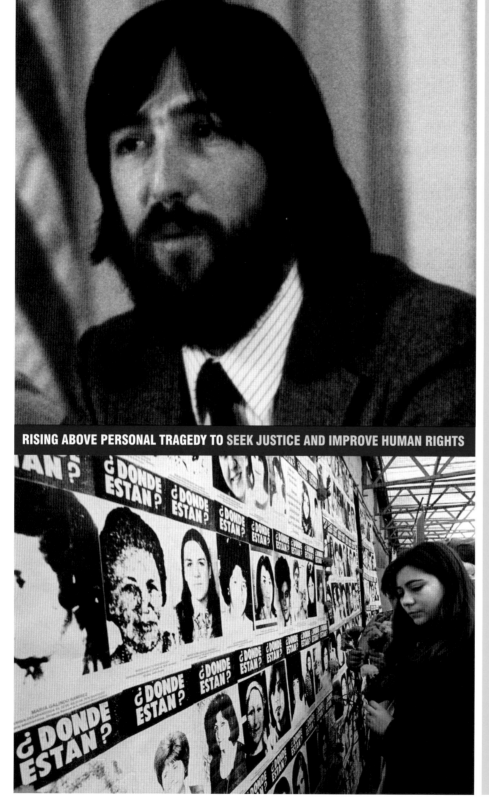

RISING ABOVE PERSONAL TRAGEDY TO **SEEK JUSTICE AND IMPROVE HUMAN RIGHTS**

GET INVOLVED

TORTURE AND DISAPPEARANCES

The Inter-American Commission on Human Rights (IACHR) is one of two bodies in the Inter-American System that focuses on the promotion and protection of human rights. The IACHR conducts onsite visits to observe the general human rights status of different countries and to investigate specific situations. It is expressly authorized to examine complaints and petitions about specific cases of human rights violations.
www.cidh.oas.org

The Americas Program of Human Rights Watch has published several reports and articles on the human rights situation in Chile:
www.hrw.org/americas/chile.php
www.hrw.org/reports/world/chile-pubs.php

JUAN PABLO LETELIER

CHILE 1988 AGE 26

ADVOCATE FOR HUMAN RIGHTS IN CHILE

JUAN PABLO LETELIER WAS FIFTEEN YEARS OLD IN 1976 WHEN A CAR BOMB EXPLODED IN WASHINGTON, DC. AMONG THOSE KILLED WERE HIS FATHER, ORLANDO LETELIER, A FORMER MINISTER IN ALLENDE'S GOVERNMENT IN CHILE, AND A YOUNG AMERICAN, RONNIE KARPEN MOFFIT. IT WAS LATER LEARNED THAT THE BOMB WAS PLANTED BY A CHILEAN HIT SQUAD UNDER ORDERS FROM PINOCHET TO KILL JUAN PABLO'S FATHER. BUT RATHER THAN TURN TO REVENGE, JUAN PABLO CHOSE TO DEDICATE HIS LIFE TO SEEKING JUSTICE AND IMPROVING HUMAN RIGHTS.

In 1973, General Augusto Pinochet led a military coup that overthrew the democratically elected government of Salvador Allende Gossens. As president, Pinochet reversed the policies of Allende, who had begun a peaceful transition to socialism. Although Pinochet's economic policies met with some approval internationally, his political practices did not. He disbanded the Congress and banned political parties and labor unions. He stifled opposition by using force and torture. And during his regime, thousands of Chileans were murdered or "disappeared," and many others were tortured.

As a student at Georgetown University, Juan Pablo volunteered for both the Working Group for Peace and Non-violence and the Human Rights Project in Washington, DC. Upon graduation, he enrolled in the Centro de Investigaciones y Docencias Economicas (Center for Economic Studies and Investigations) in Mexico City to study how he could best serve people mired in underdevelopment. His participation in "Casa Chile," the gathering place and center of activity for Chilean exiles in Mexico, led him to conclude that he could help improve the deteriorating Chilean situation.

In 1983, Juan Pablo returned to Chile and began working with the Youth Commission on Human Rights. During this period, social unrest and protests against Pinochet's regime were intense. Juan Pablo organized clearinghouses for information on human rights violations and medical support groups that provided emergency aid to people injured during protests. In 1984, he was one of the principal organizers of the Segundas Jornadas de los Derechos Juveniles (Second Conference on Juvenile Rights). A year later he was elected president of the Chilean National Preparatory Committee of the XII World Youth Festival. Under his direction, the festival addressed human rights in Chile, particularly the violence perpetrated on Chilean youth. And when the Latin American Institute for Transnational Studies created the Commission for Peace and appointed Juan Pablo director of analysis and research, he proposed solutions to reverse military control of Chilean life.

Juan Pablo's denunciation of the military government for the murder of his father and Ronnie Karpen Moffit, however, and his pursuit of legal action in Chilean courts, resulted in government persecution. He was imprisoned three times, his home was ransacked, and he received numerous death threats.

Today, Juan Pablo still resides in Chile. He is a leader in the Socialist Party and remains active in a number of human rights issues.

"DURING THE 1989 STUDENT DEMONSTRATIONS IN CHINA, I TASTED THE DREAM OF FREEDOM. I ONLY GLIMPSED IT, BUT WHAT I SAW WAS SO BEAUTIFUL AND SO POWERFUL THAT IT WON'T EASILY LEAVE MY MIND AND MY HEART."—LI LU

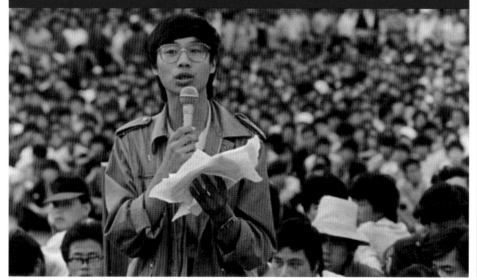

GET INVOLVED

FREEDOM OF EXPRESSION

Human Rights in China (HRIC) is composed of an international group of Chinese scientists and scholars who work to promote universally recognized human rights and advance the institutional protection of these rights in China. HRIC believes human rights are universal and indivisible, and it seeks to protect all rights recognized by international human rights instruments, including political, civil, economic, social, and cultural rights. iso.hrichina.org/iso

For more information on the human rights situation in China, visit: www.hrw.org/asia/china.php

LI LU, WANG DAN, CHAI LING, AND WU'ER KAIXI

CHINA 1989 AGES 23, 21, 23, AND 24, RESPECTIVELY

RISKING THEIR LIVES FOR A FREE SOCIETY

THE SHOT WAS SEEN AROUND THE WORLD: A LONE, UNARMED MAN, HIS SHOULDERS SLIGHTLY BOWED BUT HIS BACK STRONG, FACING DOWN A COLUMN OF TANKS RUMBLING TOWARD TIANANMEN SQUARE. IT WAS JUNE 5, 1989, LESS THAN TWO DAYS AFTER THE CHINESE GOVERNMENT, BENT ON CRUSHING A STUDENT-LED PROTEST FOR DEMOCRATIC REFORM, HAD SHOT DOWN THOUSANDS OF PEACEFUL DEMONSTRATORS, SPRAYING THE ANCIENT COURTYARD WITH BLOOD.

The protests had begun two months earlier, when a handful of student leaders lit the flame of democracy, rallying workers, journalists, and intellectuals to join them in peaceful protests and a massive hunger strike. Among them were student leaders Li Lu, Wang Dan, Chai Ling, and Wu'er Kaixi.

As leader of the weeklong hunger strike and the official press spokesman for the pro-democracy movement, Li Lu excelled at unifying vast crowds of students. During the final hours of the Tiananmen Square massacre, he and other leaders led the last 3,000 survivors out of the Square. After escaping from China, Li Lu traveled widely on behalf of the democratic movement in China and co-founded the China Human Rights Fund, based in New York. He continues to support efforts to promote human rights and democracy in China.

Wang Dan, noted for linking prominent Chinese intellectuals with the student movement and delivering inspiring speeches to the hunger strikers, has been called "the brains" behind the pro-democracy movement. He was arrested in July 1989 and two years later was charged with engaging in "counter-revolutionary activities." He was released from prison in 1993, but was arrested again two years later. After being held without charge for seventeen months, he was charged with conspiracy to overthrow the government and sentenced to eleven years in prison.

In 1998, he was released from prison for medical reasons. Now enrolled in graduate studies at Harvard University, he remains actively involved in the movement for democracy and human rights in China.

Chai Ling, one of the few female leaders of the student movement, initiated and organized the student hunger strike in Tiananmen Square, which grew to more than 3,000 people and inspired millions of others throughout China to march in support of democracy and human rights. Chai Ling played a major role in comforting the students and mobilizing them to maintain their stance for peace. She is now president of China Dialogue, a nonprofit organization in Washington, DC, that works to bring about political and social change for a democratic China through communication and education.

Wu'er Kaixi, a principal leader in the student movement, is best known for his role in a televised meeting between students and government officials, during which he continually criticized hard-line Prime Minister Li Peng. Wu'er Kaixi's natural ability to mobilize the students became apparent during the Tiananmen Square demonstrations and the hunger strike. After escaping from China, Wu'er Kaixi helped establish The Democratic Front in Paris to keep working for democracy in China from abroad. He now lives in Taiwan, where he continues his work with the Democracy for China Fund.

"THIS SAD REALITY OF MY FAMILY'S SUFFERING MADE ME MORE CONSCIOUS OF JUSTICE FOR THOSE IN NEED."

REFUGEES AND ASYLUM SEEKERS

United States Committee for Refugees (USCR) was founded in 1958 to coordinate the United States' participation in the United Nations' International Refugee Year (1959). In the forty years since, USCR has worked for refugee protection and assistance in all regions of the world. www.refugees.org

The Center for Justice and Accountability (CJA) works to deter torture and other severe human rights abuses around the world by helping survivors hold the perpetrators accountable. CJA is the leading center in the United States that represents survivors in civil suits against perpetrators who live in or visit the United States. CJA is pioneering an integrated approach to the quest for justice that combines legal representation with referrals for needed medical and psychosocial services, and outreach to schools, community organizations, and the general public. www.cja.org

MIRTALA LOPEZ

EL SALVADOR 1991 AGE 22

SEEKING JUSTICE FOR DISPLACED VICTIMS OF REPRESSION

MIRTALA LOPEZ WAS ONE OF FOURTEEN CHILDREN IN A PEASANT FAMILY OF FARMERS. SHE HAD NO FORMAL EDUCATION AND WORKED PRIMARILY IN THE FIELDS. HER LIFE WAS FOREVER TRANSFORMED WHEN HER FATHER AND THOUSANDS OF OTHERS FORMED A FARM WORKERS UNION, WHICH LED TO REPRESSION AND MASSACRES THROUGHOUT THE REGION. DURING ONE RAMPAGE, HER FATHER WAS KILLED AND TWO OF HER BROTHERS WERE HANGED FROM A TREE. MIRTALA FLED TO THE MOUNTAINS, LEARNED TO READ AND WRITE, AND AT AGE FIFTEEN BECAME A LEADER IN THE FIGHT FOR HUMAN RIGHTS IN EL SALVADOR.

The Salvadoran military's "de-population campaign" in the 1980s displaced thousands of El Salvadorans from their homes. Fleeing bombings and massacres, many people sought refuge both in their own country and in neighboring countries such as Honduras. Refugees and displaced persons were often subjected to harsh living conditions and denied basic human rights. Mirtala, one of El Salvador's internal refugees, helped form the Christian Committee of the Displaced of El Salvador (CRIPDES) to work for the rights of displaced persons.

As secretary of human rights and legal affairs of CRIPDES, Mirtala was instrumental in assisting Salvadoran refugees by repatriating them, promoting their rights, and focusing public attention on their situation. Mirtala developed the legal and human rights department of CRIPDES initially to provide documentation for people whose identity papers had been destroyed during the war, as well as for those fleeing conflict who had been born in the mountains and had no birth records.

Mirtala also played a leading role in the CRIPDES effort to repatriate 4,500 refugees from Honduras back to El Salvador. As a result, she was interrogated and tortured by the Salvadoran National Guard. When she refused to sign a false police statement, she was imprisoned for months, along with sixty-four others from CRIPDES. While in prison, she became ill and almost died.

Despite repeated arrests, torture, and imprisonment, Mirtala never wavered in her dedication to serving the displaced. She was motivated, she said, by the murders of her father and seven brothers and sisters who simply wanted to live on the land with dignity.

Mirtala is currently working to promote the rights of both underserved youth and the aged. She is also a delegate and major leader of the Farabundo Martí para la Liberación Nacional, the political party with the most seats in the Salvadoran National Assembly.

"LONG AGO WE WERE HAPPY. THINGS WERE GOOD—OUR FISH WERE CLEAN, OUR FOOD WAS PURE, OUR WAY OF LIFE IN THE FOREST WAS GOOD. NOW OUR LAND IS BEING DESTROYED. THERE IS NOT ENOUGH TO EAT; MANY PEOPLE WILL DIE SOON."

GET INVOLVED

INDIGENOUS PEOPLES' RIGHTS

The Borneo Project assists Borneo's indigenous peoples in their struggle to regain control of their ancestral lands. Their many initiatives are built on a foundation of direct personal contact, local control, and long term commitment.
www.earthisland.org/borneo

Rainforest Action Network works to protect the earth's rainforests and support the rights of their inhabitants through education, grassroots organizing, and nonviolent direct action. The network has played a key role in strengthening the worldwide rainforest conservation movement by supporting activists in rainforest countries, as well as organizing and mobilizing consumers and community action groups throughout the United States.
www.ran.org

DAWAT LUPUNG

MALAYSIA 1989 AGE 25

STANDING UP FOR CULTURAL AND ENVIRONMENTAL PRESERVATION

THE JUNGLES OF BORNEO HAVE CHANGED LITTLE SINCE THE TIME OF THE DINOSAURS. NOWHERE ON THE EARTH IS THERE AN OLDER ECOSYSTEM; NOWHERE IS THERE ONE THAT IS SO COMPLEX. AND NOWHERE IN THE WORLD WERE THE FORESTS BEING DESTROYED AT SUCH A FEROCIOUS RATE AS IN THE MALAYSIAN STATE OF NORTHERN BORNEO. DAWAT LUPUNG, A YOUNG PENAN NATIVE, RISKED HIS LIFE TO PRESERVE HIS PEOPLE'S NATIVE LANDS FROM DEFORESTATION BY MALAYSIAN LOGGING COMPANIES. HE COURAGEOUSLY STOOD WITH OTHERS TO CREATE A HUMAN BARRICADE ON A LOGGING ROAD THAT SURROUNDED THEIR FOREST HOME.

In the mid-1980s, Malaysian logging provided 58 percent of all tropical log exports on the world market. The earth's oldest and richest ecosystem was being destroyed, along with the only people who had a thorough knowledge of it. What was taking place was a massacre—a biological and cultural massacre affecting the entire global ecosystem. Despite the fact that the native Penan are a nomadic people who depend on the natural resources of the Borneo Rainforest, the Malaysian government permitted the indiscriminate logging of its forests for export. It was one of the only nations that did not pass protective legislation and it openly encouraged the logging industry. Dawat Lupung became a leader among his tribe in the effort to preserve the rights of the Penan people and their native lands.

The Penan's struggle was nonviolent and consisted primarily of blockading logging roads. These logging roads surrounded their traditional hunting areas, and food supplies diminished rapidly. Dawat Lupung thoroughly understood the intricate life-systems of his rainforest homeland and became a leader in the Penan's struggle. He was arrested three times for participating in human blockades of logging roads that surrounded traditional hunting areas where food supplies were being destroyed.

During his imprisonment, and despite the beatings and ill treatment he received, Dawat continued to lobby for a reserved area of land for his people. Dawat and his work on behalf of the Penan people was the subject of a book by the Endangered People's Project entitled *Dawat: A Voice from the Borneo Rainforest.*

GET INVOLVED

DISCRIMINATION AND RACISM

The National Coalition for the Homeless promotes housing justice, economic justice, health care justice, and civil rights through grassroots organizing, public education, policy advocacy, technical assistance, and partnership formation.
www.nationalhomeless.org

The National Association for the Advancement of Colored People (NAACP) has as its primary focus the protection and enhancement of the civil rights of African Americans and other people of color.
www.naacp.org/index.shtml

"ALL TOO OFTEN, WE HERE IN THE UNITED STATES FIND IT TOO EASY TO POINT THE SELF-RIGHTEOUS FINGER AT HUMAN RIGHTS ABUSES IN FOREIGN COUNTRIES, WHILE IGNORING THE INJUSTICES IN OUR OWN BACKYARDS."

TRACYE MATTHEWS

UNITED STATES 1990 AGE 24

DEFENDING THE RIGHTS OF THE POOR

MANY POOR MINORITIES IN THIS COUNTRY ARE FORCED TO LIVE IN PUBLIC HOUSING THAT IS OFTEN SUBSTANDARD AND UNSAFE. HAMPERED BY UNEMPLOYMENT, A LACK OF EDUCATION AND HEALTH CARE, POVERTY, DRUG DEPENDENCY, AND RACISM, THEY SEE LITTLE HOPE FOR A BETTER FUTURE. IN ADDITION TO LIVING DAY TO DAY IN DEPLORABLE CONDITIONS, MANY TENANTS HAVE HAD THEIR HOUSING UNITS SEIZED BY FEDERAL AUTHORITIES AND HAVE BEEN EVICTED WITHOUT DUE PROCESS. TRACYE MATTHEWS, A TWENTY-FOUR-YEAR-OLD GRADUATE STUDENT AT THE UNIVERSITY OF MICHIGAN, SOUGHT TO IMPROVE THE LIVING AND WORKING CONDITIONS OF THE POOR AND TO EMPOWER THEM TO STAND UP FOR THEIR RIGHTS.

A native of Detroit, Tracye is an activist working to combat racial discrimination, inadequate housing and education, homelessness, and poverty. Tracye has a strong belief that access to safe and decent housing is a fundamental human right. Much of her work centered on the UNITY Tenants Organization in Ann Arbor, Michigan, an organization of public housing tenants comprised largely of poor black women. UNITY brought the public's attention to the harsh and often substandard conditions these women lived in, and helped empower them through education and emotional support. Tracye mobilized campus and community support against federal seizure of local public housing units and organized resources to support families who had been evicted without due process. She also served as a mentor to teenage children of UNITY members.

As a student at the University of Michigan, Tracye helped develop strategies to combat racist attacks on campus and to raise awareness of the needs of students of color. She served on the steering committee of the United Coalition Against Racism (UCAR). As a result of her work with UCAR, Tracye helped found the Ella Baker–Nelson Mandela Center for Anti-Racist Education on campus. The center offered tutoring and educational and cultural activities for students. As its first full-time coordinator, Tracye also made the center's resources accessible to people of color and low-income people in the local community.

Additionally, Tracye was involved with organizations in solidarity with struggles of people of color internationally. She was a member of a Michigan Student Assembly–Palestine Solidarity Committee fact-finding delegation to the occupied West Bank, Gaza Strip, and Israel.

Today, Tracye remains committed to the culture and concerns of the African American working class and to improving the living conditions of disadvantaged people.

"EVERY DAY THERE ARE KILLINGS, AND VILLAGES ARE BURNED AND DESTROYED. AND I BELIEVE THAT IF THE WORLD KNEW THE DIMENSIONS OF THE TRAGEDY IN KURDISTAN, THEY WOULD MOURN A LONG, LONG TIME FOR US."

GET INVOLVED

REFUGEES AND ASYLUM SEEKERS

The Kurdish Human Rights Project is committed to the protection of the human rights of all persons within the Kurdish regions of Iran, Iraq, Syria, Turkey, and the former regions of the Soviet Union, regardless of race, religion, sex, political persuasion, beliefs, or opinions. Its supporters include both Kurdish and non-Kurdish people. www.khrp.org

The American Kurdish Information Network (AKIN) seeks to provide timely and relevant information about the situation of the Kurds. AKIN does this by monitoring events that are taking place in the Kurdish regions of Turkey, Iran, Iraq, and Syria, and by providing the American public with access to materials on the subject. www.kurdistan.org

AKRAM MAYI

IRAQ 1990 AGE 28

DEFENDING THE RIGHTS OF REFUGEES

BETWEEN 1987 AND 1988, THOUSANDS OF KURDISH CIVILIANS WERE KILLED WHEN IRAQI SOLDIERS INVADED AND BOMBED THEIR VILLAGES AND TURNED CHEMICAL WEAPONS AGAINST THEM. THE ATTACKS WERE PART OF SADDAM HUSSEIN'S LONG-STANDING CAMPAIGN THAT DESTROYED ALMOST EVERY KURDISH VILLAGE IN IRAQ AND DISPLACED AT LEAST A MILLION OF THE COUNTRY'S ESTIMATED THREE AND A HALF MILLION KURDS. THOUSANDS MANAGED TO ESCAPE AND SOUGHT REFUGE IN TURKEY. AKRAM MAYI WAS ONE OF THEM. ONCE THERE, HOWEVER, A NEW NIGHTMARE BEGAN.

The Kurds who made it into Turkey did not have official refugee status because the Turkish government signed the United Nations Refugee Convention with the stipulation that Turkey would not recognize non-Europeans as refugees. Consequently, the Kurds had no rights, and no international agencies at the time were able to secure permission from the Turkish government to provide aid and protection for them.

Thousands of Iraqi Kurd refugees were forced into overcrowded makeshift camps that the Turkish military ran like prisons. Surrounded by barbed wire, the refugees were only allowed out in small groups for short periods of time. Mass poisonings and beatings were widely reported. The lack of medical supplies, water, and electricity caused hundreds of men, women, and children to die of cold, hunger, malnutrition, and communicable diseases.

Akram Mayi became the council leader for the Divarbakir refugee camp, as well as a spokesperson for two other such camps in Mardin and Mus. At great personal risk, he sought to protect the welfare and lives of his displaced people. He took the Kurds' case to both Turkish officials and to the international community, including the press, human rights agencies, voluntary organizations, and the United Nations High Commission on Refugees. His mission was not only to improve the conditions in the camps, but also to spotlight the human rights violations against Kurdish people. His efforts made a significant difference in bringing international recognition and understanding of the Kurds' plight.

Akram lived in exile in Lausanne, Switzerland, for several years, where he lobbied the government about the rights of Kurdish refugees and provided assistance to Kurdish families seeking asylum in Switzerland. In 2002, he returned to Iraqi Kurdistan to explore the formation of a new human rights organization there.

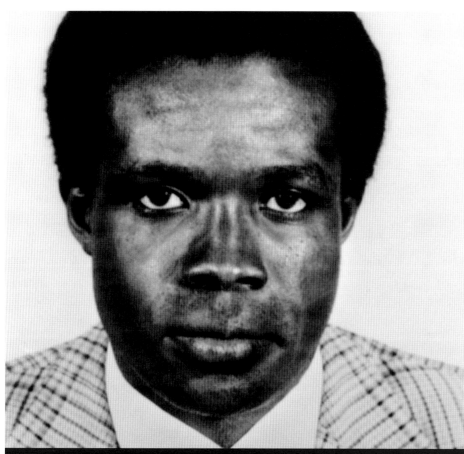

"IF ALL THE ACTS OF PERSECUTION AND HARASSMENT AGAINST ME WERE DESIGNED TO RENDER ME HOPELESS AND HELPLESS, THE GOVERNMENT MUST REALIZE THAT IT HAS, TO THE CONTRARY, EMBOLDENED ME."

GET INVOLVED

RIGHT TO EDUCATION

The Kenya Human Rights Commission (KHRC) is a nonprofit organization working to protect and promote human rights in Kenya. Through various programmatic approaches and activities, KHRC monitors human rights violations, researches human rights issues, undertakes advocacy interventions, and conducts human rights education activities. KHRC works in partnership with individuals and communities in different parts of Kenya to put into place the building blocks of an active, community-based human rights movement. www.hri.ca/partners/khrc

African Rights is an organization dedicated to working on issues of human rights abuses, conflict, famine, and civil reconstruction in Africa. www.unimondo.org/AfricanRights

SUBA CHURCHILL MESHACK

KENYA 1999 AGE 26

HEROIC CRUSADER FOR HUMAN RIGHTS

AT THE SAME TIME THAT KENYA'S HUMAN RIGHTS RECORD STEADILY DETERIORATED IN THE 1990S, THE STUDENT MOVEMENT OPPOSING GOVERNMENT OPPRESSION HAD GAINED STRENGTH. THE MOVEMENT'S INFLUENCE EXTENDED BEYOND CAMPUSES, AS IT PUSHED FOR CONSTITUTIONAL REFORM TO INCREASE PLURALISM AND CREATE A MULTIPARTY CIVIL SOCIETY. THE GOVERNMENT, RECOGNIZING THIS THREAT, REGULARLY CHARGED, DETAINED, ARRESTED, AND EVEN EXECUTED STUDENT ACTIVISTS.

A young veterinary student could not remain passive. An activist since high school, Suba Churchill Meshack co-founded and then chaired the Kenya University Student Organization (KUSO), an unregistered national student union seeking to broaden student representation in Kenya's universities. Because of his work to expose corruption and human rights abuses, Suba was arrested eight times, tortured, and expelled from his university. During one of his incarcerations, his toenails were all pulled off. In 1996, his elderly father died of shock after being wrongly informed that his son had been killed in prison. That same year, Suba became the subject of an Amnesty International campaign that sought to bring charges against his torturers.

As Kenya's most prominent student leader, Suba addressed both the student rights and constitutional reform issues pressing his country. He served as youth representative and chair of the Implementation Commission of the National Convention Executive Council (NCEC), an influential coalition of nongovernmental organizations seeking to achieve constitutional reform. Under NCEC's auspices, Suba organized a national workshop on constitutional reform. The workshop not only united youth to discuss and advocate change, but it also led to the government's agreement to convene a parliamentary group focused on constitutional overhaul. Other reforms that resulted from NCEC's work included the reallocation of national radio airtime, which had been 90 percent presidential, so that it was divided equally among opposition parties.

Suba also founded the National Youth Convention, a branch of the National Youth Movement of Kenya, which focused on protecting students' rights and preparing youth for democratic leadership. In addition, he became a founding member of the Kenyan chapter of the Youth Federation for the Release of Political Prisoners, a pressure group that works to secure the release of arbitrarily detained prisoners nationwide.

Using funds he received with his Reebok Human Rights Award, Suba established the Education Rights Forum to reframe education as a rights issue, to work in communities to learn about the challenges facing schools and families on education issues, and to lobby the government to improve the education system in Kenya.

"THIS AWARD WILL STRENGTHEN AND INVIGORATE ALL IN CUBA WHO STRUGGLE FOR FREEDOM."

GET INVOLVED

FREEDOM OF EXPRESSION

Oxfam America's Cuba Program was established in response to the economic crisis facing Cuba after the fall of the Soviet Union. The program is aimed at easing the food crisis and helping community groups learn to solve problems themselves. Oxfam is the only U.S. nongovernmental organization actively involved in community development and advocacy for normalized relations between the U.S. and Cuban governments.
www.oxfamamerica.org

For more information on the human rights situation inside Cuba, visit:
www.hrw.org/reports/world/cuba-pubs.php

www.hrw.org/americas/cuba.php

DAVID MOYA

CUBA 1990 AGE 24

A TENACIOUS CRUSADER FOR FREEDOM

IN APRIL 1989, A GROUP OF HUMAN RIGHTS ACTIVISTS ATTEMPTED TO ORGANIZE A PEACEFUL PRO-DEMOCRACY DEMONSTRATION DURING MIKHAIL GORBACHEV'S VISIT TO CUBA. THEY WERE MEMBERS OF THE PARTIDO PRO DERECHOS HUMANOS DE CUBA (THE PARTY FOR HUMAN RIGHTS IN CUBA). THEY WANTED TO SHOW SUPPORT FOR LIBERALIZATION IN THE SOVIET UNION AND TO PROTEST THE SOVIET'S FINANCING OF THE CUBAN GOVERNMENT'S "REPRESSIVE APPARATUS." THEIR LEADER, DAVID MOYA, WAS ARRESTED AND THROWN INTO PRISON. EVEN THOUGH HE KNEW HE WOULD LIKELY BE ARRESTED, HE CHOSE TO FOLLOW HIS CONSCIENCE AND TO SPEAK OUT FOR DEMOCRATIC VALUES AND RESPECT FOR THE DIGNITY OF HIS FELLOW CUBANS.

Located ninety miles southeast of Florida, Cuba has lived under the repressive communist regime of Fidel Castro since 1959. His totalitarian government has systematically violated a number of articles in the United Nations Universal Declaration of Human Rights and severely restricted the lives of Cuban citizens. In Castro's Cuba, political opposition is not allowed. There is no freedom of speech, no freedom of association or assembly, and no freedom of the press. The government also prohibits its citizens from freely leaving the country. Activists who speak out for their rights are routinely harassed, arrested, and imprisoned.

By the time he was twenty-five years old, David had spent seven years in prison for speaking out for human rights. He was first arrested at age sixteen when he attempted to leave Cuba. His four-year sentence was extended by one year because he refused to cooperate with jailers. Following his release, he was arrested again for printing and distributing an illegal publication calling for an end to political repression in Cuba, and attempting to see a delegation from the United

Nations Commission on Human Rights visiting Cuba. For the Gorbachev demonstration, he was arrested and charged with illegal association. He was not permitted to retain a lawyer, nor did the court appoint one for him. Cuban law says that defense attorneys are "not indispensable" in the People's Courts. He was sentenced to nine months. While imprisoned, he was sentenced to an additional twelve months for "contempt"—allegedly for inciting fellow prisoners to disobedience. Reportedly, the motive for his extended sentence was because he had attempted to gain support among the prisoners for the Party for Human Rights in Cuba.

David was released from prison in 1990, the year he was honored with the Reebok Human Rights Award. The Cuban government would not let him leave the country to receive the Award, however. Finally, in 1991, he was forced to flee Cuba for the United States. Reebok presented him with the Award at the 1991 ceremony. Exiled in Miami, David continues to work for human rights and democracy in Cuba.

"WE CALL UPON THE AMERICAN PEOPLE TO PUT PRESSURE ON THE EGYPTIAN AUTHORITIES TO LEGALIZE ALL HUMAN RIGHTS GROUPS AND TO IMPROVE THE STATUS OF HUMAN RIGHTS IN OUR COUNTRY."

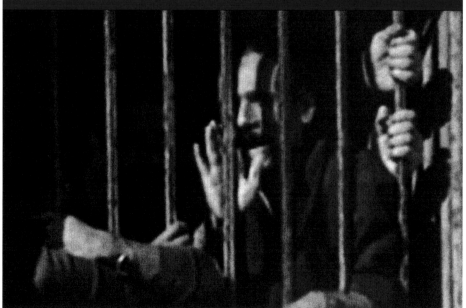

GET INVOLVED

HUMAN RIGHTS MONITORING

Hisham Mubarak Law Center, established in memory of Hisham Mubarak, provides legal assistance to those unjustly imprisoned and undertakes advocacy on political, economic, and social human rights issues in Egypt. For more information, contact the Hisham Mubarak Law Center, 1041 Corniche al-Nil, 6th Floor, Flat 10, al-Malek al-Saleh, 11441 Cairo (fax: +20 2 362 1613; email: chrla@idsc.gov.eg).

The Lawyers Committee for Human Rights has a special initiative focused on human rights defenders in North Africa and the Middle East. www.lchr.org/defenders

HISHAM MUBARAK

EGYPT 1993 AGE 30

COURAGEOUS DEFENDER OF HUMAN RIGHTS

AS GOVERNMENT FORCES BATTLED A GROWING THREAT FROM ISLAMIC EXTREMISTS IN THE EARLY 1990S, THE HUMAN RIGHTS SITUATION IN EGYPT CONTINUED TO DETERIORATE AT AN ALARMING RATE. ARMED MILITANTS WERE KILLING MEMBERS OF THE COPTIC CHRISTIAN MINORITY, FOREIGN TOURISTS, AND POLICE AND SECURITY FORCES. THE EGYPTIAN GOVERNMENT RESPONDED WITH MASS ARBITRARY ARRESTS, TORTURE, DETENTIONS WITHOUT TRIAL, AND MURDERS THAT BORE THE HALLMARK OF EXTRAJUDICIAL EXECUTIONS. FROM MARCH 1992 TO SEPTEMBER 1993, MORE THAN TWO HUNDRED PEOPLE WERE KILLED IN THE UNREST.

At the time, Hisham Mubarak had already begun a career in human rights, beginning when he was an undergraduate law student. In 1989, after receiving his law degree, he had been arrested for providing legal defense to striking steel workers. For the two weeks he was detained, he was tortured and beaten severely, which left him with a permanent hearing loss.

Undaunted, Hisham worked at Amnesty International in London and the Ibn Khaldoun Center in Cairo. In 1991, he became executive director of the Egyptian Organization for Human Rights, an independent organization aimed at protecting the human rights of Egyptians caught in the country's increasingly violent political environment. The political neutrality of Hisham's leadership brought threats and intimidation from both sides of the conflict.

Hisham believed that as long as either side refused to abide by internationally accepted human rights standards, the situation would only worsen. Working an average of twelve hours a day, he interviewed witnesses to abuses and assisted victims who needed legal representation. He authored major reports on prison conditions, torture and mistreatment in police stations, and "disappearances" in Egypt—reports that served as important sources of information for the foreign media.

In 1994, with money from his Reebok Human Rights Award, Hisham established Egypt's first free legal aid clinic to defend political prisoners and other victims of violence. Under his leadership, the Center for Human Rights Legal Aid became one of the most respected and effective human rights organizations in Egypt.

On January 12, 1998, Hisham died suddenly of a heart attack, some claim as a result of the torture he had suffered while imprisoned. He was thirty-five years old. The Hisham Mubarak Law Center for Human Rights was established in his memory.

"THIS IS A PLACE WHERE YOU FEAR FOR YOUR LIFE, WHERE YOU COULD ACTUALLY BE KILLED FOR SPEAKING OUT. I SPEAK FOR THOSE PEOPLE WITHOUT A VOICE."

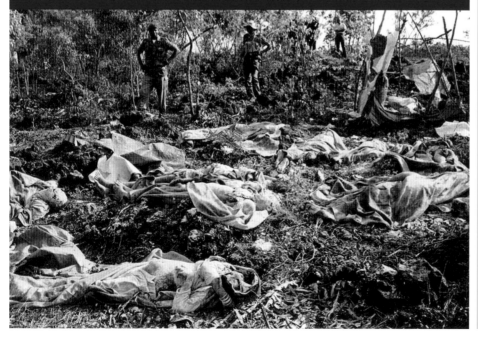

GET INVOLVED

HUMAN RIGHTS MONITORING

Amnesty International's International Justice Campaign aims to bring an end to impunity for the worst crimes known to humanity—genocide, crimes against humanity, war crimes, torture, extrajudicial executions, and disappearances. To achieve this, the organization, together with thousands of nongovernmental organizations and civil society groups worldwide, is lobbying all governments to take steps to establish an international system of justice, complemented by national systems to bring perpetrators to justice. web.amnesty.org/web/web.nsf/pages/int_jus

For more information on the human rights situation in the Democratic Republic of Congo, visit: www.hrw.org/africa/congo.php

CHRISTIAN MUKOSA

DEMOCRATIC REPUBLIC OF CONGO 2003 AGE 28

A COURAGEOUS VOICE AGAINST TYRANNY AND REPRESSION

LATE AT NIGHT, A GROUP OF REBELS WALKED INTO A SMALL VILLAGE OUTSIDE OF BUKAVU IN THE EASTERN PART OF THE DEMOCRATIC REPUBLIC OF CONGO AND SET FIRE TO A SMALL HOUSE. WHEN FAMILY MEMBERS RAN OUT SCREAMING, THE REBELS MASSACRED THEM WITH MACHETES, LEAVING THEIR BODIES STREWN IN FRONT OF THE BURNING HOUSE. A LAWYER AND COURAGEOUS HUMAN RIGHTS MONITOR NAMED CHRISTIAN MUKOSA EXPOSES ATROCITIES LIKE THIS TO THE WORLD AND WORKS TO PROTECT THE RIGHTS OF VICTIMS OF HUMAN RIGHTS ABUSES IN THIS WAR-TORN COUNTRY.

Since 1996, the eastern provinces have been the battleground between Congolese forces and a host of armed rebel groups. The broader war has fueled interethnic strife, resulting in civilian deaths and the punishment of groups for suspected loyalty to rival factions. Forces on all sides of the conflict have been responsible for horrific crimes and human rights violations, including massacres, rape, mass destruction of property, disappearances, and arbitrary detention. Human rights defenders who try to report on the abuses are repeatedly threatened and arrested. Some have been tortured and killed.

Christian grew up in Bukavu, in the heart of the conflict area, and decided to go into law to fight the widespread corruption and abuse that he had witnessed most of his life. After graduating in 1999, he became a lawyer and field investigator for Héretiers de la Justice, an organization dedicated to promoting and protecting human rights.

With little or no compensation, Christian provided legal assistance to more than 120 people a month. Traveling throughout the most dangerous regions, he investigated reports of torture, rape, and killings by meeting with victims and visiting detentions centers. His reports have been distributed to local and international human rights organizations and the United Nations. Christian regularly confronts authorities with direct evidence and pressures them to release those arbitrarily detained. He has helped free more than a hundred prisoners, many of whom were tortured in detention centers. Christian also trains other activists to investigate and report on human rights abuses.

Christian and his colleagues have been arbitrarily detained and threatened on numerous occasions. In one incident, after locating a missing man in a detention center, Christian issued a report stating that the authorities were detaining the man illegally. The authorities sent an agent to Christian's house with orders to "break his legs." Fortunately, Christian's wife knew the agent, and he was able to escape harm. But he had to go into hiding for several days until the situation calmed down.

In 2003, Christian left Héretiers and established the Congolese Institute for Justice and Peace, where he continues to provide legal aid to the poor and to document and report on human rights abuses in one of the world's most dangerous and turbulent settings.

"RWANDA HAS STUPIDLY SHED ITS OWN BLOOD. BROTHER TURNED AGAINST BROTHER, NOT BECAUSE LOVE AND PITY WERE ABSENT, BUT BECAUSE THEY WERE OVERWHELMED BY COWARDICE AND FEAR."

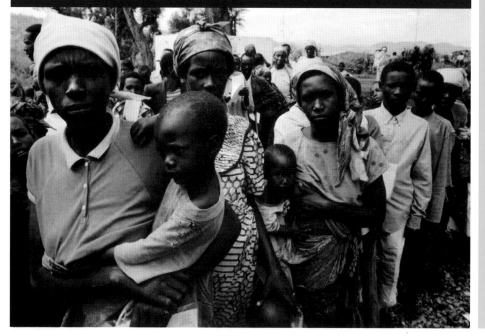

CONFLICT RESOLUTION

Societé Pour La Paix (SOPA) investigates the origins of conflict, the direct and indirect parties involved, the immediate and probable consequences of conflicts, and possible solutions. SOPA seeks to initiate nonviolent communication techniques in conflict resolution exercises and to incorporate grassroots actors in peace negotiations. For more information, visit: www.forefrontleaders.org

International Alert, a nongovernmental organization based in the United Kingdom, was established in 1985 by human rights advocates in response to the rise in violent conflict within countries and the subsequent abuse of individual and collective human rights in conflict situations. The organization addresses the ever more pressing need for conflict resolution and peace-building efforts. www.international-alert.org

RICHARD NSANZABAGANWA

RWANDA 1995 AGE 26

A COURAGEOUS SURVIVOR EXPOSING THE TRUTH OF GENOCIDE

"THE DAY THE CARNAGE BEGAN, I HAD GONE TO A CHURCH TO VISIT DISPLACED PEOPLE WHO HAD TAKEN REFUGE THERE," SAYS RICHARD NSANZABAGANWA. "THEIR FACES WERE DARK AND FULL OF DESPAIR. WE TRIED TO ENCOURAGE THEM, NOT KNOWING THAT THAT VERY EVENING WOULD BE THE END OF THE WORLD FOR US, THAT WE OURSELVES WOULD BECOME THE TARGETS OF THE KILLERS."

By the time night fell on April 6, 1994, one of the most intensive genocides in history had begun. Within hours of the Rwandan president's plane being shot down, the Hutu-dominated government and armed forces began systematically killing members of the Tutsi minority, as well as moderate Hutus. They also urged Hutu citizens to join in the killing spree; over the state-sponsored radio, a leading pop singer even pressed his countrymen to "kill the cockroaches." Hutu husbands slashed their Tutsi wives to death with machetes. Schoolchildren were slaughtered. Rivers became clogged with dead bodies. Within a hundred days, an estimated 800,000 people had been massacred.

Richard Nsanzabaganwa, a Tutsi, barely escaped. Most of his family members were murdered; only he and an older sister survived. One of only a few activists to defend human rights before the 1994 genocide, Richard had begun mediating for the peaceful coexistence of the Hutus and Tutsis at an early age. As a teenager, he brought Hutu and Tutsi students together to increase communication and mutual understanding. Following high school graduation, Richard volunteered his services to Association Rwandaise des Droits de l'Homme (ARDHO), a human rights group that included both Hutu and Tutsi members who were monitoring human rights abuses throughout Rwanda. In 1993, Richard became a paid employee of ARDHO.

The genocide ended when the Tutsi-dominated Rwandan Patriotic Front took power in July 1994, causing the flight of thousands of Hutus in fear of Tutsi reprisal. Despite the establishment of a multiethnic coalition government, human rights violations continued to occur daily in Rwanda, and civilians faced death, starvation, and displacement. Richard was one of the few original activists who continued to do human rights work in the ongoing climate of ethnic violence. As chief investigator of ARDHO, Richard traveled continuously across the war-torn country to investigate and report on human rights violations. He directed mobile field workers, gathered testimony from victims, and intervened in cases of arbitrary detention, compiling information for the United Nations Human Rights Field Operation in Rwanda. His neutrality was no protection against retaliation, however. He was threatened by both Tutsi extremists, who considered him pro-Hutu, and Hutu extremists, who considered him pro-government.

In 2002, Richard earned a law degree from the University of Ottawa in Canada. He remains active with Societé Pour La Paix (Society for Peace), a volunteer organization he founded in Hull, Quebec, that focuses on conflict prevention and resolution.

"I PRAY THAT THE MINDS OF THE CHINESE BECOME GENTLE AND CALM, THAT THROUGH TRUE LOVE AND COMPASSION, THOSE WHO ARE DRUNK WITH DELUSIONS, LOST IN THE DARKNESS OF IGNORANCE, ACQUIRE THE WISDOM EYE TO SEE WHAT IS RIGHT AND WHAT IS WRONG."

GET INVOLVED

FREEDOM OF CONSCIENCE

The Freedom Project campaigns for the unconditional release from prison of members of Forefront, a network of recipients of the Reebok Human Rights Award. International law, as stated in such documents as the Universal Declaration of Human Rights and the International Covenant on Civil and Political Rights, protects the right to freely associate with others and express one's beliefs. Phuntsok Nyidron, one of several Forefront members who have been imprisoned for speaking out on behalf of human rights, is the only one still incarcerated.
www.forefrontleaders.org/freedom/freedom.php

The Free Tibet Campaign stands for the Tibetans' right to determine their own future. Independent of all governments, it campaigns for an end to the Chinese occupation of Tibet and for the Tibetans' fundamental human rights to be respected.
www.freetibet.org

PHUNTSOK NYIDRON

TIBET 1995 AGE 27

A SYMBOL OF COURAGE IN TIBET'S STRUGGLE FOR FREEDOM

DURING THE PAST FIFTY YEARS, MORE THAN ONE MILLION TIBETANS HAVE DIED AS A RESULT OF THE CHINESE OCCUPATION OF THEIR COUNTRY. BECAUSE TIBETAN NATIONALISM IS CLOSELY INTERTWINED WITH BUDDHISM, THE PERSECUTION OF MONKS AND NUNS HAS BEEN ESPECIALLY UNRELENTING. THE CHINESE HAVE BANNED PUBLIC CEREMONIES, IMPOSED CONTROLS ON RELIGIOUS TEACHINGS, AND DESTROYED NEARLY ALL OF TIBET'S MORE THAN 6,000 MONASTERIES AND NUNNERIES. AND THEY ROUTINELY TORTURE POLITICAL DISSIDENTS—OFTEN MONKS AND NUNS—DURING THEIR IMPRISONMENT.

In 1989, three days after Tibetans learned that the Dalai Lama had won the Nobel Peace Prize, a twenty-four-year-old Buddhist nun, Phuntsok Nyidron, led a peaceful demonstration in Lhasa to protest the Chinese occupation. Within minutes, police had arrested the nuns. Phuntsok, judged to be the ringleader, was beaten repeatedly and subjected to electric shocks in an effort to force her to sign a confession. She refused to cooperate with her tormentors, and she was condemned to nine years of imprisonment.

Four years into her sentence, Phuntsok and thirteen other nuns recorded Tibetan independence songs on a tape recorder that had been smuggled into the prison. On the tape each of the nuns bravely announced her name and dedicated a song or poem to friends and supporters. The tape was then smuggled out of the prison,

copied, and circulated, to offer solace to the Tibetan people. For that recording, Phuntsok's oppressors added eight years to her sentence, for a total of seventeen years, the longest cumulative sentence of any female political prisoner in Tibet. In 2002, the Chinese government announced a one-year reduction in her sentence. Today, she remains in prison, where her health is reportedly failing. She is due for release in 2005.

On the smuggled tape, Phuntsok had sung, "We, the captured friends in spirit, we may be the ones to fetch the jewel. No matter how hard we are beaten, our linked arms cannot be separated." Through Forefront, her fellow Reebok Human Rights Award recipients have not forgotten her, and they have linked arms around the world in a campaign to free her.

"I THINK ALL OF US IN THE WORLD SHOULD HAVE LEARNED BY NOW THAT VIOLENCE NEVER WORKS AND NORTHERN IRELAND IS A GOOD EXAMPLE OF THAT, WITH ONE PIECE OF VIOLENCE LEADING TO ANOTHER. WE HAVE TO FIND ANOTHER WAY WHICH IS BASED ON THE SANCTITY OF ALL LIFE."

GET INVOLVED

CONFLICT RESOLUTION

The Committee on the Administration of Justice (CAJ) seeks to secure the highest standards in the administration of justice in Northern Ireland by ensuring that the government complies with its responsibilities in international human rights law. CAJ works closely with other domestic and international human rights groups such as Amnesty International, the Lawyers Committee for Human Rights, and Human Rights Watch, and makes regular submissions to a number of United Nations and European agencies established to protect human rights. www.caj.org.uk

The International Federation for Human Rights (FIDH) works to advance the implementation of all the rights defined by the Universal Declaration of Human Rights and the other international instruments protecting human rights. The FIDH brings together 115 human rights organizations from ninety countries. The Committee on the Administration of Justice is its Northern Ireland affiliate. The FIDH provides affiliates with a network of expertise and solidarity, as well as a clear guide to the procedures of international organizations. www.fidh.org/fidh-en/index.htm

MARTIN O'BRIEN

NORTHERN IRELAND 1992 AGE 28

BRIDGING THE DIVIDE THAT SEPARATES NEIGHBORS

GUNSHOTS ECHOED IN THE STREETS. PEOPLE RAN FRANTICALLY SEEKING REFUGE FROM ROCKS, BOTTLES, AND BULLETS. MEN WITH MASKS COVERING THEIR FACES LAY IN THE STREET BLEEDING. UNFORTUNATELY, THIS SCENE WAS ALL TOO FAMILIAR FOR PEOPLE IN NORTHERN IRELAND, WHERE DECADES OF ENTRENCHED CONFLICT STILL EXPLODED WITHOUT WARNING—DESTROYING LIVES, FUTURES, AND HOPE. ENTIRE GENERATIONS HAD GROWN UP WITNESSING TERROR AND VIOLENCE FIRSTHAND, AND LEARNING LESSONS OF DESPAIR AND PARTISAN HATRED THAT SEEM TO HAVE NEITHER BEGINNING NOR END. AT AGE TWELVE, A YOUNG MAN FROM BELFAST NAMED MARTIN O'BRIEN STRUGGLED TO OVERCOME THIS LEGACY AND CO-FOUNDED YOUTH FOR PEACE, AN ORGANIZATION DEDICATED TO PROMOTING PEACE AND UNDERSTANDING. AS HE GREW UP, HE BECAME A HUMAN RIGHTS CHAMPION WHO PROMOTED THE RULE OF LAW AND SOUGHT CREATIVE SOLUTIONS TO MURDEROUS VIOLENCE.

After the partition of Ireland in 1920, decades of conflict ensued between the Catholic and Protestant communities in Northern Ireland. The Protestants, who constitute approximately two-thirds of the population, wish to maintain the link with Great Britain, while most Catholics aspire to a united Irish Republic. This deep-seated division of political and religious interests has brought death and despair to generations of Irish families and has extended well beyond national boundaries.

At the age of twenty-one, Martin O'Brien joined with several other human rights activists to establish Kilcranny House, a rural education center committed to healing the divisions in Northern Ireland. He was instrumental in developing adult training in human rights as well as a youth program, the Peace People Farm project. He sought to carve out neutral environments in which both Catholics and Protestants could search for common ground away from the killing that surrounded them.

While still in his twenties, Martin became a founding member of the Irish Network for Nonviolent Action Training and the coordinator of the Committee on the Administration of Justice (CAJ). Through his work in both groups, Martin sought to stop human rights abuses from all sides of the conflict in Northern Ireland. Under his leadership, CAJ became an internationally respected nonpartisan, nonviolent human rights group dealing with the concerns of every community in Northern Ireland. This committee reported killings, worked to establish a bill of rights for Northern Ireland, and disseminated information about human rights abuses and atrocities. Perhaps most significant was Martin's work in investigating allegations of torture of suspected terrorists by the Northern Irish police force.

Today, Martin continues his work with CAJ to bring about peace in Northern Ireland. He has also served on Amnesty International fact-finding delegations to such areas as the West Bank and Gaza Strip in Palestine.

"I BEGAN TO TALK ABOUT THE MASSACRES, LIKE THE ONE IN RIO NEGRO. IT WAS NOT GUERILLAS WHO DIED. THE MAJORITY WHO DIED WERE PREGNANT WOMEN AND CHILDREN."

GET INVOLVED

TORTURE AND DISAPPEARANCES

The Guatemalan Human Rights Commission is dedicated to the protection and promotion of human rights in Guatemala.
www.derechos.org/nizkor/guatemala/ongmain.html

The Guatemala Project of Peace Brigades International offers an unarmed international presence to Guatemalan individuals, organizations, and communities threatened with violence and human rights abuses. The team works to develop and maintain channels of communication with the different players involved in the conflict both to deepen its understanding of the situation and to facilitate communication between the groups.
www.peacebrigades.org/guatemala.html

JESUS TECU OSORIO

GUATEMALA 1996 AGE 25

COURAGEOUS WITNESS SPEAKING OUT AGAINST ATROCITIES

IN THE EARLY HOURS OF MARCH 13, 1982, SOLDIERS AND CIVIL DEFENSE PATROLLERS ENTERED THE TINY GUATEMALAN VILLAGE OF RIO NEGRO. ENRAGED AT FINDING THE MEN ABSENT, THEY ROUNDED UP ALL THE WOMEN AND CHILDREN AND MARCHED THEM UP A MOUNTAINSIDE TO A PLACE CALLED LA CUMBRE PACOXOM. THERE ELEVEN-YEAR-OLD JESUS TECU OSORIO WITNESSED HORRORS THAT WILL REMAIN WITH HIM FOR THE REST OF HIS LIFE: THE WOMEN AND CHILDREN WERE RAPED AND BEATEN BEFORE BEING STRANGLED, SLASHED WITH MACHETES, OR BLUDGEONED TO DEATH WITH WOODEN STICKS. SOME OF THE CHILDREN WERE PILED UP, FOUR AND FIVE AT A TIME, AND SHOT WITH MACHINE GUNS. JESUS'S OWN THREE-YEAR-OLD BROTHER, JAIME, WAS SEIZED FROM HIS ARMS AND SMASHED AGAINST ROCKS. THE TODDLER'S BODY WAS THEN TOSSED INTO A RAVINE WITH THE OTHER CORPSES.

Eighteen children's lives were spared, but only because the civil defense patrollers needed domestic servants. For two years, Jesus was forced to live and work in the home of the same patroller who had killed his little brother.

In the Rio Negro massacre, 177 Mayan-Achi women and children were killed as part of the Guatemalan government's attempt to eliminate civilian populations in areas with suspected guerilla presence. In the late 1970s and early 1980s, this counterinsurgency "pacification" campaign resulted in the murder of an estimated 150,000 Guatemalans, the forced "disappearance" of 45,000, and the displacement of one million.

Ten years after the Rio Negro massacre, Jesus became one of a handful of witnesses to testify in court against the civil defense patrollers who had participated in the brutal murders. For breaking the silence, he was harassed and threatened with death. Yet his public denunciations led to the exhumation of mass graves in the municipality of Rabinal, where 5,000 people had been slaughtered.

Several years later, Jesus founded the Rabinal Widows, Orphans and Displaced Persons Committee, an organization that works to protect the economic and social rights of the people of the Rabinal area and seeks to break the traditional climate of impunity that has protected uniformed killers in Guatemala. In 1998, Jesus again served as a key witness in the trial of three former paramilitary men who had participated in the 1982 massacre. Despite receiving numerous death threats, he and the other witnesses provided sufficient evidence to convict all three men.

Jesus remains committed to speaking out about the mass murder and other human rights abuses in Guatemala. Despite great personal risk, he continues his struggle to bring former death squad members to justice. And his persistence in exposing the truth about the atrocities he witnessed has given others the courage to speak out as well.

"WITHOUT SAUVEUR'S UNFLAGGING ENTHUSIASM AND COMMITMENT, FEW OF THE FARMWORKERS' ADVANCES WOULD HAVE BEEN POSSIBLE."
—FLORIDA RURAL LEGAL SERVICES

MIGRANT AND IMMIGRANT RIGHTS

Florida Rural Legal Services (FRLS) is part of a nationwide network of more than 300 federally funded legal services programs. As part of this network, FRLS serves disadvantaged people in fourteen rural counties of central Florida. FRLS also serves all Florida-based migrant farmworkers in cases arising in Florida and throughout the eastern United States. www.frls.org

The Farmworker Justice Fund, Inc. (FJF) is a nonprofit organization that seeks to improve the living and working conditions of migrant and seasonal farmworkers throughout the United States. Using a multifaceted approach, FJF engages in litigation, administrative and legislative advocacy, coalition-building, training, technical assistance, and public education. www.fwjustice.org

SAUVEUR PIERRE

UNITED STATES 1991 AGE 31

FIGHTING FOR THE RIGHTS OF MIGRANT FARM WORKERS

IN 1980, A YOUNG MAN NAMED SAUVEUR PIERRE CLIMBED INTO AN OVERCROWDED, RICKETY BOAT AND MADE A PERILOUS VOYAGE FROM HIS NATIVE HAITI TO THE COAST OF FLORIDA. HE WAS ONE OF THOUSANDS OF HAITIANS FLEEING THE POVERTY AND VIOLENCE OF THE DUVALIER REGIME. HE LEFT HIS ISLAND HOMELAND HOPING TO FIND A BETTER LIFE. WHAT HE FOUND WAS BRUTAL EXPLOITATION IN THE SUGAR CANE FIELDS OF SOUTHERN FLORIDA.

Exploitation in Florida's sugar cane fields was common in the early 1980s. Employers paid well below minimum wage, and often money deducted for taxes was pocketed by supervisors. They knew the workers were helpless because they didn't speak English, and mostly because they feared being deported. Harvesting sugar cane was also one of the most dangerous occupations in the United States. Working under a relentless sun, these men had to cut a ton of cane every hour or face deportation. Injuries were frequent, and meeting the quota often meant losing a finger. Surrounded by security guards and barbed-wire fences, workers were also forced to live in squalid conditions—three hundred to a room. Sauveur resolved to find a way to pursue justice for the 200,000 migrant farm workers in Florida's sugar cane industry.

After teaching himself English, Sauveur was hired by the Farmworker Justice Fund of Washington, DC, as a paralegal/investigator to assist in that organization's lawsuit against Florida sugar cane growers. Sauveur helped to obtain crucial information required by the courts without benefit of immediate supervision of his Washington employers, thereby earning their respect and confidence. With tireless work, he helped move the various pieces of litigation forward.

As an employee with Florida Rural Legal Services (FRLS), Sauveur identified important legal problems, assisted in devising appropriate legal strategies, and served as a client contact. He helped clients remain committed to the effort of federal court litigation, which can take years and become very discouraging. Sauveur also acted as a translator and confidante of clients as he traveled throughout Florida in search of farmworkers in labor camps and slum communities who were willing to fight their oppressed conditions. According to his FRLS employer, recent advancements in farmworker conditions would not have been possible without Sauveur's unflagging dedication.

Today, Sauveur continues his work, acting as a translator for migrant workers through legal services in New Jersey and Pennsylvania.

"RECOGNIZING MARIA WOULD BE TO RECOGNIZE THE DIGNITY OF THE REFUGEES SITTING IN JAIL BECAUSE OF THEIR DESIRE FOR A SAFE HAVEN."

—PROJECTO LIBERTAD

REFUGEES AND ASYLUM SEEKERS

The Texas Immigrant and Refugee Coalition (TIRC) works to ensure that the residents and government officials of Texas support the social and political integration and self-sufficiency of immigrants and refugees through public policies. TIRC strengthens local advocacy, coalition-building, and public policy by building upon local organizational and individual expertise. www.main.org/tirc

Refugees International (RI) is an advocacy organization for humanitarian action, serving refugees, displaced persons, and other dispossessed people around the world. Onsite field assessment missions are the heart of RI's work. RI field representatives assess each situation; recommend concrete actions to protect people and save lives; distribute brief, timely reports to policy and opinion makers worldwide to mobilize help for the victims; and follow up with public, private, and media advocacy. www.refugeesinternational.org

MARIA PAZ RODRIGUEZ

UNITED STATES 1988 AGE 27

SOURCE OF HOPE FOR REFUGEES SEEKING A SAFE HAVEN

MARIA PAZ RODRIGUEZ WAS A YOUNG MOTHER WHO WAS FORCED TO FLEE EL SALVADOR WHEN SECURITY FORCES LABELED HER SISTER AND BROTHER-IN-LAW AS "SUBVERSIVES"—WHICH, IN ESSENCE, WARRANTED DEATH TO THE ENTIRE FAMILY. CARRYING HER NEW BABY, SHE FLED THROUGH MEXICO AND WADED ACROSS THE RIO GRANDE INTO TEXAS. AS AN UNDOCUMENTED REFUGEE, SHE LIVED IN FEAR OF BEING DEPORTED TO HER HOMELAND. BUT RATHER THAN REMAIN QUIET AND HIDDEN, SHE DECIDED TO ALLEVIATE THE PLIGHT OF HER FELLOW REFUGEES.

Between 1979 and 1992, the people of El Salvador were ravaged by a violent civil war that left thousands dead and many more victims of horrific crimes. Countless people fled the country seeking safe haven from persecution, torture, and murder. Many of them fled to the United States without proper immigration documents and, like Maria Paz Rodriguez, feared deportation. Projecto Libertad was virtually the only source of legal representation for indigent Central American refugees and others in deportation proceedings in the lower Rio Grande Valley of Texas, specifically the Harlingen Immigration and Naturalization Service (INS) District. Maria devoted herself to helping these refugees, particularly the women and children.

Maria began working as a volunteer at Projecto Libertad sweeping floors. Although she knew little English and even less about immigration law, she dedicated herself to working with Central American refugees, especially the detained refugees, in order to ensure that their rights under both domestic and international law would be protected.

Within three years, Maria was working at Projecto Libertad as a paralegal interviewing Central American refugees. She visited minors held at INS processing centers, where many of them had been detained for months and had only Maria and other staff members from Projecto Libertad as visitors. She became a source of hope, comfort, and compassion for these victims, keeping them from despair when they were ready to give up and face the perils of deportation. Maria also found attorneys, raised bond money, and collected money to aid the deportees.

When the refugees in detention at the Port Isabel Processing Center heard of Maria's nomination for the Reebok Human Rights Award, they sent a signed petition on her behalf stating, "We the 'alien detainees' conclude that Ms. Rodriguez has the heart of an angel and the zeal of a giant." The executive director of Projecto Libertad said that recognizing Maria would be to recognize the dignity of the refugees sitting in jail because of their desire for a safe haven.

"THE WORLD COMMUNITY NEEDS TO UNDERSTAND THE RELATIONSHIP THAT INDIGENOUS PEOPLES HAVE TO THEIR LANDS, TERRITORIES, AND RESOURCES, AND THAT IT IS INHERENT TO THEIR HUMAN RIGHTS."

DALEE SAMBO

UNITED STATES 1988 AGE 29

ADVOCATE FOR ALASKA NATIVES' RIGHTS AND CULTURES

FOR TENS OF THOUSANDS OF ALASKA NATIVES, SUBSISTENCE LIVING IS A WAY OF LIFE. THEY DEPEND ON NATURAL, RENEWABLE RESOURCES TO SURVIVE. FISH, WILDLIFE, PLANTS, BERRIES, AND TIMBER PROVIDE THEM WITH FOOD, FUEL, CLOTHING, AND CONSTRUCTION MATERIALS. SUBSISTENCE LIVING IS NOT ONLY THEIR MEANS OF SURVIVAL—IT IS THEIR CULTURE. BUT IN RECENT DECADES, THE HUMAN RIGHTS OF ALASKA'S INDIGENOUS PEOPLES HAVE COME UNDER ASSAULT BY THE GOVERNMENT AND OUTSIDE INTERESTS THAT WANT TO EXPLOIT THE RESOURCES FOR COMMERCIAL AND RECREATIONAL USE. A YOUNG INUPIAT NAMED DALEE SAMBO IS A LEADER IN THE FIGHT TO PROTECT THEIR RIGHTS AND PRESERVE THEIR CULTURE.

As executive director of the Inuit Circumpolar Conference (ICC) Alaska office, and special assistant to the ICC president for Alaska, Dalee worked on behalf of Alaska Native communities in their attempts to maintain the integrity of their traditional socioeconomic structures. She worked closely with Inuit land claims leaders in Alaska, Canada, and the Greenland Homerule Government. Together, they helped to create the Arctic Nuclear Free Zone; to promote opposition to oil and gas tankering through the Canadian Arctic Archipelago and the Davis Strait separating the Northwest Territories from Greenland; to provide defense of Inuit subsistence whaling, sealing, and hunting; and to reestablish relations between North American and Siberian Inuit communities.

In addition to her work with the ICC, Dalee worked for Chugach Alaska as a paralegal in its land department and a legal researcher for Alaska law firms, the Alaska Judicial Council, and with several Inupiat village councils. She also helped create the Alaska Native Coalition, a statewide tribal and village advocacy organization that works to protect native land and usage, to strengthen tribal governments, and to monitor legislation that affects the rights of Alaska Native tribes.

Dalee's work with the Alaska Native Review Commission resulted in one of the most important books of this generation on native rights: *Village Journey* by Thomas R. Berger. She has been described as the fire and soul behind the commission and its historic work.

Dalee completed her doctorate in law and today continues working with Alaska Native communities. She has been active in the promotion and protection of indigenous human rights at the United Nations, the International Labour Organization, the Organization of American States, and other human rights organizations.

"IT IS CLEAR TO ME THAT MANY YOUNG PEOPLE OF MY GENERATION HAVE FORGOTTEN OR NEVER KNEW THAT PEOPLE DIED IN THE '60'S FOR OUR RIGHT TO VOTE. WE NEED TO DEVELOP A WHOLE NEW GENERATION OF LEADERS WHO UNDERSTAND OUR CIVIL RIGHTS LEGACY AND WHO WANT TO CONTINUE TO FIGHT FOR EQUALITY."

GET INVOLVED

DISCRIMINATION AND RACISM

21st Century Youth Movement is dedicated to developing leadership and community-building skills, providing technology training, and helping young people understand civil rights and their cultural heritage. The organization aims to build a new generation of civil rights activists who not only have the skills and knowledge to improve their own communities, but also have the ability to think globally and connect with the larger world. For more information, visit: www.forefrontleaders.org

The Education Department of the National Association for the Advancement of Colored People (NAACP) works to provide all students with access to quality education through policy development, training, collaboration, negotiation, legislation, litigation, and organizing. www.naacp.org/work/education/education.shtml

MALIKA ASHA SANDERS

UNITED STATES 2002 AGE 27

21ST CENTURY CIVIL RIGHTS ACTIVIST

IN 1955, A FORTY-TWO-YEAR-OLD BLACK WOMAN FROM ALABAMA NAMED ROSA PARKS REFUSED TO GIVE UP HER SEAT TO A WHITE PERSON. THAT SINGLE ACT OF DEFIANCE HELPED TRIGGER THE CIVIL RIGHTS MOVEMENT IN THE UNITED STATES. TWENTY YEARS AFTER ROSA PARKS'S COURAGEOUS ACT, ANOTHER WOMAN FROM ALABAMA NAMED MALIKA SANDERS WAS BORN. HER PASSION FOR JUSTICE WOULD LEAD HER TO CONTINUE THE STRUGGLE FOR CIVIL RIGHTS IN THE TWENTY-FIRST CENTURY.

Despite the great accomplishments of the civil rights movement, activists and political leaders alike agree that the unfinished business of the movement is to improve the lives of poor African Americans. To do that, a new generation of leaders must emerge, one that builds on the legacy of the civil rights movement—and connects it to the larger world of *human* rights.

The daughter of prominent civil rights activists in Selma, Alabama, Malika attended her first demonstration when she was literally in the womb. By the time she was sixteen, Malika was leading her own protest against a new kind of segregation called "racial tracking." Racial tracking was a practice that resulted in white students being placed in higher-level classes, while black students were placed in the lower levels, regardless of ability. After an intensive information campaign and a year of protests, including a sit-in that closed down the high school for five days, Selma's city leaders finally relented. They changed their policy to include more objective assessments and to provide better opportunities for black students.

After earning her degree at Spelman College in Atlanta, Malika returned to Selma and became executive director of the 21st Century

Youth Movement. Each year, 21st Century runs training camps for teenagers from poor rural and urban areas to focus on leadership development and the preservation of black heritage. The program also helps young people find solutions to youth-on-youth violence, drug abuse, crime, and the continuation of racism, sexism, and poverty in their communities.

21st Century received national attention in 2000 when it organized a "get out the vote" campaign to unseat Selma's notoriously racist mayor, Joe Smitherman, whose acts of intimidation and threats had kept him in power for thirty-five years. Malika's use of innovative outreach efforts, including hip-hop artists recording civil rights messages, resulted in the registration of hundreds of young black voters and an 80-percent turnout at the polls—a first in Selma's history. Smitherman was defeated, and the media called the campaign the most significant accomplishment of the national celebration of the right to vote.

Today, Malika continues as executive director of 21st Century Youth Movement, fighting injustices and inequalities and helping to build a new generation of leaders in the fight for civil rights and human rights.

"I HAVE A VISION THAT OUR CRIMINAL JUSTICE SYSTEM OUGHT TO DO BETTER. A SYSTEM THAT TREATS YOU BETTER IF YOU'RE RICH AND GUILTY THAN IF YOU'RE POOR AND INNOCENT DOESN'T MEET UP TO WHAT A SOCIETY COMMITTED TO EQUAL JUSTICE REQUIRES."

BRYAN STEVENSON

UNITED STATES 1989 AGE 29

FIGHTING RACIAL DISCRIMINATION IN THE CRIMINAL JUSTICE SYSTEM

EVERY DAY, HUNDREDS OF VOICELESS POOR AND BLACK CITIZENS IN THE SOUTHERN UNITED STATES FIGHT FOR THEIR LIVES IN A CRIMINAL JUSTICE SYSTEM THAT OFFERS THEM LITTLE HOPE. ATTORNEYS WHO REPRESENT SUCH CITIZENS ARE FEW, AND THE PUBLIC DEFENDER SYSTEMS INADEQUATE. INFLUENCED BY HIS OWN EXPERIENCES AS A BLACK YOUTH IN RURAL DELAWARE, A YOUNG LAW SCHOOL GRADUATE NAMED BRYAN STEVENSON DECIDED TO REPRESENT THOSE WITHOUT SUPPORT OR RESOURCES TO DEFEND THEMSELVES, AND TO FIGHT RACIAL DISCRIMINATION IN THE JUSTICE SYSTEM—PARTICULARLY CAPITAL PUNISHMENT CASES.

A number of studies have shown a persistent pattern of racial disparities in the application of the death penalty in the United States. Their findings have been conclusive: poor blacks are sentenced to death far more often than other defendants who committed similar crimes. Such studies also point out that the key decision makers in death penalty cases are often predominantly white men.

When he graduated from Harvard Law School in 1985, Bryan Stevenson decided to provide poor people and death row prisoners fair representation in the criminal justice system rather than pursue a less difficult and more financially rewarding career. He was one of only 3 percent of law school graduates to choose public service. Bryan served as a staff attorney for the Southern Prisoners' Defense Committee in Atlanta, Georgia, and was acting director of the Alabama Death Penalty Resource Center. He worked not only to challenge court decisions, but also to involve religious and community leaders and the families of both the victims and the defendants.

Bryan wrote several manuals on death penalty litigation and lectured on race, poverty issues, and the criminal justice system across the country. His day-to-day work encompassed a broad spectrum of concerns, including class action challenges to prison conditions throughout the South, representation of capital defendants in trial, post-conviction litigation, and consultation with other attorneys on capital cases. And Bryan successfully documented many cases of racial bias in the courts.

Along with his law degree, Bryan also earned a master's degree in public policy at Harvard's Kennedy School of Government and has been honored with numerous awards, including the Kennedy Fellowship in Criminal Justice Award and the Harvard University Fellowship in Public Interest Law Award.

Today, Bryan is the executive director of the Equal Justice Initiative of Alabama. He and his staff have been successful in overturning a number of capital murder cases. Bryan is also a member of the Reebok Human Rights Award Board of Advisors.

"THEY CAME HERE FOR THE AMERICAN DREAM, BUT WHAT THEY FOUND WAS THE AMERICAN NIGHTMARE."

MIGRANT AND IMMIGRANT RIGHTS

Asian Pacific American Legal Center of Southern California serves the Asian American community through advocacy, education, litigation, and direct service. They work to provide legal services; to do policy advocacy on workers' rights, affirmative action, immigrant welfare, domestic violence, hate crimes, and voting rights; and to strengthen race relations. www.apalc.org

The International Labor Rights Fund (ILRF) is an advocacy organization dedicated to achieving just and humane treatment for workers worldwide. ILRF serves a unique role among human rights organizations as advocates for and with working poor around the world. www.laborrights.org

JULIE SU

UNITED STATES 1996 AGE 27

FIGHTING FOR THE RIGHTS OF IMMIGRANT WORKERS

IN 1995, A MULTI-AGENCY TASK FORCE RAIDED A SWEATSHOP COMPLEX IN EL MONTE, CALIFORNIA. THERE THEY FOUND SIXTY-SEVEN WOMEN AND FIVE MEN HELD LIKE ANIMALS IN A CAGE, STRIPPED OF THEIR HUMANITY. RECRUITED BY A CRIMINAL FAMILY IN THAILAND, THE WORKERS HAD BEEN KEPT IN DEBT SERVITUDE FOR YEARS, FORCED TO LABOR EIGHTEEN HOURS A DAY, SEVEN DAYS A WEEK, FOR LESS THAN A DOLLAR AN HOUR. RATS AND ROACHES CRAWLED OVER THEM AS THEY SLEPT, AND ARMED GUARDS HINDERED ANY ATTEMPTS AT ESCAPE. BUT LIBERATION FROM THE SWEATSHOP DID NOT MEAN FREEDOM FOR THOSE WORKERS; AS ILLEGAL IMMIGRANTS, THEY WERE THEN JAILED FOR NINE DAYS IN A FEDERAL DETENTION CENTER, WHERE THEY WERE SHACKLED AND FORCED TO WEAR PRISON UNIFORMS.

Julie Su, an attorney at the Asian Pacific American Legal Center of Southern California, worked around the clock to free the El Monte workers, whom she believed to be doubly victimized—first by the cruel employers who had brought them to the United States as indentured laborers, then by the federal authorities who had treated them like criminals.

On behalf of the Thai workers and their Latino coworkers at the El Monte sweatshop, Julie sought back pay from the retailers who sold their products. On her own time she eased the Thai workers' transition to normal life by helping them learn English, secure housing, find jobs, and obtain desperately needed health care. And even when the sweatshop owners had been sentenced to prison terms of two to seven years each, Julie did not give up her fight against sweatshops.

Instead, she founded Sweatshop Watch, a coalition of human rights activists, lawyers, community advocates, and factory workers. The organization published newsletters that called attention to substandard working conditions. In Southern California alone, at least 500 sweatshops were found to be violating minimum wage rules, and few met health and safety regulations. Sweatshop Watch pressured corporations and retailers to sign corporate codes of conduct aimed at putting such sweatshops out of business.

Julie also worked with local shelters to house and protect women and girls who are trafficked into the United States to serve as either forced laborers or prostitutes. She taught the women about their rights and helped them find new employment.

Julie's passion for seeking justice extended beyond labor conditions for immigrants. She worked to identify and combat hate crimes and anti-immigrant violence in the United States, and she educated community groups and workers about their rights and how to identify crimes that are based on racist or anti-immigrant sentiment.

Today, Julie continues to help immigrant garment workers speak out against dismal conditions and demand a living wage, and she develops educational initiatives designed to make purchasing and wearing clothes made in good conditions a fashionable trend.

"THE BOY'S FAMILY WAS SHOT IN FRONT OF HIM AND CUT TO PIECES. HE SHARED WITH ME THE WORST MOMENTS OF HIS YOUNG LIFE."

GET INVOLVED

CHILDREN AND YOUTH

Wona Sanana (Seeing Children) is the first attempt in Mozambique to gather basic information about children after the war. The project trains community volunteers in remote villages to collect data about the health and welfare of the children there, then works with community members to interpret the data in order to determine initiatives that will help meet the children's needs.
www.worldofchildren.org/Sultan.htm

Save the Children Federation, a leading international relief and development organization, works with families around the world and in Mozambique to define and solve the problems their children and communities face, using a broad array of strategies to ensure self-sufficiency.
www.savethechildren.org

ABUBACAR SULTAN

MOZAMBIQUE 1991 AGE 28

RESCUER OF CHILD SOLDIERS

A SIX-YEAR-OLD BOY WHO WITNESSED THE MURDER OF HIS PARENTS WAS THEN FORCED TO HOLD A GUN AND KILL OTHERS IN HIS VILLAGE. HE BECAME ONE OF MORE THAN 200,000 CHILDREN ORPHANED AND ONE OF THOUSANDS ENSLAVED AS CHILD SOLDIERS IN THE MOZAMBICAN CIVIL WAR, WHICH LASTED NEARLY A DECADE. HE, LIKE OTHERS, WAS HAUNTED BY THE TRAUMA AND WITHDREW INTO A DEEP, LONELY SILENCE. BUT A YOUNG MAN, ABUBACAR SULTAN, GAINED HIS TRUST WHEN NO ONE ELSE COULD AND HELPED HIM DEAL WITH HIS LOSS AND PAIN.

Children, innocent victims, were caught between two armies in a war that devastated Mozambique's civilian population between 1985 and 1992. Government forces headed by the Mozambique Liberation Front (Fremilo) were pitted against rebel forces—the Mozambican National Resistance Movement (Renamo). It was civilians, however, who were most harmed in this conflict. Villages were ravaged and looted; innocent people were slaughtered. In this carnage, children were kidnapped and indoctrinated as soldiers. They were beaten, abused, sexually violated, and forced to commit murder. They soon learned they had no choice but to kill or be killed.

Abubacar Sultan, who was a teacher at the time, decided to do something to stop this atrocity. He began working with Save the Children Federation's Project on Children of War, a psychological rehabilitation program for former child soldiers, many of whom were between the ages of six and thirteen. The program provided counseling to help traumatized children heal feelings of guilt, pain, and loss.

Abubacar brought a special gift for working with these children, including the use of creative reenactments to rescue children from their silence and withdrawal. Former child soldiers, who previously would talk with no one, began drawing their parents' murder for him in the sand. Within six months, Abubacar rose from co-trainer of other treatment workers to national director of Save the Children Federation. He trained 500 workers in fifty of Mozambique's worst war-torn areas and wrote a manual to facilitate the training.

Abubacar played another important role by reuniting children with their parents. Despite grave personal danger, he frequently flew into war zones to document orphaned children and to try to locate missing relatives. He created biographies and photographs of orphans and families to help with the search. Posters were put up in villages and refugee camps where relatives were thought to have fled. When matches were made, Abubacar took children to join their families. Through his efforts, more than 8,000 children and families were reunited.

Today, Abubacar works as a child protection officer for UNICEF in Angola. He also continues as an advisor to an organization he founded in Mozambique called Wona Sanana (Seeing Children), which focuses on community education and improving children's rights.

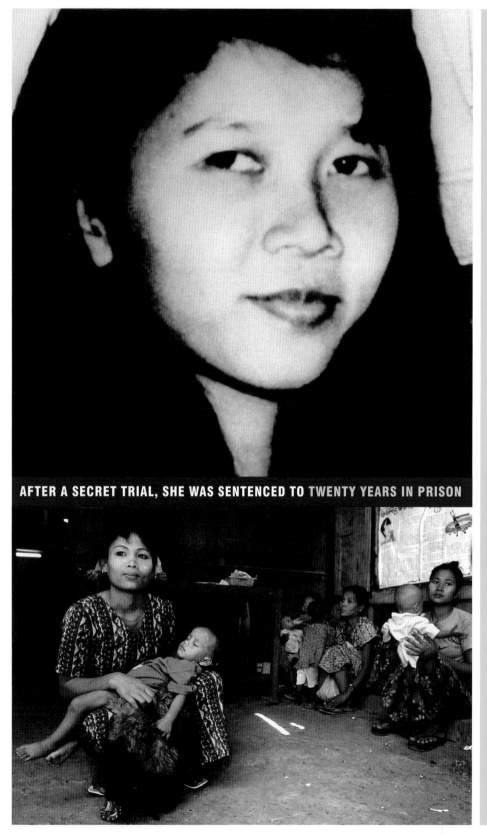

AFTER A SECRET TRIAL, SHE WAS SENTENCED TO TWENTY YEARS IN PRISON

GET INVOLVED

FREEDOM OF EXPRESSION

The Burma Project, established by the Open Society Institute in 1994, is dedicated to increasing international awareness of conditions in Burma and to helping the country make the transition from a closed society to an open one. www.burmaproject.org

Physicians for Human Rights (PHR), which argues that human rights are essential preconditions for the health and well-being of all people, seeks to promote health by protecting human rights. Using medical and scientific methods, PHR investigates and exposes violations of human rights worldwide and works to stop them. www.phrusa.org

MA THIDA

BURMA 1996 AGE 30

INSPIRING THOSE WHO CONTINUE TO STRUGGLE FOR FREEDOM IN BURMA

SHE WAS HELD IN SOLITARY CONFINEMENT, IN A CRAMPED PRISON CELL WITH LITTLE LIGHT. SHE WAS ALLOWED NEITHER READING NOR WRITING MATERIALS. SHE SUFFERED FROM TUBERCULOSIS, AND FOR THREE YEARS WAS DENIED THE SURGERY SHE DESPERATELY NEEDED FOR A PAINFUL MEDICAL CONDITION. HER SENTENCE: TWENTY YEARS. HER CRIME: DISTRIBUTING PRO-DEMOCRACY LEAFLETS.

Ma Thida was a medical student when Burma erupted in turmoil. In September 1988, the government crushed a series of student-led pro-democracy demonstrations, killing thousands of unarmed citizens and arresting thousands of others. Risking her own safety, Ma Thida helped treat students who were injured by the government troops.

The ensuing chaos sparked a military coup and installation of the State Law and Order Restoration Council (SLORC), soon to prove itself one of the most oppressive regimes in the world. When the SLORC temporarily shut down the nation's universities, Ma Thida began working in the office of the National League for Democracy (NLD), a non-violent political party that was campaigning for basic human rights. In October 1988, she joined the election campaign of NLD founder Aung San Suu Kyi. When Aung San Suu Kyi was placed under house arrest the following year, Ma Thida returned to her medical studies but maintained her ties with the NLD.

Upon completing medical school in 1991, Ma Thida became a voluntary surgeon at the Muslim Free Clinic, one of the few private hospitals in Burma to provide free treatment to the poor. She hoped to continue her medical training in Britain or Singapore and to start a mobile surgery van to bring health care to rural parts of Burma. She dreamed of establishing a clinic in Rangoon to treat released prisoners.

At the same time, Ma Thida was writing stories that depicted the lives of ordinary Burmese people. Between 1985 and 1988, she had published more than sixty short stories, many containing veiled criticism of the government. Following the military crackdown, her stories were increasingly banned. In October 1991, her name appeared on a blacklist of writers, and she was prohibited from publishing until January 1993.

In August 1993, Ma Thida was arrested, along with several other NLD members, for distributing leaflets and campaigning for democratic change in Burma. After a secret trial, she was sentenced to twenty years in prison for "endangering public tranquility, having contact with illegal organizations, and distributing unlawful literature."

Forefront activists joined other human rights groups in campaigning for her release. In February 1999, six years after she was incarcerated, Ma Thida was at last freed from prison, on humanitarian grounds. Since her release, Ma Thida has worked to establish a mobile health clinic. She also continues to provide medical services to area hospitals.

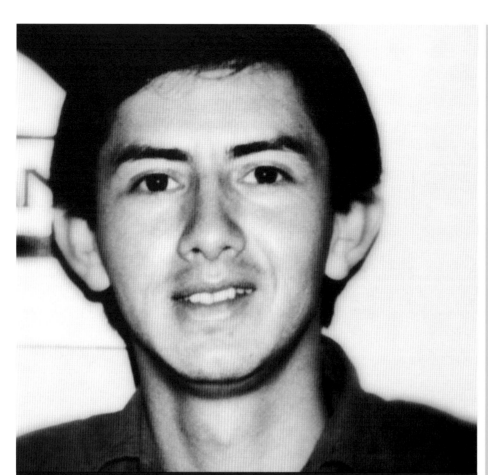

"WE HAVE TWO CHOICES. WE CAN EITHER LIVE IN SILENCE OR RAISE OUR VOICES. WE HAVE CHOSEN TO RAISE OUR VOICES."

GET INVOLVED

CHILDREN AND YOUTH

Casa Alianza (Covenant House) is an independent, nonprofit organization dedicated to the rehabilitation and defense of street children in Guatemala, Honduras, Mexico, and Nicaragua. www.casa-alianza.org

Defence for Children International is an independent, nongovernmental organization set up during the International Year of the Child (1979) to ensure ongoing, practical, systematic, and concerted international action directed toward promoting and protecting the rights of children. www.defence-for-children.org

CARLOS TOLEDO

GUATEMALA 1991 AGE 24

RESCUER AND DEFENDER OF STREET CHILDREN

EVERY DAY HUNDREDS OF POOR HOMELESS CHILDREN WOULD GO TO THE MUNICIPAL DUMP IN GUATEMALA CITY, SEEKING SCRAPS OF FOOD TO SUSTAIN THEIR EMACIATED BODIES. THEY ROAMED THE STREETS BEGGING FOR MONEY, SLEPT IN DESERTED DOORWAYS, AND OFTEN SNIFFED GLUE TO DULL THEIR PAIN. WITHOUT PARENTS, FOOD, OR HOPE, THEY FACED A DISMAL FUTURE. CARLOS TOLEDO HAS DEDICATED HIS LIFE TO RESCUING THESE CHILDREN AND RESTORING THEIR HOPE FOR A BETTER LIFE.

The civil war in Guatemala left 130,000 dead and thousands of orphans in the street. Already facing poverty, hunger, and homelessness, Guatemala's children now faced other deadly foes: the Guatemalan National Police and armed civilians who treated street children as nuisances to be "cleaned up." In 1991 alone, more than forty homeless children were murdered, and hundreds of others were beaten and tortured by the police. One ray of hope was Casa Alianza, or Covenant House, where children found food, clothing, shelter, and protection from the police.

As coordinator of Casa Alianza's Street Educators Program, Carlos walked an average of ten hours a day throughout the city to help these young victims. He buried those who had died in the streets and fought to save the living ones by giving them food, medical attention, and care. Carlos also took on the police by documenting and reporting their acts of abuse. In one incident, he photographed police beating children with pistol butts. Although some police officers threatened to kill him, he refused to give up the cam-

era. His photos eventually led to the police officers' arrest. As a result of his efforts, Carlos, too, became a frequent target of police threats and beatings. In addition to Carlos' personal actions, Casa Alianza challenged the police numerous times by filing lawsuits charging them with human rights violations.

In 1991, Carlos, who had been educated to become a philosophy teacher, founded Nuestros Derechos: Movimiento Nacional de los Niños (Our Rights: National Children's Movement) in Guatemala City. Nuestros Derechos is an outreach and assistance program that provides a safe and supportive environment for children and teens, many of whom have not been successful in other programs because of their age or other factors. Services included visiting youth in prison, appearing in court with their families, and providing young people with food, clothing, shelter, and alternative education.

Today, Carlos continues to serve as the general coordinator of Nuestros Derechos, working to protect and better the lives of refugees and Guatemalan street children.

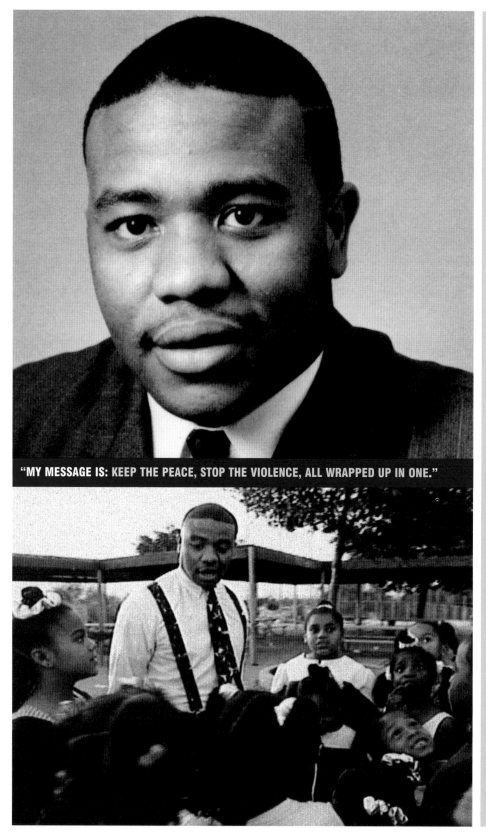

"MY MESSAGE IS: KEEP THE PEACE, STOP THE VIOLENCE, ALL WRAPPED UP IN ONE."

GET INVOLVED

CONFLICT RESOLUTION

AmeriCorps is a federal "domestic Peace Corps" program that has enlisted thousands of young volunteers to combat violence in their communities. www.cns.gov/americorps/index.html

The Office of Juvenile Justice and Delinquency Prevention seeks to provide national leadership, coordination, and resources to prevent and respond to juvenile delinquency and victimization. Its website offers information and resources—including conferences, funding opportunities, and publications—on areas of interest about juvenile justice and delinquency. www.ojjdp.ncjrs.org

CARL WASHINGTON

UNITED STATES 1993 AGE 28
INNOVATIVE AND COMPELLING PEACEMAKER

IN THE EARLY 1990S, THE MORE THAN 400 GANGS WARRING IN LOS ANGELES HAD A TOTAL OF AT LEAST 50,000 MEMBERS. FUELED BY THEIR ANIMOSITY, DRIVE-BY SHOOTINGS CLAIMED THE LIVES OF 400 PEOPLE IN 1992 ALONE. THAT SAME YEAR, A YOUNG MINISTER, CARL WASHINGTON, SUCCESSFULLY MEDIATED A TRUCE BETWEEN FACTIONS OF TWO OF THE MOST NOTORIOUS GANGS, THE CRIPS AND THE BLOODS, WHO HAD BEEN KILLING EACH OTHER AT AN ALARMING RATE. THE TRUCE WAS JUST PART OF REV. WASHINGTON'S MISSION TO HALT GANG VIOLENCE THROUGH BOTH IMMEDIATE ACTIONS AND LONG-TERM SOLUTIONS TO THE PROBLEMS THAT ARISE AMONG THE GANGS.

Rev. Washington had begun his antiviolence work in 1988, when he led a boycott of gun stores to halt the flow of weapons into the community. During the 1992 riots, which were sparked by the acquittal of police officers who had beat motorist Rodney King, Rev. Washington emerged as a prominent community leader, serving as founder of and spokesperson for the Minister's Coalition for Peace.

Rev. Washington served as a youth minister, deputy to a Los Angeles County Supervisor, and as a board member of Hands Across Watts, a group of former gang members seeking to improve economic opportunities for inner-city youth. He continued to mediate and advocate for gang truces and summits, and frequently addressed groups of students on the need to support the gang truce and channel their energy into constructive alternatives. He also organized peace marches and a weapons turn-in program in Los Angeles.

One of Rev. Washington's greatest strengths has been his ability to reach out to a range of groups. As Goodwill Ambassador to South Korea, he led a group of African American high school and college students on a cultural tour of South Korea. The purpose of the trip was to expose young African Americans to Korean culture and help to bridge the rift between African Americans and Korean Americans in Los Angeles.

In 1996, Rev. Washington was elected to represent California's 52nd Assembly District, for which he served two terms. During that time, he authored, sponsored, and supported legislation aimed at promoting school safety, solving California's education crisis, reducing the rate of recidivism among California's prisoners, preventing crime and violence, increasing youth employment, and fostering economic growth throughout California. In 2002, Rev. Washington was appointed a full-time member of the California Integrated Waste Management Board.

"WE'RE ALL AFRAID TO DIE. BUT SOMETIMES YOUR DESIRE TO CHANGE YOUR COUNTRY CAN OVERCOME YOUR FEAR. THEN IT DOESN'T MATTER ANYMORE; DEAD OR ALIVE YOU'LL KEEP THE CHANGE GOING."

GET INVOLVED

HUMAN RIGHTS MONITORING

The Justice and Peace Commission (JPC) of Liberia works to restore normalcy to the strife-torn country. Using fact-finding, human rights education, and advocacy to promote and protect human rights, the JPC is one of the few organizations that continues to work in Liberia today. For more information, visit: www.forefrontleaders.org

The West African Refugees and Internally Displaced Persons Network (WARIPNET) is a coalition of West African nongovernmental organizations active in protecting refugees, asylum seekers, and internally displaced persons in Liberia and other West African countries. www.waripnet.org

SAMUEL KOFI WOODS

LIBERIA 1994 AGE 30

A POWERFUL VOICE FOR THE PEOPLE

IN 1989, CIVIL WAR BROKE OUT IN LIBERIA, AND AT LEAST 150,000 PEOPLE DIED IN THE KILLING RAMPAGES THAT FOLLOWED. EIGHTY PERCENT OF LIBERIANS WERE FORCED TO FLEE THEIR HOMES, AND HALF THE POPULATION SOUGHT REFUGE IN NEIGHBORING COUNTRIES. THE NATION WAS THROWN INTO A CHAOS THAT WOULD LAST WELL PAST THE WAR'S END SIX YEARS LATER.

In the midst of this turmoil, in 1991, a courageous young human rights activist founded the Justice and Peace Commission of Liberia, a Catholic-affiliated group dedicated to returning the strife-torn nation to normalcy. On a shoestring budget, Samuel Kofi Woods established a network of people to monitor human rights abuses, then reported those violations to the international community. Through a weekly human rights radio program, he not only reported on arrests and extrajudicial executions, but he also educated tens of thousands of Liberians about their rights.

For this work, Samuel's life was constantly threatened, and he was often forced into hiding and exile. This was not new to him; in college, his student activism had led to harassment, death threats, and incarceration. But prison had only deepened his convictions. He had met countless people who were detained illegally, without charge,

without due process, without representation, even without the right to a lawyer. Upon leaving prison, Samuel went to law school, determined to make a difference.

And he did make a difference. During the civil war, in addition to his leadership in human rights monitoring, he created a legal aid program for political prisoners. He was instrumental in improving living conditions in the Central Prison in Monrovia, and he mobilized a group of lawyers to liberate more than fifty inmates there who had been arbitrarily arrested and incarcerated without charge.

Samuel continues to promote efforts to bring about peace and respect for human rights in Liberia. In 2002, he founded the Foundation for International Dignity (FIND), based in Sierra Leone, which works for the rights of thousands of West African refugees.

GET INVOLVED

CHILD LABOR

The International Labour Organization (ILO) has been fighting child labor since it was formed in 1919. The ILO has developed twelve international labor conventions (or labor standards) to help nations eradicate child labor. In 1992, the ILO created its International Program on the Elimination of Child Labor (IPEC). IPEC works with countries to help them combat child labor and has implemented more than 600 anti-child labor action programs since its inception. www.ilo.org

FACED WITH SEEMINGLY INSURMOUNTABLE OBSTACLES AND HARDSHIPS IN HIS SHORT LIFETIME, IQBAL MASIH STOOD TALL IN THE FACE OF ADVERSITY AND ROSE TO BECOME AN ARDENT SPOKESPERSON AGAINST CHILD LABOR.

When Iqbal was four years old, his impoverished father sold him into bonded labor. For six years, Iqbal was chained to a carpet loom for fourteen hours a day, tying knots in carpets in his owner's small factory. His owner verbally and physically abused him, and barely fed him enough food to survive. As a result, Iqbal suffered from malnutrition and stunted growth, along with other physical ailments.

With the help of the Bonded Labor Liberation Front (BLLF), Iqbal was lucky to escape from his owner at the age of ten. Although he was freed from bondage, Iqbal did not forget the plight of the millions of other Pakistani children still in bonded labor. As a spokesman for BLLF, Iqbal began to travel throughout the United States and Europe speaking to children his own age about his struggle, advocating for an end to child labor, and calling for a boycott of Pakistan's carpet industry. He became internationally renowned for his activism. Thanks in part to his efforts, thousands of children were released from bonded labor and the Pakistani carpet industry began to wane.

On Easter Sunday of 1995, Iqbal was murdered in his hometown. It is still unknown who his killers are, but it is suspected that he was targeted for his political activism.

YOUTH IN ACTION AWARD: **BROAD MEADOWS MIDDLE SCHOOL** 1995

GET INVOLVED

CHILD LABOR

School for Iqbal Fund

When Iqbal Masih was killed, a group of students at Broad Meadows Middle School in Massachusetts found a way to channel their anger into activism. They went online on the Scholastic Network and organized the Kids Campaign to Build a School for Iqbal, a school in his memory, his name, and his village in Pakistan. The money was also used to create a small credit program to enable fifty families to buy back the children they had sold into bondage. And the Iqbal Masih Education Foundation was established to take over the daily operating expenses of the school.
www.amnesty133.org/iqbal/index.html

The United Nations Children's Fund (UNICEF) helps children get the care and stimulation they need in the early years of life, encourages families to educate girls as well as boys, strives to reduce childhood death and illness, and works to protect children in the midst of war and natural disaster. UNICEF supports young people, wherever they are, in making informed decisions about their own lives, and seeks to build a world in which all children live in dignity and security.
www.unicef.org

WHEN IQBAL MASIH VISITED THE BROAD MEADOWS MIDDLE SCHOOL DURING HIS BRIEF VISIT TO THE UNITED STATES IN DECEMBER 1994, HIS LIFE STORY SHOCKED AND OUTRAGED THE STUDENTS. THE TEN-TO-FOURTEEN-YEAR-OLDS BEGAN AN INTENSIVE LETTER-WRITING CAMPAIGN THAT RESULTED IN 670 LETTERS BEING SENT TO THE HEADS OF GOVERNMENTS IN COUNTRIES WHERE MANY CHILDREN ARE FORCED TO SPEND THEIR CHILDHOODS IN BONDED LABOR.

After learning of Iqbal's murder in April 1995, the students at Broad Meadows sought action as a way to help their grieving. They kicked off the "A Bullet Can't Kill A Dream" campaign to raise money for "A School for Iqbal," to educate poor Pakistani children in Iqbal's hometown. The campaign engaged children throughout the United States, as well as in twenty-one other countries. Together, they raised more than $140,000 for the school, which opened in January 1997. The school accommodates nearly 300 children between the ages of four and twelve. The poorest of the poor, these working children had never attended school before.

Today, the students at Broad Meadows continue to spread the word about forced, abusive child labor. They educate students and the general public about the ways youth can use consumer power to help end child labor by buying only child-labor-free items. And they have released a CD to raise money for the School for Iqbal Fund.

CRAIG KIELBURGER 1996 AGE 14

GET INVOLVED

CHILD LABOR

(Kids Can) Free the Children's School Building Campaign has built more than 300 primary schools in the developing world, providing education to more than 15,000 children. Based on the conviction that education is the key to helping stop the exploitation of children and break the cycle of poverty, the campaign seeks to give children a chance for a better life. www.freethechildren.org/projects/buildingschoolspr.html

The Global March Against Child Labour is a movement born out of hope and the desire felt by thousands of people across the globe to set children free from servitude. The Global March movement began with a worldwide march in 1998, when thousands of people marched together to issue a strong message against child labor. The Global March movement has since begun a crusade to make education available to all. www.globalmarch.org

WHILE SEARCHING FOR THE COMICS IN THE LOCAL PAPER ONE DAY, TWELVE-YEAR-OLD CRAIG KIELBURGER HAPPENED TO NOTICE A FRONT-PAGE ARTICLE ABOUT ANOTHER TWELVE-YEAR-OLD BOY. THE OTHER BOY, IQBAL MASIH, HAD BEEN SOLD INTO BONDAGE AS A CARPET WEAVER IN PAKISTAN, HAD ESCAPED, AND WAS LATER MURDERED FOR SPEAKING OUT AGAINST CHILD LABOR. DEEPLY MOVED BY IQBAL'S LIFE AND DEATH, CRAIG GATHERED A GROUP OF FRIENDS TOGETHER AND FOUNDED FREE THE CHILDREN, A NONPROFIT YOUTH ORGANIZATION THAT CAMPAIGNS AGAINST CHILD LABOR. FREE THE CHILDREN HAS SINCE GROWN INTO AN INFLUENTIAL INTERNATIONAL CHILDREN'S ORGANIZATION WITH HUNDREDS OF THOUSANDS OF YOUNG PEOPLE IN MORE THAN THIRTY-FIVE COUNTRIES PARTICIPATING IN ITS ACTIVITIES.

Craig continues to be actively involved with Free the Children and has become an internationally recognized author and spokesman on behalf of the destitute and powerless. He has traveled to more than forty countries to visit street and working children and speak out in defense of children's rights. He frequently addresses business groups, government bodies, educators, unions, and students around the world.

YOUTH IN ACTION AWARD: **ASHLEY BLACK** 1991 AGE 11

GET INVOLVED

HATE CRIMES

The Leadership Conference on Civil Rights (LCCR), founded in 1950, has coordinated the national legislative campaign on behalf of every major civil rights law since 1957. The LCCR is advocating for hate crimes prevention legislation that will allow the federal government to provide enhanced assistance to state and local authorities to punish hate crimes to the fullest extent possible. The legislation also expands the definition of a hate crime to include crimes motivated by the victim's disability, gender, or sexual orientation.
www.civilrights.org/about/lccr

WHEN SHE WAS ELEVEN YEARS OLD, ASHLEY BLACK LEARNED THAT VIDEO GAMES PROMOTING GENOCIDE AND RACISM HAD BEEN RELEASED IN GERMANY. IN ONE GAME, "ARYAN TEST," PLAYERS—USUALLY HIGH SCHOOL STUDENTS—EARNED POINTS FOR GASSING OR HANGING DEATH-CAMP PRISONERS. IN ANOTHER, "KZ MANAGER," PLAYERS WOULD SELECT AMONG A SERIES OF VICTIMS: JEWS, TURKS, NORTH AFRICANS, PAKISTANIS, COMMUNISTS, HOMOSEXUALS, AND THE DISABLED. THE PLAYERS WOULD THEN "PURCHASE" ZYKLON B GAS CANISTERS, EXTERMINATE THEIR VICTIMS, AND SELL THE HAIR AND GOLD FILLINGS OF THOSE VICTIMS TO RECOUP ENOUGH MONEY TO BUY NEW VICTIMS.

Outraged, Ashley launched a movement to ban imported hate video games in her home state of New Jersey. Through a petition campaign, she enlisted the help of other children and mobilized her community and the local media to combat the spread of those video games. In less than two months, Ashley and other volunteers had collected 2,000 signatures. Ashley also testified before members of the New Jersey Legislature, spurring them to pass legislation that prohibited the manufacture and distribution of the games in New Jersey.

Now a law student in New York City, Ashley is planning to undertake an internship at Forefront.

AWARD RECIPIENTS LISTED BY YEAR

1988	DAVID BRUCE SOUTH AFRICA	40	
	JOAQUIN ANTONIO CACERES EL SALVADOR	42	
	JANET CHERRY SOUTH AFRICA	50	
	ARN CHORN-POND UNITED STATES	52	
	TANYA COKE UNITED STATES	56	
	LOBSANG JINPA TIBET	84	
	SALIM ABDOOL KARIM SOUTH AFRICA	94	
	WINONA LADUKE UNITED STATES	98	
	JUAN PABLO LETELIER CHILE	102	
	MARIA PAZ RODRIGUEZ UNITED STATES	132	
	DALEE SAMBO UNITED STATES	134	
1989	LOUISE BENALLY-CRITTENDEN UNITED STATES	30	
	MICHAEL BROWN UNITED STATES	38	
	CHAI LING CHINA	104	
	MERCEDES DORETTI ARGENTINA	66	
	LUIS FONDEBRIDER ARGENTINA	66	
	ALAN KHAZEI UNITED STATES	38	
	LI LU CHINA	104	
	DAWAT LUPUNG MALAYSIA	108	
	BRYAN STEVENSON UNITED STATES	138	
	WANG DAN CHINA	104	
	WU'ER KAIXI CHINA	104	
1990	JEFFREY BRADLEY UNITED STATES	34	
	MARTIN DUNN UNITED STATES	34	
	SHA'WAN JABARIN WEST BANK	82	
	TRACYE MATTHEWS UNITED STATES	110	
	AKRAM MAYI IRAQ	112	
	DAVID MOYA CUBA	116	
1991	MIRTALA LOPEZ EL SALVADOR	106	
	SAUVEUR PIERRE UNITED STATES	130	
	ABUBACAR SULTAN MOZAMBIQUE	142	
	CARLOS TOLEDO GUATEMALA	146	
1992	FERNANDO DE ARAUJO EAST TIMOR	24	
	FLORIBERT BAHIZIRE CHEBEYA DEMOCRATIC REPUBLIC OF CONGO	48	
	STACEY KABAT UNITED STATES	90	
	MARTIN O'BRIEN NORTHERN IRELAND	126	

1993	MARIE-FRANCE BOTTE BELGIUM	32	
	SIA RUNIKUI KASHINAWA BRAZIL	96	
	HISHAM MUBARAK EGYPT	118	
	CARL WASHINGTON UNITED STATES	148	
1994	ADAUTO BELARMINO ALVES BRAZIL	20	
	ROSE-ANNE AUGUSTE HAITI	26	
	DILLI BAHADUR CHAUDHARY NEPAL	46	
	SAMUEL KOFI WOODS LIBERIA	150	
1995	ANGELA ELIZABETH BROWN UNITED STATES	36	
	MIGUEL ANGEL DE LOS SANTOS CRUZ MEXICO	60	
	RICHARD NSANZABAGANWA RWANDA	122	
	PHUNTSOK NYIDRON TIBET	124	
1996	INNOCENT CHUKWUMA NIGERIA	54	
	JESUS TECU OSORIO GUATEMALA	128	
	JULIE SU UNITED STATES	140	
	MA THIDA BURMA	144	
1998	ABRAHAM GEBREYESUS ERITREA	70	
	RANA HUSSEINI JORDAN	80	
	VAN JONES UNITED STATES	86	
	DIDIER KAMUNDU DEMOCRATIC REPUBLIC OF CONGO	92	
1999	JULIANA DOGBADZI GHANA	64	
	TANYA GREENE UNITED STATES	74	
	KA HSAW WA BURMA	88	
	SUBA CHURCHILL MESHACK KENYA	114	
2001	HEATHER BARR UNITED STATES	28	
	WILLIAM COLEY UNITED STATES	58	
	KODJO DJISSENOU TOGO	62	
	NDUNGI GITHUKU KENYA	72	
2002	KAVWUMBU HAKACHIMA ZAMBIA	78	
	MAILI LAMA NEPAL	100	
	MALIKA ASHA SANDERS UNITED STATES	136	
2003	PEDRO ANAYA UNITED STATES	22	
	ANUSUYA CHATTERJEE UNITED STATES	44	
	MOHAMED PA-MOMO FOFANAH SIERRA LEONE	68	
	ERNEST GUEVARRA PHILIPPINES	76	
	CHRISTIAN MUKOSA DEMOCRATIC REPUBLIC OF CONGO	120	

AWARD RECIPIENTS LISTED BY COUNTRY

ARGENTINA	MERCEDES DORETTI	66
	LUIS FONDEBRIDER	66
BELGIUM	MARIE-FRANCE BOTTE	32
BRAZIL	ADAUTO BELARMINO ALVES	20
	SIA RUNIKUI KASHINAWA	96
BURMA	KA HSAW WA	88
	MA THIDA	144
CHILE	JUAN PABLO LETELIER	102
CHINA	CHAI LING	104
	LI LU	104
	WANG DAN	104
	WU'ER KAIXI	104
CUBA	DAVID MOYA	116
DEMOCRATIC REPUBLIC OF CONGO	FLORIBERT BAHIZIRE CHEBEYA	48
	DIDIER KAMUNDU	92
	CHRISTIAN MUKOSA	120
EAST TIMOR	FERNANDO DE ARAUJO	24
EGYPT	HISHAM MUBARAK	118
EL SALVADOR	JOAQUIN ANTONIO CACERES	42
	MIRTALA LOPEZ	106
ERITREA	ABRAHAM GEBREYESUS	70
GHANA	JULIANA DOGBADZI	64
GUATEMALA	JESUS TECU OSORIO	128
	CARLOS TOLEDO	146
HAITI	ROSE-ANNE AUGUSTE	26
IRAQ	AKRAM MAYI	112
JORDAN	RANA HUSSEINI	80
KENYA	NDUNGI GITHUKU	72
	SUBA CHURCHILL MESHACK	114
LIBERIA	SAMUEL KOFI WOODS	150
MALAYSIA	DAWAT LUPUNG	108
MEXICO	MIGUEL ANGEL DE LOS SANTOS CRUZ	60
MOZAMBIQUE	ABUBACAR SULTAN	142
NEPAL	DILLI BAHADUR CHAUDHARY	46
	MAILI LAMA	100
NIGERIA	INNOCENT CHUKWUMA	54

NORTHERN IRELAND	MARTIN O'BRIEN	126
PHILIPPINES	ERNEST GUEVARRA	76
RWANDA	RICHARD NSANZABAGANWA	122
SIERRA LEONE	MOHAMED PA-MOMO FOFANAH	68
SOUTH AFRICA	DAVID BRUCE	40
	JANET CHERRY	50
	SALIM ABDOOL KARIM	94
TIBET	LOBSANG JINPA	84
	PHUNTSOK NYIDRON	124
TOGO	KODJO DJISSENOU	62
UNITED STATES	PEDRO ANAYA	22
	HEATHER BARR	28
	LOUISE BENALLY-CRITTENDEN	30
	JEFFREY BRADLEY	34
	ANGELA ELIZABETH BROWN	36
	MICHAEL BROWN	38
	ANUSUYA CHATTERJEE	44
	ARN CHORN-POND	52
	TANYA COKE	56
	WILLIAM COLEY	58
	MARTIN DUNN	34
	TANYA GREENE	74
	VAN JONES	86
	STACEY KABAT	90
	ALAN KHAZEI	38
	WINONA LADUKE	98
	TRACYE MATTHEWS	110
	SAUVEUR PIERRE	130
	MARIA PAZ RODRIGUEZ	132
	DALEE SAMBO	134
	MALIKA ASHA SANDERS	136
	BRYAN STEVENSON	138
	JULIE SU	140
	CARL WASHINGTON	148
WEST BANK	SHA'WAN JABARIN	82
ZAMBIA	KAVWUMBU HAKACHIMA	78

AWARD RECIPIENTS LISTED BY CAUSE

FROM THE PEOPLE COME THE POWER

FOREFRONT: A NETWORK OF AWARD RECIPIENTS

FOR MORE THAN A DECADE, I SLEPT IN A DIFFERENT HIDING PLACE EACH NIGHT, OFTEN CATNAPPING FOR TWO HOURS AT A TIME. I CAME CLOSE TO BEING CAUGHT MANY TIMES. ONCE, AT THE LAST MINUTE, I DECIDED TO FORGO SLEEP. IT WAS MIDNIGHT, AND MY BODY WAS CRAVING REST, BUT I SUDDENLY FELT COMPELLED TO SLIP AWAY TO ANOTHER LOCATION. AND I MISSED, JUST BY MINUTES, A RAID ON WHAT I HAD CONSIDERED A SAFE HAVEN.

By then I had learned to be cunning, not only to save myself, but to save others. I had learned about people abducted from their homes, imprisoned without cause, savagely killed. And I had learned to fight for those too powerless to fight for themselves.

These lessons came at great cost. Colleagues were murdered. I had to leave my native Liberia for exiles in other countries. My own mother begged me not to return. She was afraid I would be killed—and so was I. But I knew that my resolve to stay and fight for justice in Liberia meant so much to so many. And I knew that good can triumph over evil only when it confronts evil head on.

My passion for human rights had developed well before high school, when a military coup threw Liberia into chaos. During college, my activism led to harassment, arrests—even death threats. Then, in 1991, the archbishop of Liberia asked me to found the Catholic Justice and Peace Commission. I began with just a desk, a typewriter, and a thirst for justice—but that was enough.

Since then, I have worked determinedly for justice, acting on behalf of those paralyzed with fear, speaking out on behalf of those terrified into silence. Through the commission, my colleagues and I established a network of people to monitor human rights violations, and we helped document those abuses for the international community. During a weekly radio program, we reported arrests and extrajudicial executions. Despite the murder of several colleagues, we persevered, because we knew we were making a difference. Dozens of prisoners held without charge after arbitrary arrests, for example, were freed because we had borne witness.

When I received the Reebok Human Rights Award in 1994, it opened a new world for me. The Award provided credibility for my work, even among those who had been reluctant to support it morally, financially, or otherwise. And the benefits of receiving the Award did not end there. The year before, Reebok had brought together past recipients of its Award. Together, they launched Forefront, an international network that has since become a central resource for Award recipients from around the world. Forefront helps us by responding to crises, communicating with the international community, bringing visibility to our work, and providing us with critical resources.

Forefront supported me when I had to flee to Côte d'Ivoire for several months. The staff raised awareness about what was happening to me, launched a letter campaign, warned the Liberian government to stop threatening me, and provided financial assistance. When I took exile in the Netherlands, Forefront gave me a computer and Internet support so I could keep in touch with peo-

ple both in Liberia and internationally. I was able to tap into a worldwide community of people from whom I could find advice and comfort. Now, several years later, I am heading a new organization based in Sierra Leone that advocates for refugees in West Africa, and it is my turn to offer advice, support, and assistance to other activists facing difficulties.

Through its Human Rights Award, Reebok has brought together a family of human rights leaders who are the first line of defense for each other, a source of practical, tested solutions to the daily challenges we face in our work, and a reminder that we are not alone in our struggle. When Jesus Tecu Osario received death threats for testifying in the first court trial of those who had carried out brutal massacres in Guatemala in the early 1980s, for example, representatives of Forefront traveled to Guatemala to talk to United Nations and government officials on Jesus's behalf and bring media attention to the case.

When Dilli Chaudhary called for assistance as thousands of bonded laborers in Nepal became displaced and a humanitarian crisis was looming, Award recipient Abubacar Sultan from Mozambique traveled to Nepal to assess the needs in the camps and advocate for help from relief agencies, the government, and embassies.

And when Award recipients are unjustly imprisoned for speaking out about human rights, we mobilize all of our resources to campaign for their release. Already, successful campaigns have led to the release of Ma Thida, a Burmese physician, writer, and activist who served almost six years of a twenty-year sentence for her peaceful pro-democracy activities; Fernando de Araujo, a human rights monitor in East Timor, who served seven years in jail for speaking out for the right to self-determination; David Moya, a student leader and activist from Cuba who served several prison terms for the peaceful expression of his pro-democracy views; and Wang Dan, a student leader of the Tiananmen Square student movement in 1989 who spent nearly nine years in prison. And we continue to advocate for the release of Phuntsok Nyidron of Tibet, the only Reebok Human Rights Award recipient still imprisoned.

When she was twenty-four years old, Phuntsok and five other Tibetan nuns held a peaceful protest against the Chinese occupation of their country. They had been marching in procession and chanting slogans for just a few minutes when the police arrested them, kicked them, and gave them electric shocks. During the interrogations that followed, the nuns were reportedly suspended by their hands and beaten with iron rods.

Four years later, while still imprisoned, Phuntsok and other nuns recorded songs to offer solace to their fellow Tibetans. Government officials labeled the songs "crimes" and added eight years to Phuntsok's sentence. She is now serving the fourteenth year of a sixteen-year sentence. Despite the brutality she had endured, the words she sang in prison were tender and hopeful. "They do not let me see the sky," she sang. "I do not know night from day. When the guards have passed, I listen for a whisper— a friend, like wind—any sign that I'm not alone."

But Phuntsok is not alone. Her fellow Award recipients have been actively campaigning for her release for nearly a decade now. Undaunted, we continue to organize rallies, write letters to government officials, and educate as many people as possible about her situation. She remains a courageous symbol of both the sacrifice that young human rights heroes are willing to make and the critical need for our collective strength.

Though our causes and our countries may differ, our fears and hopes remain the same. Through Forefront, we are able to give each other a vital source of moral support and solidarity—a spark that keeps the spirit of the Reebok Human Rights Award burning bright long after the ceremonies have ended.

SAMUEL KOFI WOODS *received the 1994 Reebok Human Rights Award for his work in crusading for justice in Liberia.*

A WINDOW OF OPPORTUNITY

In the 1940s, my maternal grandfather, Max Fisher, manufactured shoes—handsewns to be exact—in a factory in Hudson, Massachusetts. I don't know much about the working conditions in his factory; I'd like to believe he treated his workers well. But I feel it's safe to make an assumption about Grandpa Max: he knew his workers. He knew the conditions in which they labored every day. He knew those conditions, not only because of the kind of person he was, but also because his office, with its large glass window, overlooked the shop floor.

But today, products are often manufactured as far as 10,000 miles from corporate headquarters, typically in factories owned and operated by others, often in countries with inadequate regulations and little enforcement of the few regulations that do exist. It's up to multinational corporations to recreate Grandpa Max's large glass window, to ensure that business as usual is not at the expense of men, women, and children who live thousands of miles away, where they're out of sight and often—perilously for them—out of mind.

And it's up to us as individuals to make the cause of human rights our own. We must take it to heart, take it to mind, and make it the work of our hands.

PAUL FIREMAN *is chairman and chief executive officer of Reebok International Ltd.*

FROM THIS POWER COME THE CHANGE

HUMAN RIGHTS IN OUR WORK

In 1994, a *Wall Street Journal* reporter was walking along a street in Zhuhai, a small city in South China, when he fell into conversation with several young people. During the course of their discussion, the young people mentioned that they lived in nearby company housing, on the top floor of an unsafe building. Where did they work? At a local factory, making Reebok shoes.

The reporter could have gleefully written a story about hypocritical human rights posturing. Instead, he called the general manager of Reebok's Hong Kong office, who in turn called the company's human rights director in Massachusetts. When Reebok's highest-level production executives demanded an explanation from their Chinese subcontractor, they were told that the Chinese government had approved the housing, and that it would be several months before safer housing would be available.

That wasn't good enough. The executives insisted that the workers be moved to safe quarters immediately. Within two days, twenty-three buses had transported 800 workers to temporary, yet safe housing an hour's drive away. While their new housing was being built, the workers received overtime pay for their extra commute.

Reebok had demanded compliance with its Human Rights Production Standards, a code of conduct implemented two years earlier. Under this code, factories must adhere to reasonable working hours and overtime, provide fair compensation, respect the right to freedom of association, and offer a safe and healthy work environment. The code also prohibits discrimination against workers, forced or compulsory labor, and child labor. These standards are written into manufacturing contracts and enforced through an extensive program of education, training, and internal and independent audits.

"Our intention was a code that wouldn't just be shoved into a drawer and pulled out when needed for public relations purposes, but one that would truly guide us," says Doug Cahn, vice president of the Reebok Human Rights Programs. "That's why the code has been translated into sixteen languages and posted wherever Reebok contracts work. All this takes more than commitment alone; it requires traversing uncharted territory."

When Reebok began, there were no training manuals, no monitoring guides, no consultants to show the way. But it didn't take long for Reebok to learn that nothing could be taken for granted. Soon after a monitor inspected one overseas factory, for example, he noticed workers operating a leather-cutting machine in a surprising way. The machine had been designed to be operated with two hands, so workers couldn't accidentally catch and mangle a hand, but the factory owners had been hotwiring the machines to be operated with only one hand, to speed up the work. Until Reebok had installed a monitor, this dangerous subversion of safety standards had gone undetected.

While Reebok continues to value independent monitoring, it has come to realize that the best long-term strategy for ensuring good working conditions for the tens of thousands of workers who make its products is to help educate factory managers and the workers themselves to understand and defend their rights. So Reebok has expanded it role from oversight of the workplace to the education and encouragement of the workers as guardians of their rights. In a large footwear factory in Fuzhou, China, for example, Reebok sought not only to facilitate better communication between management and employees, but also to encourage workers to understand their basic rights so they could take a more active role in improving work conditions. Recently, the factory conducted its first open election of worker representatives. All the candidates were self-nominated, each employee cast a ballot in secret, and votes were tallied in an open and visible process. With truly *elected* representatives, workers now have the possibility of taking a more active role in protecting their own rights and improving factory conditions.

The progress in improving conditions for workers only confirmed what Reebok has understood and celebrated while listening to the stories of Reebok Human Rights Award recipients for fifteen years—that people working together can be a powerful source of change. The recipients teach us all that the actions of even one person can transform the lives of hundreds—or even thousands—of people. We can all raise our voices on behalf of those who have been rendered voiceless, those imprisoned for their ideas, those tortured for daring to face their oppressors.

"Over the years, we've learned a great deal from our Award recipients," says Paul Fireman, chairman and chief executive officer of Reebok. "We've learned that each of us can change things. We can't change everything, not alone, not overnight. But we can change things incrementally, one step at a time. And if sometimes the change is so small as to seem insignificant—well, there may be a young woman whose dignity you've preserved, a man whose life you've saved, a child to whom you've given a chance."

UNIVERSAL DECLARATION OF HUMAN RIGHTS

RESOLUTION 217 A (III) OF THE GENERAL ASSEMBLY OF THE UNITED NATIONS, 10 DECEMBER 1948

PREAMBLE:

WHEREAS recognition of the inherent dignity and of the equal and inalienable rights of all members of the human family is the foundation of freedom, justice and peace in the world,

WHEREAS disregard and contempt for human rights have resulted in barbarous acts which have outraged the conscience of mankind, and the advent of a world in which human beings shall enjoy freedom of speech and belief and freedom from fear and want has been proclaimed as the highest aspiration of the common people,

WHEREAS it is essential, if man is not to be compelled to have recourse, as a last resort, to rebellion against tyranny and oppression, that human rights should be protected by the rule of law,

WHEREAS it is essential to promote the development of friendly relations between nations,

WHEREAS the peoples of the United Nations have in the Charter reaffirmed their faith in fundamental human rights, in the dignity and worth of the human person and in the equal rights of men and women and have determined to promote social progress and better standards of life in larger freedom,

WHEREAS Member States have pledged themselves to achieve, in co-operation with the United Nations, the promotion of universal respect for and observance of human rights and fundamental freedoms,

WHEREAS a common understanding of these rights and freedoms is of the greatest importance for the full realization of this pledge,

Now, Therefore THE GENERAL ASSEMBLY proclaims THIS UNIVERSAL DECLARATION OF HUMAN RIGHTS as a common standard of achievement for all peoples and all nations, to the end that every individual and every organ of society, keeping this Declaration constantly in mind, shall strive by teaching and education to promote respect for these rights and freedoms and by progressive measures, national and international, to secure their universal and effective recognition and observance, both among the peoples of Member States themselves and among the peoples of territories under their jurisdiction.

ARTICLE 1 All human beings are born free and equal in dignity and rights. They are endowed with reason and conscience and should act towards one another in a spirit of brotherhood.

ARTICLE 2 Everyone is entitled to all the rights and freedoms set forth in this Declaration, without distinction of any kind, such as race, colour, sex, language, religion, political or other opinion, national or social origin, property, birth or other status. Furthermore, no distinction shall be made on the basis of the political, jurisdictional or international status of the country or territory to which a person belongs, whether it be independent, trust, non-self-governing or under any other limitation of sovereignty.

ARTICLE 3 Everyone has the right to life, liberty and security of person.

ARTICLE 4 No one shall be held in slavery or servitude; slavery and the slave trade shall be prohibited in all their forms.

ARTICLE 5 No one shall be subjected to torture or to cruel, inhuman or degrading treatment or punishment.

ARTICLE 6 Everyone has the right to recognition everywhere as a person before the law.

ARTICLE 7 All are equal before the law and are entitled without any discrimination to equal protection of the law. All are entitled to equal protection against any discrimination in violation of this Declaration and against any incitement to such discrimination.

ARTICLE 8 Everyone has the right to an effective remedy by the competent national tribunals for acts violating the fundamental rights granted him by the constitution or by law.

ARTICLE 9 No one shall be subjected to arbitrary arrest, detention or exile.

ARTICLE 10 Everyone is entitled in full equality to a fair and public hearing by an independent and impartial tribunal, in the determination of his rights and obligations and of any criminal charge against him.

ARTICLE 11 (1) Everyone charged with a penal offence has the right to be presumed innocent until proved guilty according to law in a public trial at which he has had all the guarantees necessary for his defence.
(2) No one shall be held guilty of any penal offence on account of any act or omission which did not constitute a penal offence, under national or international law, at the time when it was committed. Nor shall a heavier penalty be imposed than the one that was applicable at the time the penal offence was committed.

ARTICLE 12 No one shall be subjected to arbitrary interference with his privacy, family, home or correspondence, nor to attacks upon his honour and reputation. Everyone has the right to the protection of the law against such interference or attacks.

ARTICLE 13 (1) Everyone has the right to freedom of movement and residence within the borders of each state.
(2) Everyone has the right to leave any country, including his own, and to return to his country.

ARTICLE 14 (1) Everyone has the right to seek and to enjoy in other countries asylum from persecution.
(2) This right may not be invoked in the case of prosecutions genuinely arising from non-political crimes or from acts contrary to the purposes and principles of the United Nations.

ARTICLE 15 (1) Everyone has the right to a nationality.
(2) No one shall be arbitrarily deprived of his nationality nor denied the right to change his nationality.

ARTICLE 16 (1) Men and women of full age, without any limitation due to race, nationality or religion, have the right to marry and to found a family. They are entitled to equal rights as to marriage, during marriage and at its dissolution.
(2) Marriage shall be entered into only with the free and full consent of the intending spouses.
(3) The family is the natural and fundamental group unit of society and is entitled to protection by society and the State.

ARTICLE 17 (1) Everyone has the right to own property alone as well as in association with others.
(2) No one shall be arbitrarily deprived of his property.

ARTICLE 18 Everyone has the right to freedom of thought, conscience and religion; this right includes freedom to change his religion or belief, and freedom, either alone or in community with others and in public or private, to manifest his religion or belief in teaching, practice, worship and observance.

ARTICLE 19 Everyone has the right to freedom of opinion and expression; this right includes freedom to hold opinions without interference and to seek, receive and impart information and ideas through any media and regardless of frontiers.

ARTICLE 20 (1) Everyone has the right to freedom of peaceful assembly and association.
(2) No one may be compelled to belong to an association.

ARTICLE 21 (1) Everyone has the right to take part in the government of his country, directly or through freely chosen representatives.
(2) Everyone has the right of equal access to public service in his country.
(3) The will of the people shall be the basis of the authority of government; this will shall be expressed in periodic and genuine elections which shall be by universal and equal suffrage and shall be held by secret vote or by equivalent free voting procedures.

ARTICLE 22 Everyone, as a member of society, has the right to social security and is entitled to realization, through national effort and international co-operation and in accordance with the organization and resources of each State, of the economic, social and cultural rights indispensable for his dignity and the free development of his personality.

ARTICLE 23 (1) Everyone has the right to work, to free choice of employment, to just and favourable conditions of work and to protection against unemployment.
(2) Everyone, without any discrimination, has the right to equal pay for equal work.
(3) Everyone who works has the right to just and favourable remuneration ensuring for himself and his family an existence worthy of human dignity, and supplemented, if necessary, by other means of social protection.
(4) Everyone has the right to form and to join trade unions for the protection of his interests.

ARTICLE 24 Everyone has the right to rest and leisure, including reasonable limitation of working hours and periodic holidays with pay.

ARTICLE 25 (1) Everyone has the right to a standard of living adequate for the health and well-being of himself and of his family, including food, clothing, housing and medical care and necessary social services, and the right to security in the event of unemployment, sickness, disability, widowhood, old age or other lack of livelihood in cir-

cumstances beyond his control.
(2) Motherhood and childhood are entitled to special care and assistance. All children, whether born in or out of wedlock, shall enjoy the same social protection.

ARTICLE 26 (1) Everyone has the right to education. Education shall be free, at least in the elementary and fundamental stages. Elementary education shall be compulsory. Technical and professional education shall be made generally available and higher education shall be equally accessible to all on the basis of merit.
(2) Education shall be directed to the full development of the human personality and to the strengthening of respect for human rights and fundamental freedoms. It shall promote understanding, tolerance and friendship among all nations, racial or religious groups, and shall further the activities of the United Nations for the maintenance of peace.
(3) Parents have a prior right to choose the kind of education that shall be given to their children.

ARTICLE 27 (1) Everyone has the right freely to participate in the cultural life of the community, to enjoy the arts and to share in scientific advancement and its benefits.
(2) Everyone has the right to the protection of the moral and material interests resulting from any scientific, literary or artistic production of which he is the author.

ARTICLE 28 Everyone is entitled to a social and international order in which the rights and freedoms set forth in this Declaration can be fully realized.

ARTICLE 29 (1) Everyone has duties to the community in which alone the free and full development of his personality is possible.
(2) In the exercise of his rights and freedoms, everyone shall be subject only to such limitations as are determined by law solely for the purpose of securing due recognition and respect for the rights and freedoms of others and of meeting the just requirements of morality, public order and the general welfare in a democratic society.
(3) These rights and freedoms may in no case be exercised contrary to the purposes and principles of the United Nations.

ARTICLE 30 Nothing in this Declaration may be interpreted as implying for any State, group or person any right to engage in any activity or to perform any act aimed at the destruction of any of the rights and freedoms set forth herein.

ARTICLE 18: EVERYONE HAS THE RIGHT TO FREEDOM OF THOUGHT, CONSCIENCE AND RELIGION; THIS RIGHT INCLUDES FREEDOM TO CHANGE HIS RELIGION OR BELIEF, AND FREEDOM, EITHER ALONE OR IN COMMUNITY WITH OTHERS AND IN PUBLIC OR PRIVATE, TO MANIFEST HIS RELIGION OR BELIEF IN TEACHING, PRACTICE, WORSHIP AND OBSERVANCE.

ARTICLE 9: NO ONE SHALL BE SUBJECTED TO ARBITRARY ARREST, DETENTION OR EXILE.

Special thanks to Rory O'Connor, president and chief executive officer of Globalvision, for providing stills from a number of videos he has produced of the Reebok Human Rights Award recipients over the years.

Heartfelt gratitude as well to Eddie Adams, whose portraits of Award recipients appear on pages 64, 80, 86, 88, 126, 142, and 150. These images were all published in *Speak Truth to Power,* a book by Kerry Kennedy Cuomo that contains interviews with fifty human rights advocates from around the world.

pages 2–3: A group of women watch the raising of the Jonda Pole outside of the Karti Sakhi Shrine on the start of the Muslim holiday, *Nowruz,* or New Year celebrations. The Jonda pole is raised for forty days as a symbol of life's renewal. Women are now permitted to pray at the Jonda pole for the first time in five years, since the fall of the Taliban, who had prohibited women from praying there. (Kabul, Afghanistan; 21 March 2002; AP Photo/Suzanne Plunkett)

pages 4–5: A man stands alone to block a line of tanks heading east on Chang'an Boulevard in front of Tiananmen Square. The man, calling for an end to the recent violence and bloodshed against pro-democracy demonstrators, was pulled away by bystanders, and the tanks continued on their way. The Chinese government crushed a student-led demonstration for democratic reform and against government corruption, killing thousands of demonstrators in the strongest anti-government protest since the 1949 revolution. Ironically, the name Tiananmen means "Gate of Heavenly Peace." (Beijing, China; 5 June 1989; AP Photo/Jeff Widener)

page 22 bottom: A group of undocumented immigrants, forced to hold their hands above their heads, are escorted by a U.S. Border Patrol agent across a field near Calexico, California. Mexicali, Mexico is just across the border. (Calexico, California, United States; 19 July 1999; AP Photo/Denis Poroy)

page 30 bottom: A Navajo *hataalii,* a traditional medicine practitioner, stands in front of the eight-sided ceremonial hogan that serves as his office at the Winslow Indian Health Center. (Winslow, Arizona, United States; 14 April 1999; AP Photo/The Daily Times, Marc F. Henning)

page 34 bottom: Students of the Thomas J. Pappas School eat breakfast. In addition to classes, the school provides two meals and an onsite medical and clothing facility for the homeless children who attend. (Phoenix, Arizona, United States; 27 April 2000; AP Photo/Matt York)

page 36 top: Photo by Randall Richards

page 38 bottom: Members of the 2002–2003 City Year Service Corps celebrate the start of their year of commitment to the organization during festivities outside historic Faneuil Hall. (Boston, Massachusetts, United States; Tuesday, 1 October 2002; AP Photo/Bizuayehu Tesfaye)

page 40 bottom: Police fire on fleeing protesters in Boipatong township where a prior massacre had left thirty-nine people dead. After police fired on the crowd, at least one man was killed and several people were wounded. (Boipatong, South Africa; 20 June 1992; AP Photo/Greg Marinovich)

page 42 bottom: Three nuns of the Maryknoll Catholic order pray beside the bodies of their four sisters, who were kidnapped and slain. (San Salvador, El Salvador; 4 December 1981; AP Photo)

page 44 top: Photo by Sze Tsung Leong

page 48 bottom: Children wait to receive medical attention at an international aid site. (Kinshasa, Democratic Republic of Congo; 27 October 1997; AP Photo/Brennan Linsley)

page 50 bottom: Students and parents march to protest the lingering apartheid policy of a junior school that excludes blacks. (Potgietersrus, South Africa; 7 February 1996; AP Photo/Adil Bradlow)

page 52 bottom: A group of Cambodians returns to Phnom Penh. By the time the last Khmer Rouge holdouts surrendered in 1998, about three million Cambodians had died during the first civil war, the Khmer Rouge reign of terror, a Vietnamese invasion, and a decade-long occupation that brought another civil war. (Phnom Penh, Cambodia (Kampuchea); March 1980; AP Photo/Denis Gray)

page 56 bottom: An anti-death penalty group protests an execution outside the Statesville Correctional Center. (Joliet, Illinois, United States; 17 September 1996; AP Photo/Charles Bennett)

page 64 bottom: During the Voice of Victims special forum at the World Conference Against Racism, Mariama Oumarou cries while recounting her experience as a child slave in Niger. Like her mother and grandmother before her, Oumarou led a life of long days with little rest, grinding grain, fetching water, and tending livestock. Now she is an anti-slavery activist. (Durban, South Africa; 2 September 2001; AP Photo/Themba Hadebe)

page 66 bottom: The families of the victims who disappeared during the 1976–83 military junta carry portraits of the missing during a march to the Plaza de Mayo to mark the twenty-sixth anniversary of the country's last military coup. (Buenos Aires, Argentina; 24 March 2002; AP Photo/Roman von Eckstein)

page 68 bottom: A fourteen-year-old soldier of the Sierra Leone Army holds a rifle while helping patrol the small town of Ropath, near Masiaka, thirty-five miles east of the capital of Freetown. (Masiaka, Sierra Leone; 23 May 2000; AP Photo/Adam Butler)

page 70 bottom: A man practices walking with a prosthetic leg donated by the American Barr Foundation at the San Felipe Hospital. The men in the background are also landmine victims. (Tegucigalpa, Honduras; 1 March 2002; AP Photo/Esteban Felix)

page 72 bottom: Photo by Al Hartmann, *Salt Lake Tribune*

page 74 bottom: The Central Prison Gas Chamber. (Raleigh, North Carolina, United States; 4 April 1997; AP Photo/The Raleigh News & Observer, Gene Furr)

page 76 bottom: Doctors tend to a child who was rushed to the hospital following a powerful explosion that killed at least nineteen people outside the International Airport. No one claimed responsibility for the blast. (Davao, Philippines; 4 March 2003; AP Photo/Philippine Daily Inquirer, Bing Gonzales)

pages 78, 100, 136 top: Photos by Nick Cardillicchio, with permission by *Marie Claire*

page 82 bottom: At the Israeli army documentation area of the Erez Checkpoint, Palestinians wait in line to be processed and allowed to travel along the safe passage route, a twenty-eight-mile land link, between the Gaza Strip and the southern West Bank. (Erez Crossing, Israel; 25 Monday October 1999; AP Photo/Jacqueline Larma)

page 84 bottom: Exiled Tibetan monks protest the visit of People's Republic of China President Jiang Zemin to Harvard University. (Cambridge, Massachusetts, United States; 1 November 1997; AP Photo/Bikem Ekberzade)

page 88 bottom: Karen refugee children look up from a home-made bomb shelter at a refugee camp, near the Thai–Burma border, which shelters about 30,000 people. (Mae Hla, Thailand; 16 March 1998; AP Photo/David Longstreath)

page 90 bottom: A silent march marks the start of Domestic Violence Awareness month. (Charlotte, North Carolina, United States; 1 October 2002; AP Photo/The Charlotte Observer, Patrick Schneider)

page 94 bottom: A patient suffering from tuberculosis is given her medication by nurses at Baragwanath Hospital in Soweto township on the outskirts of Johannesburg. (Johannesburg, South Africa; 28 August 2002; AP Photos/Saurabh Das)

page 98 bottom: Winona LaDuke, founder of the White Earth Land Recovery Project, gestures to a map of the White Earth Indian Reservation while standing outside the project's head-quarters. The nonprofit organization was founded to reclaim land once held in trust for Anishinabe tribes and now works on a range of Native American issues. (Ponsford, Minnesota, United States; 16 September 2002; AP Photo/Jack Sullivan)

page 102 bottom: A member of the group of relatives of the detained and disappeared during the regime of former Chilean dictator General Augusto Pinochet places a flower on a wall covered with images of the disappeared in the group's headquarters. (Santiago, Chile; 23 March 1999; AP Photo/Santiago Llanquin)

page 104 bottom: Student leader Wang Dan calls for a city-wide march during the student pro-democracy demonstrations in Tiananmen Square. (Beijing, China; 27 May 1989; AP Photo/Mark Avery)

page 108 top: Photo by Thom Henley

page 110 bottom: An eight-year-old boy rides his bicycle by the dilapidated and unmaintained units of the Sunnydale public housing projects. (San Francisco, California, United States; 13 March 1997; AP Photo/George Nikitin)

page 112 bottom: Iraqi Kurdish refugees who survived chemical attacks by the Iraqi military on their homes in Halabja. (Diyarbakir refugee camp, Turkey, 1990; H. Davies/Exile Images)

page 114 bottom: Students throw stones and a canister of tear gas that had been shot at them by the police during a demonstration. About 400 students battled police in downtown Nairobi, protesting the suspensions of seventeen students who had demonstrated earlier against political violence and an increase in tuition. (Nairobi, Kenya; 5 March 1998; AP Photo/Jean-Marc Bouju)

page 120 bottom: Rebel soldiers look over lime-covered bodies of twelve people in Goma, north of Bukavu, in eastern Congo. The bodies, including those of several women and children, were claimed by Congo rebels to be the victims of the Interahamwe during recent battles. The Interahamwe orchestrated the 1994 Rwandan genocide, in which 800,000 people were killed. (Goma, Democratic Republic of Congo; 15 September 1998; AP Photo/Jean-Marc Bouju)

page 122 bottom: Tutsi refugees wait for medical care at a camp outside of Gisenyi, Rwanda, near the border with the Democratic Republic of Congo. (Gisenyi, Rwanda; 3 June 1996; AP Photo/Sayyid Azim)

page 126 bottom: Children walk past the remains of a burned-out truck left after a night of street riots. The rioters were showing their support for the more than 100,000 pro-British Protestant nationalists who, after days of rioting over their right to parade, marched through Roman Catholic neighborhoods to commemorate a battle won by Protestants in 1690. (Londonderry, Northern Ireland; 12 July 1996; AP Photo/Paul McErlane)

page 128 top: Photo by Matt Pacenza

page 132 bottom: A three-year-old Guatemalan refugee plays on the floor of a Red Cross shelter while his mother and infant sister sit on a nearby cot. (Brownsville, Texas, United States; 24 February 1989; AP Photo/Pat Sullivan)

page 134 bottom: Alaska Native hunter Mickey Agiak pulls a sled as he drives his snowmo-bile past the KIC-1 well-pipe, located in the Arctic National Wildlife Refuge, about thirteen miles southeast of the Alaskan village of Kaktovik. (Arctic National Wildlife Refuge, Alaska, United States; 22 February 2001; AP Photo/Jack Smith)

page 138 bottom: Inmates of the Limestone Correctional Facility. (Capshaw, Alabama, United States; 25 July 2001; AP Photo/Dave Martin)

page 140 bottom: Chinese garment workers stage a protest in an effort to collect back wages from their former employers. (San Francisco, California, United States; 17 September 2002; AP Photo/Marcio Jose Sanchez)

page 144 top: Courtesy of Amnesty International

page 144 bottom: Mothers with sick children wait outside the headquarters of the National League for Democracy for free medicine. Donor nations blocked virtually all development aid to Burma after 1988 when the military violently suppressed pro-democracy demonstrations, killings hundreds. (Rangoon, Burma; 7 May 2002; AP Photo/David Longstreath)

page 166: General view of the fifty-fifth session of the Commission on Human Rights during the voting session at the United Nations building. (Geneva, Switzerland; 23 April 1999; AP Photo/Donald Stampfli)

THE REEBOK HUMAN RIGHTS AWARD PROGRAM AND FACING HISTORY AND OURSELVES HAVE ENTERED INTO A PARTNERSHIP TO USE THESE STORIES OF YOUNG HUMAN RIGHTS HEROES TO EDUCATE STUDENTS ABOUT ISSUES AROUND THE WORLD. FOR MORE THAN TWENTY-FIVE YEARS, FACING HISTORY, A NATIONAL, NONPROFIT ORGANIZATION, HAS ENGAGED TEACHERS AND STUDENTS OF DIVERSE BACKGROUNDS IN AN EXAMINATION OF RACISM, PREJUDICE, AND ANTISEMITISM IN ORDER TO PROMOTE THE DEVELOPMENT OF A MORE HUMANE AND INFORMED CITIZENRY. FACING HISTORY WILL CREATE RESOURCES TO ACCOMPANY THIS BOOK AND OFFER TEACHERS AND STUDENTS WAYS TO USE THE PROFILES TO UNDERSTAND THE HUMAN RIGHTS ISSUES AND THE WAYS IN WHICH INDIVIDUALS CAN CHOOSE TO MAKE A DIFFERENCE.

BOARD OF ADVISORS

JIMMY CARTER 39th President of the United States

SHARON COHEN Chief Communications Officer, Ewing Marion Kauffman Foundation

GERALYN DREYFOUS Human Rights Activist

PAUL FIREMAN Chairman and CEO, Reebok International Ltd.

PETER GABRIEL Musical Artist

RAFER JOHNSON Olympic Decathlete and Chairman of the California Special Olympics

ELAINE JONES Director-Counsel, NAACP Education and Legal Defense Fund

KERRY KENNEDY CUOMO Founder, Robert F. Kennedy Memorial Center for Human Rights

LI LU Alliance for a Democratic China and 1989 Reebok Human Rights Award Recipient

JOSH MAILMAN President, Sirius Business Corporation

JAY MARGOLIS President and COO, Reebok International Ltd.

ANGEL MARTINEZ Marketing Consultant

MICHAEL POSNER Executive Director, Lawyers Committee for Human Rights

ROBERT REDFORD Actor, Director, and Environmentalist

BRYAN STEVENSON Executive Director, Equal Justice Initiative of Alabama, and 1989 Reebok Human Rights Award Recipient

MICHAEL STIPE Singer/Songwriter, Song Producer, and Photographer

ROSE STYRON Poet/Journalist

REEBOK HUMAN RIGHTS PROGRAMS

DOUG CAHN Vice President, Reebok Human Rights Programs

STEPHEN DICKERMAN Director, Reebok Human Rights Award Program

SHALINI NATARAJ Associate Director, Reebok Human Rights Award Program

SUSAN CURTIS Operations Manager, Reebok Human Rights Award Program

WRITERS/EDITORS DEB BERGERON and **PAULA BREWER BYRON**

SPECIAL THANKS to the present and past employees of Reebok International Ltd. who have enthusiastically supported the Reebok Human Rights Award Program since 1988, especially Joseph LaBonte, Angel Martinez, Nasser Ega-Musa, Sharon Cohen, and Paula Van Gelder.

FOR MORE INFORMATION, PLEASE CONTACT:

Reebok Human Rights Award Program

1895 J. W. Foster Boulevard

Canton, MA 02021

Phone: 781 401 5061

Fax: 781 401 4806

Email: rhraward@reebok.com

Web: www.reebok.com/humanrights

Printed on 100 lb. Sappi Lustro Dull Text

Creative Direction and Design: **Sze Tsung Leong** and **Chuihua Judy Chung** / www.codagroup.net